ART

DIRECTION

AT LAST!

EXPLAINED,

STEVEN HELLER + VERONIQUE VIENNE

LAURENCE KING

Published in 2009 by Laurence King Publishing Ltd
361–373 City Road
London EC1V 1LR
Tel: +44 20 7841 6900
Fax: +44 20 7841 6910
Email: enquiries@laurenceking.com
www.laurenceking.com

A catalogue record for this book is available from the British Library.

ISBN: 978 1 85669 624 1

Design: Rick Landers

Printed in China

ART DIRECTION EXPLAINED, AT LAST!

STEVEN HELLER + VERONIQUE VIENNE

CONTENTS:

SECTION ONE:
WHAT IS AN ART DIRECTOR?

SECTION TWO:
CREATIVE TENSION 101 (WHAT MAKES ART DIRECTION WORK)

SECTION THREE:
AUTO ART DIRECTION

SECTION FOUR:
NUTS AND BOLTS

A FABLE/PREAMBLE:
"I AM AN ART DIRECTOR," SAID THE FOX
BRIAN COLLINS

Once upon a time there was a raccoon who made his living making and selling banjos.

One day a donkey entered his shop. "How can I help you?" asked the raccoon.

"Well, I would very much like to play the banjo," said the donkey.

So the raccoon sold him a basic but lovely starter model. The donkey went on his way, rejoicing in his new purchase. The raccoon was also quite pleased, reckoning he had just gained a repeat customer, as the donkey would certainly be back for a

banjo case, strings, finger picks, a pitch pipe, sheet music and—eventually—a top-of-the-line banjo.

The donkey went home and flailed away at the instrument for several days. But, as the timbre of his playing did not meet his expectations, discouragement soon set in. He stashed the banjo under his bed and did not revisit the raccoon's shop.

Soon after, the raccoon was lamenting this circumstance to

"You are not exactly a writer. You are not exactly a poster-maker. You are not a brand consultant. You are not a web designer. Yet you did all of these things."

some of his friends. Frankly, it was not the first time a promising customer had failed to return. Business was flat.

"Your logo is outdated," said the mole, a branding guru. "I will spherize it for you!"

"I will write you a clever TV spot!" said the bear, who was a copywriter. "I'll hire Joe Pytka to direct it."

"You need a transmedia, multichannel, viral marketing strategy!" said the rabbit, who was a web tycoon. "I will monetize all of those eyeballs!"

The raccoon felt paralyzed. Then the fox—who had been listening in the corner—spoke up.

"Perhaps what your customers really want," he said, "is not the banjo itself, but the magic of banjo music. So, perhaps you should be in the art of delivering them that magic."

"What?" said the raccoon, but dimly comprehending.

"Look, why not let me make some posters offering banjo classes? Then allow me to redesign your shop so it feels inviting. I will set up some chairs, put on some hot coffee and ask everyone in. Then you can hold jam sessions in your shop, where new players can mingle and hone their skills. And I could invite a visiting virtuoso to give a recital. I'll create a little newsletter that explains what you do every week. I can also film the sessions and create a website to make it all available online for creatures living in the outlying hollows. In this way, you'd start giving customers banjo…joy," suggested the fox. "Consequently, I believe the demand for your instruments will blossom."

"Capital!" exclaimed the raccoon, catching on.

And that's just what he did, following the fox's suggestions. In no time, his shop changed from a mere banjo store to a hive of banjo action. The donkey, hearing that lessons were to be had, came back. And he told others. Who then told others. Demand skyrocketed. The raccoon hired assistants and opened a recording studio. Customers came from everywhere. Best of all, the dells resounded with the dulcet ding-a-dang of the banjo.

When the raccoon went to pay the fox for his remarkable services, the raccoon asked him what line of work he was in. "You are not exactly a writer. You are not exactly a poster-maker. You are not a brand consultant. You are not a web designer. Yet you did all of these things for me."

"Well, that's because I am…an art director," answered the fox.

And soon after the raccoon came to see himself not as a banjo builder, but a "maker of musicians."

And so did everyone else.

INTRODUCTION:
TWO AUTHORS TALK ART DIRECTION

HELLER: We are writing and editing a book on art direction. We've both been art directors. We've both enjoyed being art directors. But I think the readers of our book would like to know (and maybe we'd like to know too) why in the twenty-first century is a book analyzing art direction necessary, and, no less, important?

VIENNE: If anything, art direction these days is becoming more relevant to more people. Recently I was interviewing French fashion designer Christian Lacroix, who not only creates couture and ready-to-wear collections, but puts his signature on products, curates exhibitions, presides over festivals, steps in as decorator, consults with architects, collaborates with graphic artists, teams up with engineers, and sponsors cultural events. "I am not a designer," he says, "I am an art director. I don't cut or drape fabrics, I don't decorate rooms, I don't design objects. What I do is art direct projects."

Is he just a dabbler? Or a facilitator? Does he simply show up and let others do the work? Maybe that's it. But even if he is only a go-between, what's wrong with that? Because his name is on a project, things happen. Proposals are accepted. Ideas get the go-ahead. Ventures are successful.

Some art directors still want to be hands-on. They love to design and resent the fact that they have to travel, go to meetings, keep up with the scene. It's understandable. But an increasing number of people, who call themselves art directors, function as "impresarios." Like Christian Lacroix, they are multidisciplinary, talented individuals who are able to actualize a vision from beginning to end.

How do they do it? That's the subject of our book. I hope that we can explain—at last—how art directors operate in situations that demand they be both versatile and efficient.

HELLER: Let's start by talking about the traditional role of an art director. Although a few, such as Alexey Brodovitch, the storied "facilitator" and designer, creative stimulator, and more, of *Harper's Bazaar* in the 1950s and 1960s, were collaborators with great editors (in his case Carmel Snow), most art directors are the handmaidens of those in higher positions. Depending on what medium is involved, the editor, account executive, producer, director, etc., is the one who decides upon content, while the art director shapes it in conceptual and aesthetic ways.

> "An increasing number of people, who call themselves art directors, function as 'impresarios'... multidisciplinary, talented individuals who are able to actualize a vision from beginning to end."

As former art directors both of us did the shaping, always answering to an editor who ultimately had the last word. We were, in fact, only as good as we were allowed to be by those people. In my case I had some editors who held a tight grip and others who gave me licence (fortunately more of the latter than the former). But I always knew that I was "serving at the pleasure of the king." As long as my decisions were in favor, I could be a "great" art director. But if my ideas went counter to the editor's preconception I was relegated to the role of a technician.

Would you agree that this is the conventional practice? And if so, has it changed any? And if so, again, how has it changed? What are the nuances of today's "new art direction?"

VIENNE: Serving a master is certainly part of the experience of being a traditional art director. And since we are on the subject of tradition, I was reading just yesterday about one of the least celebrated yet most prolific art directors of the Age of Enlightenment. Have you heard of Louis-Jacques Goussier? You probably have—you, of all people! Anyway, he was Diderot's art director for the famous *Encyclopédie*. Between 1751 and 1772 he researched, art directed, and produced more than 900 engravings to illustrate the 21 tomes of the dictionary, 12 of which are bound volumes of meticulously designed spreads replete with gorgeous and intricate information graphics.

Diderot praised Goussier often, saying that his work was more valuable and compelling than all the written entries put together. But history chose to forget the man whom Diderot called "the third encyclopedist" (the second was a mathematician, Jean le Rond d'Alembert, who shared the credit for the *Encyclopédie* with Diderot even though he only stuck with the project for eight years whereas Goussier labored on it for more than 20 years).

That's the way it still is. Art directors are seldom remembered by the public at large. Hollywood makes movies about editors (Diana Vreeland was the inspiration for *Funny Face* and Anna Wintour for *The Devil Wears Prada*) but studio executives would never put money behind a script romancing the life of Alexey Brodovitch or Paul Rand.

But, thank heaven, the master whom art directors serve usually is not their famous boss. The only higher authority art directors defer to is the project itself. The Louis-Jacques Goussiers and Paul Rands of this world work for an ideal, not a person. They take the abuse because they feel they signed a contract with themselves, not with an individual or an organization.

Still, there are exceptions. I am sure a number of art directors have worked with editors-in-chief, agency heads, or clients who've treated them like full-fledged partners. But, come to think of it, I have trouble coming up with precise examples.

Paul Rand and Eliot Noyes? But Noyes was a friend of Rand, not a boss. Alex Liberman and Si Newhouse? Gael Towey and Martha Stewart? Stefan Sagmeister and David Byrne?

Come on. Help me. Are today's "new art directors" less likely to be treated like indentured servants?

HELLER: In the good ol' days the art director was always on staff. Even Paul Rand, when he was art director for

"Advertising art directors have to be smart. Editorial art directors have to be intelligent. Two very different qualities—and *vive la différence!*"

Weintraub Advertising in New York, was an employee, not a partner or principal. His work was the lure that brought many clients into the agency. He transformed the look and content of advertising. But he was still a well-paid indentured art director.

Then something amazing happened, at least in advertising. Creatives—copywriters and art directors—joined account executives as "masters" of their own agencies. The sands shifted and "creativity" was valued as much, if not more, than business acumen. After all, if there was no creative, there was no business. And if there was no business, there was no agency. You get the picture.

Today it is *de rigueur* for creatives to be the partners or principals in agencies. Debbie Millman, one of the contributors to this book, is a principal at Sterling Brands, and in this capacity she is responsible for more (and accomplishes more) than a mere staff art director. But, more definitively, certain art directors—Fabien Baron or Jean-Paul Goode, for example—are not just hired hands in a process; they are sought-after geniuses. They are hired directly by large companies to work their magic by creating unique identities and brands. This is the portrait of the "new" art director: someone who is expert enough to be autonomous within a larger structure.

Still, as much as I wax poetic about this "new" role, the independent art director is not the norm. Art directors come in all shapes and sizes, and most are not in a position to dictate overall policy. So, let's now discuss the role of the editorial art director—the most common-or-garden variety. Can you describe for the reader what it means to be such an art director?

VIENNE: Before we get into the editor–art director relationship, I would like to talk a little more about the situation of the advertising art director. Granted, in ad agencies art directors have much more power. They can even bully their clients sometimes. I often hear stories about flamboyant "creatives" who storm out of meetings when their ideas are rejected, only to be called back a few minutes later (or the next day) by apologetic account executives who then let them have their way. Many great ad campaigns have been created that way. But I am not as impressed as you are by the dynamics of this type of situation. It's more about power play than about content, and the ideas that see the light of day are usually the ones promoted by whoever has more charisma. Someone like Saul Bass, for instance, had the larger-than-life personality as well as the talent required, so he made it look easy to be an artist in the business world. His poster and titles for *The Man with the Golden Arm* are iconic. But what about art directors who are not driven in the same way? An ad agency is a great environment—yes—if you happen to be blessed with a type "A" personality.

Editorial art directors don't have to "sell" their work in quite the same way. There are a lot less theatrics in publication design. Even though it takes some finesse to get a magazine or a book editor to go along with a layout, a typographical treatment, a photograph, or a choice of illustration, the rules of the game are more civilized. Commerce is not the only concern. In editorial work abstract concepts for instance do matter. Cultural references are celebrated. Journalistic accuracy has its place. So the role of the "most common-or-garden variety art director" can be exciting, in spite of his or her more modest pay check and lower status on the corporate ladder.

Advertising art directors have to be smart. Editorial art directors have to be intelligent. Two very different qualities—and *vive la différence!*

HELLER: *Vive* and let *vive*. Which means to me: let the art director do his or her job as a creative practitioner. Common variety or unique genius, smart or intelligent, art directors are trained to make a product appeal to an audience. This is not an easy task, and it takes considerable skill and extreme talent. I'm waxing poetic again—and even gushing. But the best art directors in any discipline are those who grasp the whole picture (at least of their specific discipline). This is what I love about the contributions in Section Three of this book—conceived, produced, and "art directed" by 13 really intelligent or smart art directors engaged in everything from branding to fashion.

But what I want (and our readers need) to know is how an art director becomes an art director, as opposed to a designer. What are these special traits? What is the path that one must take to shift from being the exclusive creator to being the orchestrator of all creatives?

Let's talk about what it takes to join the ranks of M.F. Agha, Alexey Brodovitch, George Lois, Bea Feitler, Ruth Ansel, and scores of other great ADs. What makes an art director an art director?

VIENNE: This is my analysis: the best art directors are culturally literate. They are not necessarily well educated or well read, but they are up to speed as far as what's happening in their field is concerned. They are able to process a lot of cultural information and synthesize it for their audience in ways that are graphically memorable. The best art directors create magazine covers, posters, and ad campaigns that not only encapsulate the zeitgeist, but also take it to the next level.

To do that art directors need to be able to handle the current visual language *and* be fluent enough to have fun with it. Unlike graphic artists, who can be loners obsessively working on esoteric typographical projects, for instance, or illustrators, whose quirky viewpoint on life is usually very personal, art directors must have a sense of what's "out there"—of what people are interested in, of what issues are relevant, and of what makes front-page news.

So, to join the ranks of the likes of George Lois, Marvin Israel, or Gail Anderson you have to sneak out of the office from time to time. Catch a matinée showing of the latest animation film. Have lunch with friends who work in other fields such as biofuels, taxidermy, or restaurant management. Pursue hobbies that do not relate to your job (beekeeping, anyone?). Hang around antiquarian bookstores. Go surfing. As Vince Frost, one of our contributors, puts it: "Don't get stuck on a computer…Take care and tread lightly."

But that's not all: the best art directors are usually people who have some notions about graphic design history. And I am not saying that because, of course, I think everyone should read your books, Steve, but because the past is such an inexhaustible source of inspiration. Last Tuesday I came across a series of line drawings by Francis Picabia, for instance, and today, three days later, I still feel energized by the discovery.

A great art director is a man about town. Or a woman of the world. Am I romanticizing the profession? I don't think so. Correct me if I am wrong.

HELLER: As a poetic waxer and ostensible romantic, I don't think you can romanticize too much. Ideally, the art director is all that you are saying he or she is. Certainly, the best art directors are those who are literate in more than one cultural language. Otherwise they wouldn't be able to pull together so many different practitioners. An art director must not only speak but also translate those languages for whatever project they are working on. For instance, Peter Buchanan-Smith was a mere graphic designer when he entered the Master of Fine Arts Design program at the School of Visual Arts, but then gradually learned different vocabularies—he became the art director of the *New York Times* op-ed page, then a book packager (PictureBox), then art director of *Paper Magazine*. At the last he learned the language of fashion and style, which pushed him into his next linguistic incarnation—that of art director for Isaac Mizrahi. All along he designed books for Maira Kalman and had other sidelines. What is this if not a mastery

"Becoming an art director is really about a process. It's a way of expressing a potential in oneself."

of literacy? Oh yes, and in the meantime, related to your Picabia revelations, he continually hunts down historical nourishment to further fine-tune his cultural language skills.

Buchanan-Smith is but one example of how literacy bolsters the art director's tool kit. But I'm not entirely certain whether this is the rule or the exception. Since there are no schools that teach art direction *per se*, how do the erstwhile art directors out there know how or what to study? Or whether to study? Or even if they should become art directors?

Wouldn't you agree that becoming an art director usually is not a goal but a byproduct? How does someone become an art director? It is the chicken and the egg scenario: are you a designer first or a culturally literate creative? Are you on a trajectory to direct or do you begin as a "person of the world?"

VIENNE: I made a living as an exhibit designer for 15 years before switching to editorial art direction. Designing exhibits was not unlike doing magazine layouts: the form had to communicate the content. But one of the reasons I was unhappy in this field was a lack of "editorial" direction. In other words, the role of exhibit designers back then (it's different now, I am sure) was to deliver information that was handed down to them by the client or the sponsor. Never, in my experience, was the cultural context ever discussed or developed as part of a team effort. My job was to find novel or spectacular ways of delivering a series of facts—but never was I involved in elaborating a coherent storyline.

Magazines seemed to offer what I missed most, which was an environment where ideas were as important as facts. But changing to art direction meant that I had to learn new skills, even though typography, layouts, and paste-ups had been part of what I did as an exhibit designer. For example, I had to learn to work with temperamental editors and high-maintenance illustrators or photographers. Eventually, after a couple of years, I had to figure out how to administer a big budget, manage an art department, and stay on top of production issues. I enjoyed all of that, but what I loved above all was being privy to the entire process, from the initial idea to the final product—from the brand positioning of the publication and its editorial philosophy down to the size of the credit line and the placement of the folios at the bottom of the pages.

Personally, what I found most challenging was to act as both a visionary art director (someone who is an arbitrator of taste and a cultural facilitator) and an operational one (someone who meets impossible deadlines). I felt squeezed constantly between my desire to encourage artists to do their best and my responsibility toward the rest of the team. In the end, after another 15 years, I walked away from the whole thing. The field had changed, computers were becoming the preferred tool, and David Carson, whom I had hired a year earlier as a lowly paste-up artist at *Self* magazine where I was art director (a disastrous episode in his experience and mine!), had become an overnight success with his magazine *Beach Culture*. I wanted to become a writer. So I quit art direction the way one quits smoking: cold turkey.

Becoming an art director is really about a process. It's a way of expressing a potential in oneself. But it might be a form of creativity that is not permanent. Can we say that it's a stage in one's development more than a profession? That's your experience as well, isn't it? Being an art director has been for you the realization of a dream as well as a step toward becoming a writer, a critic, and now an educator as well.

HELLER: Becoming an art director was the biggest fluke in my life. I wanted to be a cartoonist. I didn't even know

what a paste-up or mechanical was. I'd never heard the word "typography" before. I was a total neophyte. So not only was it a stage, I wasn't sure what stage it was.

I learned everything on the job at a small "underground" newspaper in New York. At the time I wouldn't have called myself a designer, since I didn't know what a designer actually did. I made layouts and "directed" the composition of the paper, and was listed on the masthead as "art director," yet had no idea what other art directors did. Eventually I realized that what I was doing corresponded to what others were doing in bigger, more mainstream publications. When I saw this I finally became an art director (at least in word, if not deed).

So in this sense it was a "process" of discovery. It's also hard to describe how joyous it was to realize that I had, in fact, discovered a profession I had never considered. I quickly gave up my desire to

VIENNE: Do you realize that our conception of art direction—yours and mine—is very "Anglo-Saxon," as they say here in France. We are both pragmatic, using the term to define the role of someone who is acting as a go-between, someone who is negotiating how words and images relate to each other. As I am investigating the subject matter among people who work in the field in Europe, I am surprised to discover that it is not so on the "Continent" (for people in the UK, the EU is that continental landmass across the Channel).

Indeed, this side of the Atlantic everything is about nuances! The words you use to describe stuff make a huge difference. As a result, the design professions are compartimentalized. A graphic designer, for instance, would not describe what he or she does as "art direction," no matter what. A "graphic designer" here is a

"Should all art directors have such integral roles in the overall process?"

be a cartoonist and hired others (who were better than me) to do that work—to be parts of the overall whole. I ultimately made it into a career, going from undergrounds to overgrounds (the *New York Times*, where I spent 33 years as an editorial art director).

Returning to the "person of the world" concept, eventually it was not enough simply to art direct by moving things around on paper; I had to become more integrated into the entire content of the publication. It wasn't enough to facilitate getting the text and image onto the page; I had to help in finding that content, which I then could shape. I was still subordinate to the chief editor, but I was not merely the layout guy.

In this sense art direction is a step up the creative ladder. But do you think this kind of evolution is a requisite? Should all art directors have such integral roles in the overall process? And, in fact, can they?

hands-on person who creates everything that ends up on the page. If you ask someone else to contribute to your design, your work is the result of a "design collective"—which means that the illustrators, photographers, or typographers involved are equal partners in the creative process, and their opinion has as much weight as yours. If you call yourself an "art director" you are broadcasting the fact that you are the boss, and that artists working with you (or rather for you) are nothing but hired hands. Usually, professionals who adopt the "art director" terminology on their resumé are seeking jobs in advertising where it is understood that the client has the last word anyway, and the art director is his or her trusted representative.

I had to search far and wide to find individuals working in design studios in Europe who were willing to contribute to our book—the expression "art direction" was, for the most part, foreign to them. As for art directors working either in magazines or advertising

agencies they did not respond either, because they did not consider that they could speak as independent "authors"—their primary allegiance being to the company that paid their salary.

This is, in my opinion, one of the reasons that this book is important. We need to break down categories, in order to ensure that the creative process remains fluid.

HELLER: I did not realize how different we are from those of you on the "Continent." Or maybe it's just another "French thing," like your language, to make life a little more mysteriously exclusive. Nonetheless, art direction is this nether-term. In some companies the art director is more involved with production, while in others he or she is a creative facilitator. I suspect that's why Milton Glaser coined the term "design director" to distinguish his über role at the old *New York* magazine from the art director who made the day-to-day creative decisions.

I like to think of the art director as the musical director (remember

defining the job on so many different media and platforms, art direction is flourishing.

Yet, flourishing though it may be, before jumping into this book let's talk a bit about how an art director is born. What do you think?

VIENNE: You learn art direction two ways: first by watching, then by making mistakes. My first mentor was Peter Knapp, a Swiss designer who was art director of *ELLE* magazine in Paris in the early 1960s. He was brilliant (see "The Power of the Diagonal", pp.80–83). I was a lowly intern yet he allowed me to push photographs and type on a page until I got something I liked. I still have that first layout. It's a period piece, but as such it's pretty good. Maybe it's my best work ever. I hadn't learned to make mistakes yet.

My second mentor was a young man whose name I unfortunately forget. He was Rochelle Udell's assistant at *Vogue* magazine in New York in the late 1970s. I was still a lowly intern. I had made the mistake of not pursuing art direction but studying architecture

"You learn art direction two ways: first by watching, then by making mistakes."

when he or she was called simply "conductor"?) of a large, medium, or small orchestra. This can be construed as "author" but it's more than that. On this scale art directors take on huge responsibilities. Their job is not compartmentalized, but they make harmonies out of many compartments (and departments). In America art directors strive for this kind of authority—some achieve it, others remain unsuccessful at reaching levels of parity with the "boss," whoever that may be.

Still, I had no problem finding people willing to call themselves "art directors" (even if their official titles are somewhat different) and share their respective processes for this book. What's more, I was greatly encouraged that, with so many different ways of

instead. I had become a mediocre exhibit designer. Fifteen years doing something I didn't love! At age thirty-five, I had decided to start at the bottom again and find a job—any job—on a magazine. I was lucky to land a position pasting up this young man's layouts. I was awed by the quiet elegance of his every gesture as he figured out how to fit everything on the page.

My third mentor was Charles Denson, a layout maverick who was art director of *San Francisco* magazine in the mid-1980s. I was his assistant and I made the big mistake of falling in love with him. It was a mess. Maybe we need to have a chapter in this book about the love life (or lack of it) of art directors. It would be very instructive about the dangers of this line of work.

My fourth and last mentor was Alex Liberman, who was the all-powerful editorial director of Condé Nast. In the late 1980s I was the art director of *Self* magazine, and by this time I had won many awards. But Liberman didn't care: he would walk into my office whenever he felt like it and simply redo all my layouts while I watched in a state of shock. I made the mistake of letting him do that. Yet, in hindsight, our "collaboration" produced some amazing pages. Truth be told, we did some good work together.

Did you have mentors as well? Can you name the three or four people who guided you along the way?

HELLER: I started as a cartoonist at age seventeen but got a job doing paste-ups for an underground paper. My first mentor was the illustrator Brad Holland. He taught me to appreciate type and typography (in the manner of Herb Lubalin, who became my first design "hero"). Lubalin's work showed me that type could be as expressive as pictures and that layout could be authored with personality.

My second mentor was my first boss at the *New York Times*, Louis Silverstein, who was responsible for altering the way newspapers (and particularly "The Gray Lady" *Times*) were designed. At the same time I worked with Ruth Ansel, art director of the *New York Times Magazine*. I can't say she mentored me, *per se*, but I absorbed aspects of her practice. She was a perfectionist, which I am not, but in watching her suffer over layouts, type treatments, and illustration content I learned what best suited my own practice.

At the risk of sounding arrogant, my last mentor was me! Most of what I learned subsequently about art direction I learned on my own. I was fortunate enough to be art director of the same publication, the *New York Times Book Review*, for almost 30 of my 33 years at the *Times*. So I had ample time to make many mistakes and learn from them. I never learned how to work with photographers, which is something I regret. But I learned to work very efficiently with illustrators, which we will address on pages 16–17.

My lasting lesson as an art director is to let those you direct—in other words, those you trust—make mistakes too. I always worked closely with my illustrators, but I rarely imposed ideas. I would finesse and fine-tune, but intervention was taboo. If after a few attempts an illustrator was not up to the task, then I'd cut bait. But, as it turned out, this happened very rarely.

What was your most lasting lesson?

VIENNE: From being an art director I have learned to tell stories and, specifically, to tell stories to readers—to people who enter into the narrative with their eyes first.

Now, as a writer, I am aware that what I am trying to say will end up on a page (or on a screen). I have the greatest respect for those people who will spend time deciphering the sentences that I put together. I am most concerned about delivering information to them in a way that is primarily visual, even though I am only using words.

You could say my training as an art director has taught me the same thing they teach in writing classes, which is "show, don't tell." Writing, for me, means laying out words and images in the minds of readers so that, in the end, they get the full picture.

I try to avoid explanations as much as possible, the way I used to try to avoid literal illustrations or photographs that would require drawn-out captions. I deliberately mix long and short sentences in the same paragraph the way I used to mix bold and light typographical elements on the page. As an art director I was concerned about providing visuals with a rich content. Now I support my arguments with solid details: I give precise examples, describe actual things, and choose adjectives that suggest a color, a texture, or a pattern. I also used to leave plenty of white space on my layouts—now, in my writing, I intentionally leave things unsaid.

My most lasting lesson? It's all about art directing your own creative impulses.

HELLER: I think that's a good place to end this introduction. Let's see what makes an art director and, most important, what makes an art director tick.

FOREWORD:
ART DIRECTION BECKONS
STEVEN HELLER

Art direction was not exactly my calling. It was more of a beckoning. I wanted passionately to be a humorous illustrator but the joke was on me. While I was a successful class clown, my drawing skills never equaled my innate wit (or lack thereof). So if I wanted to have any semblance of a career in commercial art, which I did, I needed to transcend my failing and find an alternative path to fulfillment.

Enter the art direction muse.

Well actually, before the muse formally made her appearance I got a job. When I was seventeen I was given a "mechanical" or paste-up job on a 1960s underground newspaper. I emphasize the date and type of publication because in those days no experience was necessary. What the Punks later called "DIY" (do it yourself) was the requisite way to work for the hippy/new-left underground. Training was brief, expertise was minimal, even aptitude was inessential as long as one had the will to work all hours. Since money was scarce—and salaries virtually nonexistent—these ersatz newspapers relied (as Blanche DuBois would say) on the kindness of strangers—or more accurately on wannabe artists like me to work for no lucre. Nonetheless, I took the job with the assurance that by way of compensation the newspaper would publish my puerile drawings, which they did until the editors and I realized I was a better "layout guy" than cartoonist.

As it happened, the nominal "art director"—a portly gent with half-a-dozen years of solid design and illustration experience behind him—was poised to leave the paper for a paying job the moment I arrived. He stayed just long enough—a day to be exact—to teach me everything I needed to know about paste-up and, well, art direction; he also left me, a total novice, as his replacement.

Impressive, no? What had started as an ad hoc job in the summer between my final year of high school and the first year of college surprisingly turned into a pivotal career move.

Although I was clueless (Typography? Doesn't that have something to do with geography?), I was consumed with enthusiasm, a willingness to learn, and happy to produce something, one day, that I would see printed and distributed to the world. I spent the subsequent weeks after I had been begrudgingly named "art director" tirelessly learning the trade. I visited the web-offset printer in Brooklyn in the hope that I would absorb all skills, crafts, or insights. The first time I watched as the printed paper rolled off the press was cathartic. I was truly impressed that even the ink-and-sweat-stained pressmen were interested enough in the paper that they immediately grabbed copies off the roller and read them (I learned only later they were just checking for ink coverage, and not very well it seemed since many copies were fairly light).

Once I mastered (naively it turns out) the techniques of printing I turned to conquering art direction. In fact, existentially speaking, I wanted to know what it meant to be an "art director." I intuited it meant controlling the visual content of my newspaper. I believed I was supposed to wield an iron fist when it came to who and what was commissioned and how it was used. I thought I was now a supreme being—not an equal among equals, but the noblest of all creative entities: the one who doled out assignments like the longshoreman union boss in the classic film *On the Waterfront*. It meant illustrators and photographers had to show me their portfolios. It meant I would be the one to pass judgment. It didn't matter how little I knew—my name on the masthead as art director ensured respect, or at least fealty, or at the very least deference.

I won't relive all the sordid details of my speedy transformation from grunt to apprentice to journeyman to full-fledged art director; suffice to say, while I learned much I still knew very little. Everything was done by the seat of my pants and what my work lacked in nuance it overflowed with, hmmm, the opposite of nuance. In fact, the issues of that underground newspaper I pasted up and art directed were pretty awful—only recently (almost 40 years later) do the wretched mistakes take on a patina of vintage documentary evidence from a special time and place. No longer can these issues be judged as good or bad, only as history. Thank heavens for the gauze of history.

I will admit, however, there are three lessons I learned about being an art director that took a long time—and if I'd had formal training I may or may not have learned them sooner. They are: 1, Humility: I really thought I was God's gift to the world. I was arrogant and impatient with those who were decidedly more talented than me. It took years to realize that as an art director I needed my creative collaborators as much, if not more, than they needed me. 2, Perfection: I thought I had to be, but didn't need to be, perfect. I only had to be able to discern the difference between good and bad, and then do something to engender the former and to rectify the latter. By hiring smart, talented people art directors can delegate, and by delegating they make their world (in my case publications) better places. 3, Typography: I learned to realize that an art director can have a smattering of many skills, but without a grounding in typography—I mean really good typographic eyes and hands—they are hacks. While I am not a good typographer, I know what's good when I see it. That is key.

I wish I'd understood these things coming out of the gate. My one-day apprenticeship was nowhere near enough to understand the essentials of art direction (or anything else about my new job). Whenever I asked an editor, printer, typesetter, or passerby on the street for the definition of an art director I got blank stares. I know it sounds odd that the editor of the publication didn't know what art directors did, but it was indicative of how nebulous the role was. I wish there was a book that could have taught me, but there wasn't. Of course, over the past two decades art direction has become more definable, and I'm happy to say that, in some small part, *Art Direction Explained, At Last!* will make it easier for the next generation whose calling or beckoning is art direction.

 + + +

PREFACE:
TO BE AN ART DIRECTOR, YOU MUST HAVE…
(IN NO PARTICULAR ORDER)

- ☐ a sense of style
- ☐ an eye for talent
- ☐ great friends on Facebook
- ☐ a nose for the unusual
- ☐ a grasp of the big picture
- ☐ an interest in art
- ☐ that thing called "flair"
- ☐ a penchant for design
- ☐ an ability to work and play with others
- ☐ conceptual acuity
- ☐ historical knowledge

- ☐ the wherewithal to stay up all night
- ☐ endless curiosity
- ☐ good taste
- ☐ a reliable Chinese take-out restaurant around the corner
- ☐ an ego large enough to command, and modest enough to delegate
- ☐ a collector's mentality
- ☐ a trusted accountant
- ☐ an ear for foreign names
- ☐ a well-developed visual memory
- ☐ miles of white walls

- ☐ a healthy distrust of automatic spell checks
- ☐ empathy with struggling artists
- ☐ tolerance for pretentious snobs
- ☐ intolerance for visual illiteracy
- ☐ friends in the business in London, Berlin, and Barcelona
- ☐ an understanding wife (or husband)
- ☐ a pair of good scissors
- ☐ sleeves you can roll
- ☐ the conviction that stress is good for you
- ☐ a belief in no pain, no gain

 + + +

- [] enough self-confidence to buck the trends
- [] a knack for spotting the next thing
- [] grace under fire
- [] a palate for cheap wine
- [] a couch in your office
- [] an earring
- [] multicolored socks
- [] red shoes
- [] a MacBook Air
- [] an iPhone
- [] a couple of huge bookcases
- [] membership in the Art Directors Club and AIGA
- [] a good reason to laugh at yourself
- [] a very nice apartment

- [] the ability to think fast
- [] the capacity to compromise, but not be compliant
- [] the skill to talk expertly without jargon
- [] a goatee (if a guy)
- [] big blue eyes (if a gal)
- [] a swell disposition
- [] the courage to stand up for yourself
- [] an assistant with a driver's license
- [] a quick response to challenges
- [] a black turtleneck
- [] an old fax machine
- [] a good sound system
- [] an analytical mind
- [] a gift for making others feel excited

- [] a sunny spot in your studio
- [] a former assistant who is more successful than you are
- [] lots of dictionaries
- [] a very expensive desk chair
- [] the reputation of being someone who knows how to listen
- [] a hobby requiring manual dexterity
- [] a class to teach one night a week
- [] clients who do not wear ties
- [] Ricola candies in a desk drawer
- [] your own life's philosophy
- [] a friend who knows how to write a business plan
- [] a Skype account
- [] cool reading glasses

SECTION ONE:
WHAT IS AN ART DIRECTOR?

1. ART DIRECTION: WHAT MAKES A GREAT ART DIRECTOR?

This may not be the question for the ages, but it is at the forefront of the mind of anyone aspiring to art directorial greatness (or, for that matter, just plain old goodness). So here's one answer: a "Great Art Director" is infused with talent, skill, and luck.

Yes, luck plays a greater role than one would prefer to admit. It is often the determining factor when it comes to whether those the art director works with—the editor or account executive, the client or patron—are enlightened enough to appreciate the value of a "great art director" (GAD). Luck (or, if you prefer, call it fate) influences whether the GAD and the enlightened client are brought together in the first place. An art director is, after all, in the precarious position of answering to various authorities, while being an authority as well. Although most people understand what a CEO does (and genuflect accordingly), by virtue of the art director's variegated responsibilities in both creative and managerial roles the lines blur. Therefore, determining what makes a "great art director" and how to become one is not as easily describable—or formulaic—as it would be for other professions.

A tried-and-true path is impossible because fate is famous for throwing up roadblocks (not the least being unappreciative editors, account executives, clients, and patrons). Yet all things being equal, a "great art director" must be "blessed" with certain indispensable character traits that underscore specific design aptitudes. They are (in no particular order):

- **CONFIDENCE:** The GAD must exude a positive hubris that signals control of all the elements of a project.

- **TASTE:** The GAD must have this most subjective of all qualities and be so confident in his or her judgment that no one disputes it.

- **WISDOM:** The GAD must be able to make the right decisions at the right time.

- **COMPASSION:** The GAD must not be unsympathetic to those who are visually challenged.

- **AN OPEN MIND:** The GAD must accept that others have much to contribute to the process.

- **VISION:** The GAD must weigh up all contributions from others, but ultimately be the "decider."

In truth, not every designer can (or will) be an art director—great or otherwise. Many great designers are simply ill-suited to manage others; they prefer to do the design things themselves rather than oversee other people's work. Take, for instance, Paul Rand, who in his twenties, during the early 1940s, worked as an art director for Weintraub Advertising in New York, and was called the "wunderkind." He bridged the role of designer and art director. He was the consummate conceiver (he was the master of every campaign that passed through the agency). He delegated the production while keeping most of the creative for himself. This certainly made him tops in his profession at that time. It was he who pioneered the idea that the art director was a creative principal. Prior to Rand copywriters ruled the advertising agency roost, and it is in large part thanks to his example that "creative teams" of copywriter and art director became established. But did all this make him a "great art director?"

Let's review the qualifications. A GAD is someone who exhibits a commanding presence. The gruff-sounding Rand definitely commanded the respect of his superiors, clients, colleagues, and employees. A GAD is someone who has myriad talents that are applied to the tasks at hand. Rand was a brilliant typographer, visualizer, thinker, and writer—attributes present in each of the advertisements he created, which broke the mold and raised the bar throughout the industry. A GAD is persuasively articulate. Although Rand preferred to let his work speak for itself, he was prepared to argue a concept if necessary (according to him, most jobs were accepted). A GAD is able to let other designers and art directors carry the creative weight when necessary. Rand, however, held his projects tight to his chest, relinquishing them only when they were not interesting or were headed towards mishap. A GAD is a leader. Rand clearly led the way as a seminal American Modernist. He assimilated and synthesized the principles and ethos of European design, which influenced other designers and art directors. Although four out of five GAD criteria is not a bad statistic, the truly "great art director" (as opposed to a truly "great designer") accomplishes all five.

To be a "great art director" it is just as important to delegate responsibility to those who have equal talent as it is to lead, as Rand did, with a solid philosophical underpinning. One of the most critical roles is to nurture and nourish talented others—art direction is a process of growth built largely on the apprenticeship model. Some art directors will be thrust into responsible roles by happenstance (being in the right place at the right time when, say, someone goes on maternity leave or moves to another job), but

"Great Art Directors are those who grow within their niches."

most enter the field following conventional pathways. It is useful at this juncture to review these milestones.

Remember, specific fields offer slightly different means of entry so there is no single path, yet in most instances there are similar trajectories:

- Art directors routinely begin their careers as designers (or illustrators or photographers).

- The usual first step toward art directorship is to be an "assistant" or "associate" art director; if someone is hired initially as a designer, the next stage may be one of these positions (or higher).

- From these entry-level jobs the neophyte art director acquires a smattering of many competencies. Yet certain art directors are better at photography or illustration, while others are more adept with motion or three-dimensional space. However, overall, a really good art director, at any level, must be fluent in all media and platforms.

- Art directors are a peripatetic and restless species and do not commonly stay in the same job for too long, resulting in frequent advancement potential.

- Nonetheless, some art directors find a niche and stick with it, creating ways to significantly build on, rather than stagnantly retain, methods and techniques.

- GADs are those who grow within their niches.

Let's use this example: Tom Bodkin, design director and assistant managing editor of the *New York Times*, is a true GAD (full disclosure: Steven Heller worked for him for many years). A veteran of over two decades, he has shepherded the newspaper's visual persona through many major and minor aesthetic, functional, and technological changes. He oversees more than 100 art directors, designers, associate designers, graphics editors, and production artists. While others under his umbrella do most of the design, his overarching vision ensures continuity while welcoming ingenuity.

Bodkin didn't study design, but fell into the practice while working on his college newspaper. His first job as a designer was under the legendary Herb Lubalin at *Avant Garde* magazine. Afterward he became art director for *US* magazine (which was about to be launched by the *New York Times*). Then he came to the *Times* as art director of one of its many sections. Being versatile, he moved from one section to another completely redesigning them as well as developing new sections. When he was finally appointed design director his job was to see that the newspaper was designed with distinction, but also with enough flexibility to use design advances to meet the challenges of a shifting newspaper field.

As a design director for the *New York Times* conventional art direction is not an option, and even to use the term "conventional" affixed to "art direction" is somewhat misleading. It is necessary to be an editor and journalist—an advocate of art and design in the service of quantifying information. Bodkin has never been "merely" a visual manipulator. Although somewhere, in someone's desk, a job description exists that codifies Bodkin's duties, in reality he, like most art directors, makes it up as he goes along. Perhaps the single constant in any art director's repertoire is working with art and design (and even this depends on the medium or platform in question).

Being a "great art director" is determined by how well—indeed, how exceptionally well—one addresses the variables. Some GADs are better with one medium than another. Some are more brilliant when it comes to working with photography rather than illustration (or vice versa). Some are keen stylists, while others are incredible typographers. Greatness comes in how the art director marshals the strengths and balances the weaknesses. Ultimately, the proof of greatness is the continued quality of the end product, whether magazines, advertisements, websites, books, etc.

Of course, this "great art director" principle begs the obvious question: is there, similarly, a "not-so-great art director" principle? What separates the one from the other is rooted in the traits described above. The opposite of the GAD is someone who holds the art directorial title but is no more than a pair of hands. Too often the art director does the bidding of the editor or client. A weak art director may fulfill the job description, but will nonetheless fail to bring the work up to a higher level. Art directors must do one fundamental activity: they must "direct." If they fail to do this they are not art directors. While this should not imply that art directors must exhibit arrogance or rigidity, it does mean that they have "the divine right of expertise." The art director may not always have the final say (that is the client's prerogative) but he or she should remain the ultimate arbiter of art and design. Certainly, even the ultimate arbiter can be wrong, and therefore not a GAD, but the first rule is making the decisions, the second is making the right decisions.

Circumstance—and luck—may dictate whether an art director has the potential to be great. No amount of talent will overcome a bad working situation. But every art director should start with the belief that his or her job is to lead not follow, direct not be directed, and be as great as possible and not settle for the line of least resistance.

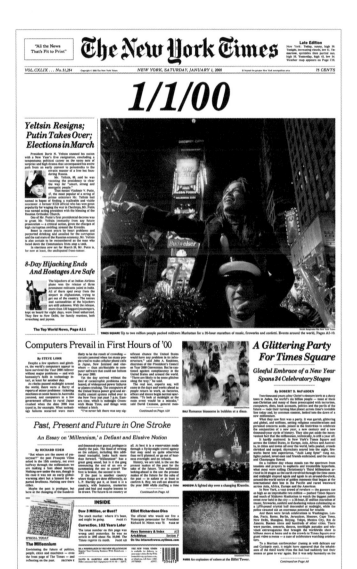

▲ *NEW YORK TIMES*, January 1, 2000
Front page
Design Director: Tom Bodkin

"

TOM BODKIN: CONFESSIONS OF A GAD

How did you become an art director?
Dumb luck and a really good connection.

How so?
My mother was a painter, my grandmother a sculptor, my aunt an interior designer. I've always been surrounded by people with a creative vision and strong aesthetic convictions.

I was the editor of my high school newspaper, but enjoyed working on layout more than writing. While pursuing a liberal arts education in college I found myself drawn to the daily college paper, specifically to its design and production. Leaving college without a degree or marketable skill, I leveraged my print production experience

running his small art department, where I refined my graphic design skills executing layouts from rough sketches by Herb Lubalin, Ginzburg's long-time design consultant.

From there you went to the legendary CBS?
With that experience behind me, Dorfsman hired me at CBS.

Sounds like connections really paid off…
My real love was editorial and Dorfsman suggested I see his friend Lou Silverstein, the pioneering art director of the *New York Times*. The *Times* was just about to launch a new consumer magazine, *US*, and I was hired as its first art director. When the *Times* sold *US*, I moved to the newspaper

I thought that was ninety percent, but no matter. Did you have a preconception of what an art director was?
Not really.

Do you have any art directorial models or mentors?
I was fortunate to work with some of the greatest art directors of our time: Lou Dorfsman, Herb Lubalin, Lou Silverstein, Roger Black.

And how did they influence what you do today?
My critical eye was developed at the feet of these masters, and through their example I learned about the creative process. They each had their own personal approach to developing imaginative solutions and managing talent. I had the luxury of choosing from an array of powerful examples which methods I felt were most effective and consistent with my own style and beliefs.

"I had the luxury of choosing from an array of powerful examples which methods I felt were most effective and consistent with my own style and beliefs."

into several minor jobs, then went to see the father of a good friend who happened to be Lou Dorfsman, the legendary art director of CBS. Dorfsman suggested I see his friend Ralph Ginzburg, the publisher of *Eros* and *Avant Garde* magazines. This led to a job

as art director of the Home section. Roger Black succeeded Silverstein and when Black left the *Times* for *Newsweek* I became the design director of the *Times*. As Woody Allen said, "Eighty percent of success is showing up."

As art director—design director—of the *New York Times* you oversee the entire visual style and philosophy of the paper. How do you manage such a large, multifaceted operation?
The art department of the *New York Times* is divided into several functional groups: feature design, news design, magazine design, information graphics, production.

Each of these groups has a strong manager. They share my values and principles and are vital to spreading those standards through the ranks.

I do a lot of talking. When critiquing a layout I explain carefully how my suggestions relate to larger design concerns. If I think a creative solution is not on target I try to understand how the artist came to that solution and where he or she veered off-track.

The lesson can then be applied more broadly. My goal is to cultivate a common vision so that independent judgments can be made that are consistent with the character of the paper.

I also spend considerable time explaining to editors how our standards of design are an extension of the standards they apply to the words—clarity, economy, intelligence. There is a shared commitment to excellence that informs both the writing and presentation of the *Times*. It's in the air.

Being an art director for an organization/ institution that has such deep-rooted traditions, how do you balance tradition with the currency?
By adhering to some basic and enduring principles and insisting that all design serves those ends: effective communication, functionality, evocative storytelling.

You oversee many designers and art directors. How tight do you hold the leash over their creativity?
I firmly believe that the success of a large, creative enterprise depends on trust. Holding the reins too tight undermines trust, inhibits creativity, and retards the development of good judgment. The *Times* is the product of thousands of decisions made every day by hundreds of people. If permissions are required to be creative, very little invention will occur. I depend on my designers to make the right calls and to know when a consultation is called for. I try hard not to impose prior restraint, but certainly let people know when a solution is inappropriate or below our standards. One of the wonderful things about a daily paper is that it is remade every day and offers unending opportunities to experiment, teach, and learn.

What traits do you look for in hiring art directors?
Intelligence and taste.

Typography is an essential part of the newspaper. How much of your energy is devoted to maintaining and refining typographic standards?
Considerable. We are in the business of conveying and organizing information, and type and image are the two basic instruments

we have to accomplish this. The refined application of type is critical to effective communication.

What is the most challenging—and by extension, the most important— element of *Times* design?
Maintaining the optimum balance of variety and consistency. The *Times* is a multitude of publications rolled into one. We publish 16 weekly sections along with five daily sections. Each section has its own thematically or geographically defined content. The challenge is to create a distinct identity for each section that is appropriate to its subject, while maintaining a common approach and character that is recognizable throughout the paper.

You are more than an art director, you are an assistant managing editor; does this title and role give you more weight as an art director?
Good publication design depends on the seamless union of design and content. The title acknowledges that an effective editorial designer thinks and functions like an editor.

If you were to change the way you art direct, how would you change?
I'd learn to draw better.

2. PHOTOGRAPHY: PICTURE MAGAZINE REVOLUTION

Photography records the gamut of feelings written on the human face, the beauty of the earth and skies that man has inherited, and the wealth and confusion man has created.
 —Edward Steichen, *Time* magazine (1961)

Photography changed how the world was recorded. Likewise, the "picture magazine" changed how the world was seen. The photojournalist Edward Steichen referred to this genre as a "major force in explaining man to man." But just as the invention of the photograph in the early nineteenth century made representational painting obsolete, during the past 30 years the spontaneity and immediacy of that other revolutionary medium, television, made the picture magazine an anachronism.

Yet before television, picture magazines, with their rotogravure pages awash with halftones, printed with luminescent inks on velvety paper, were veritable eyes on the world. Photography may have been static, but when edited like a motion picture and narratively paced to tell a story, the images of never before recorded sights offered audiences the same drama—and more detail—than any newsreel. Innovative editors at the leading magazines advanced revolutionary storytelling ideas that altered the way photography was used and perceived. With the advent of faster films and lightweight cameras photography was freed from the confines of the studio; photographers were encouraged to capture realities that previously had been hidden in the shadows.

As photography evolved from single documentary images into visual essays, the forms and formats of presentation changed as well. From the mid-nineteenth to the early twentieth centuries the picture magazine evolved from a repository of drawn and engraved facsimiles of daguerreotypes into albums of real photographs. With new technology in place, innovation became inevitable. Soon sequences of integrated texts and images, designed to capture and guide the eye, were common methods of presenting current events of social, cultural, and political import.

While photojournalism (though not officially referred to as such) had been practiced since 1855 when Roger Fenton made history photographing the Crimean War, the ability to reproduce photographs was really only possible after 1880 when Stephen H. Horgan's invention of the halftone was tested at the *New York Daily Graphic* and ultimately improved upon by the *New York Times*. Moreover, prior to 1880 cameras were so large and heavy that they

impeded candid or spot news coverage. That is until the Eastman Kodak Company reduced the camera to a little box in 1900, which launched a huge amateur photography fad in Europe and America (and then encouraged publication of amateur photography magazines). The resulting pictures were often frank and informal—the forerunners of Polaroid's instant pictures in the 1960s and digital snaps today.

Professionally speaking, the most important technological advance occurred in Germany after World War I. In 1924 and 1925 two compact cameras, the Ermanox and the Leica respectively, were marketed to professional shooters. These two cameras made unobtrusive photography possible, while providing an excellent negative for crisp reproduction. The Leica was the first successful small camera to use a "roll" of film (actually, standard motion-picture film), and it was also fitted with interchangeable lenses and a range finder. The Ermanox was equally efficient, although it used small glass plates, which were later superseded by film. Nevertheless the small camera became an extra appendage, freeing the shooter to make quick judgments.

One of the chief beneficiaries of this new technology was the weekly *Berliner Illustrirte Zeitung* (*BIZ*), then the most progressive of the early photographic picture magazines, whose photographers elevated candid photography into high art and viable journalism. *BIZ* captured the artistic tumult and political turmoil of the 1920s and bore witness to extraordinary global events as no other picture magazine had before. Its photographers—precursors of the now pesky paparazzi—reveled in shooting candid photos of the famous and infamous. And, in concert with a new breed of "photo" editor, they set standards for the modern picture magazine, built on what photographer Erich Salomon called *bildjournalismus* or photojournalism. In the decades that followed *BIZ* was a model for imitators and a point of departure for innovators.

Erich Salomon fathered the candid news picture for *BIZ*, and dubbed himself "photojournalist." A lawyer by profession, once bitten by the camera bug he devoted his life to photography. By force of will, tempered by an acute understanding of the social graces, he secured entrance to the halls of government, homes of the powerful, and hideaways of the well-to-do. He devised intricate ways to capture the rich and famous on film unaware, and he published them with impunity. He busted the formal traditions that the high and mighty found acceptable and brought mythic figures down to life-size scale. Today these images, collected in books, provide vivid documents of his times.

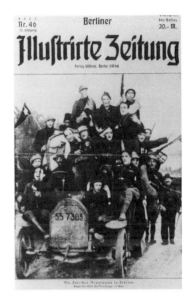
▲ *BERLINER ILLUSTRIRTE ZEITUNG*, 1922
Front cover

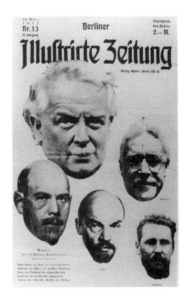
▲ *BERLINER ILLUSTRIRTE ZEITUNG*, 1922
Front cover

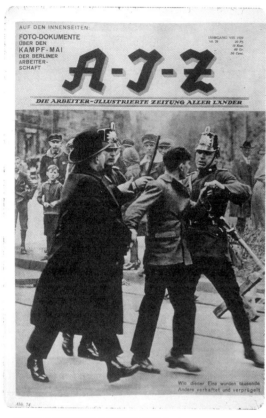

▲ **ARBEITER ILLUSTRIERTE ZEITUNG,** 1929, front cover

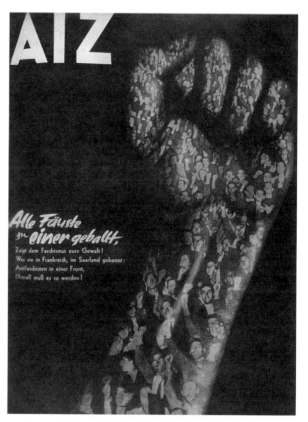

▲ **ARBEITER ILLUSTRIERTE ZEITUNG,** 1934, front cover. Illustrator: John Heartfield

When Salomon began shooting in the late 1920s Kurt Szafranski was appointed editor-in-chief of *BIZ* and its sister publication, the monthly *Die Dame*. Both magazines were part of Ullstein, Germany's largest publisher of periodicals. Salomon was already working in Ullstein's promotion department when photography became his obsession. He showed Szafranski his now famous candid pictures of exhausted delegates to the League of Nations and was immediately awarded a contract to work for *BIZ*. Szafranski also employed other pioneers of photojournalism: Martin Munkácsi, the action photographer, and André Kertész, then a travel photographer.

Szafranski and his colleague Kurt Korff (both eventually moved to *Life* magazine in New York) were early experimenters with the modern essay approach—a form that required a variety of pictures and concise captions linked together to build impact and drama. They applied what they called the principle of the "third effect," which means that when two pictures are brought together and

positioned side by side, each picture's individual effect is enhanced by the reader's interpretative powers. This juxtaposition was sometimes possible with disparate images, but usually required thematic pictures reproduced in radically different scales. Sometimes this would be accomplished with serious conceptual photographs; at other times novelty pictures, such as a stark close-up of a horse's head next to, say, a close crop of a similarly featured human's head, made a comic statement. Yet for all their innovation, the *BIZ*'s photographic essays were usually strained juxtapositions of pictures—not stories in the truest sense. The key to success—the integration of image, idea, and words—was frequently lost amid poor and ineffectual layouts. Nevertheless, *BIZ* was the linchpin in picture magazine history.

Münchner Illustrierte Presse (*MIP*), a popular Bavarian picture magazine, however, took the photograph and ran with it. Its editor and art director was a young Hungarian émigré named Stefan

Lorant, who before leaving his native Budapest in his early twenties was already an accomplished photographer and film director. He decided to settle in Munich rather than America or England because he was fluent in German. Fortuitously he fell into a job as assistant to the editor of *MIP* and, owing to his remarkable energy and ambition, was very soon afterward named its photo editor. Lorant was inspired by the *Berliner Illustrirte Zeitung*, yet also understood that it had failed to use photographs as effective narrative components.

Over the course of a few years he guided *MIP* into realms of unique photographic endeavor. Partly through intuition, partly through basic inquisitiveness, he discerned exactly what was wanted of a picture journal and directed photographers to follow his vision. Lorant convinced Erich Salomon to contribute to *MIP* and also sought out new talents who, as he said "not only took beautiful pictures but who had similar curiosity and journalistic savvy." An elite corps was assembled, including Felix H. Man, Georg and Tim Gidal, Umbo, Kurt Hübschmann, and Alfred Eisenstaedt (who was later hired by Henry Luce to shoot for *Life* magazine).

Lorant said he encouraged photographers "to travel and shoot as many pictures as possible," so that he could mold them into essays. Editorial space was no object; a good feature story would run for as many pages as it warranted. Lorant, who was an admitted autocrat, designed the layouts himself. Although the basic layout conventions already existed, he introduced certain design tropes, including what might be criticized today as excessive use of geometric borders, overlapping photographs, and silhouettes. Although he had a tendency to fiddle, he acknowledged that his most successful layouts were those where he left pictures alone. He believed that when astutely edited and dramatically cropped, one striking picture reinforced the next and so furthered the narrative. He was partial to photographs that emphasized pure human expression. One of his most famous assignments was sending Felix H. Man to spend a day with Mussolini in Rome. The photos—an exclusive—were extraordinary exposés of *Il Duce* carrying out his mundane acts of power. Lorant's layout focused on two key, though contrasting, features: Mussolini's rarely seen relaxed body in the context of his charged imperial surroundings.

Although the *Münchner Illustrierte Presse* was not partisan, in a Weimar Germany fraught with dissonant ideologies and political violence it was difficult to remain totally objective. *MIP*'s picture exposés often attacked the National Socialist Party by focusing on the darker side of Nazi rallies and leaders. It wasn't surprising, therefore, that when Adolf Hitler assumed power in 1933 Lorant was summarily imprisoned. Had it not been for the persistence of his wife, a well-known German actress at the time, in pursuit of obtaining his release (and the fact that he was still a Hungarian citizen) Lorant's future would have been bleak. After being released, he emigrated to England, wrote a best-selling book entitled *I Was Hitler's Prisoner*, and also launched two new picture magazines: *Weekly Illustrated* in 1934 and *Picture Post* in 1938. Between these two publishing milestones, Lorant also founded *Lilliput*, a humor magazine to rival the venerable *Punch*. After the war he emigrated to America where he edited documentary picture books.

During the late 1920s and the 1930s the impact of German *bildjournalismus* had spread to many of the world's capitals, but none more so than Paris. *Paris Match* was arguably the most popular picture magazine, but the news weekly *VU*, founded in 1928 and edited by Lucien Vogel, a photographer and publisher of the *Gazette du Bon Ton* and *Jardin des Modes*, was the most innovative in terms of picture essays. Vogel had always been more interested in politics than fashion and was fascinated by photography's power to document (indeed, comment upon) current events. Early issues of *VU* contained an erratic mix of politics, sports, culture, and spot news, and carried excerpts from the "Babar the Elephant" stories by Vogel's brother-in-law, Jean de Brunhoff. But in later years photographers such as André Kertész, Robert Capa, and Brassaï provided memorable reportage. Capa's most famous photograph, of a Spanish Loyalist soldier in mid-fall after being hit by a Fascist's bullet, was originally published in *VU*.

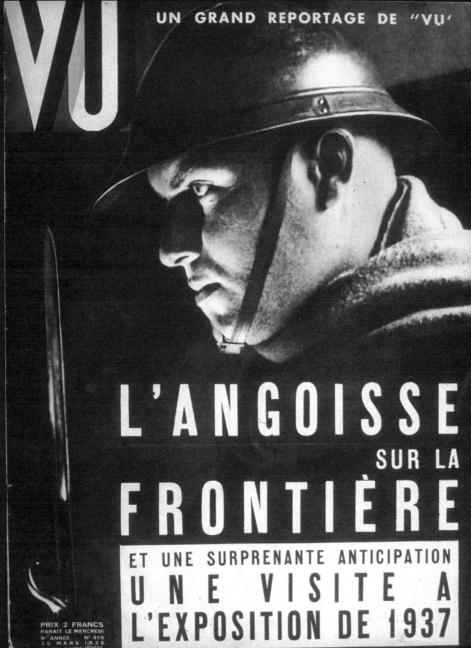

UN GRAND REPORTAGE DE "VU"

VU

L'ANGOISSE
SUR LA
FRONTIÈRE

ET UNE SURPRENANTE ANTICIPATION
UNE VISITE A
L'EXPOSITION DE 1937

PRIX 2 FRANCS
PARAIT LE MERCREDI
9e ANNÉE. N° 419
25 MARS 1936
Directeur - Lucien VOGEL

▲ *VU*, March 1936, front cover

▲ *VU*, February 1930, front cover

▲ *VU*, September 1930, front cover

▲ *VU*, February 1931, front cover

Vogel believed graphic design was crucial to the success of his magazine. *VU*'s logo was designed by the French poster artist A.M. Cassandre, while Charles Peignot, proprietor of the Deberny & Peignot foundry, consulted on the interior typography. A Russian émigré, Irene Lidova, was the first art director, and from 1933 her layout assistant was another Russian, Alexander Liberman. He assumed her position a few years later (and subsequently became the art director of *Vogue* and creative director of all Condé Nast publications until his retirement in 1995).

Vogel knew how to make pictures tell a story. One of his pioneering efforts was the double-page spread, for which a strong photograph was greatly enlarged to mammoth proportions. Pacing photos from large to small to huge to small again provided impact and surprise. Vogel had a profound influence on Liberman, who later finely tuned the journalistic photo essays in *VU*. He ascribed his ability to freely manipulate pictures to the fact that "There was no cult of photography at that time." He could edit photographs and design layouts without the kind of interference from egotistical photographers that is often tolerated today. He further spent long periods ensconced in the darkroom projecting photos onto layout sheets, cropping and juxtaposing images. He also played with photomontage. Eventually he took responsibility for *VU*'s covers. Vogel would often make rough sketches that Liberman would execute using a photomontage technique—he would sign them "Alexandre."

By 1936 Vogel's left-wing leanings had a profound effect on *VU*'s overall content (essays excoriating the Fascists were more frequent) and the magazine's bias was alienating advertisers as France was turning more vociferously towards the right. Owing to diminishing capital Vogel was forced to sell the magazine to a right-wing businessman who kept Liberman on as managing editor for a year. Ultimately Liberman could not tolerate *VU*'s new political orientation any longer. After his departure the quality of the magazine's photographic essays declined.

Photography as both an information and propaganda medium did not go unnoticed by manipulators of thought and mind. Throughout Europe, and especially in Germany, the picture magazine was used to win the hearts and minds of certain constituencies. Among the most influential of these was the socialist/communist-inspired *Arbeiter-Illustrierte Zeitung* (*AIZ*, or "Workers' Illustrated News"), which began in 1921 as an offshoot of *Sowjet-Rußland im Bild* ("Soviet Russia in Pictures"), a magazine that propagated a positive image of the Bolshevist workers' paradise. *AIZ* was edited by Willi Münzenberg, who was a fervent supporter of the Russian revolution and saw the picture magazine as a vehicle for aiding German workers in their struggle against capitalism.

When *AIZ* began, getting photographs that addressed workers' concerns from leading picture agencies was difficult. Münzenberg developed a strategy to encourage societies of amateur photographers who would, in turn, become photo correspondents. In 1926 he established the first Worker Photographer group in Hamburg, which grew into a network of viable shooters throughout Germany and the Soviet Union. He further founded a magazine called *Der Arbeiter-Fotograf* ("The Worker Photographer"), which offered technical and ideological assistance.

Bertolt Brecht once wrote to Münzenberg that "the camera can lie just like the typesetting machine. The task of *AIZ* to serve truth and reproduce real facts is of immense importance, and, it seems to me, has been achieved splendidly." In fact, while the photographs in *AIZ* were objective accounts of workers' triumphs, the layouts often served to heroicize (and therefore politicize) the activities covered. Except for its ideological orientation, *AIZ* was really no different to the Nazi counterpart, the *Illustrierte Beobachter* ("Illustrated Observer"), founded in 1926, which employed similar photojournalistic conventions. But when the Nazis assumed power in 1933 *AIZ* was deemed illegal.

Münzenberg moved the operation to Prague after the last issue of *AIZ* was published in Berlin on 5 March 1933. Until its final issue in 1938 it was a satiric thorn in the side of the Nazi regime. In 1930 John Heartfield, who was then art director and co-publisher for the Malik-Verlag, had begun doing satiric photomontages (a marriage of Dada and caricature) that graphically ripped the façade from the

▲ *USSR IN CONSTRUCTION*, 1930, front cover

Nazi leaders and functionaries. Montage was key to *AIZ* in the years after Nazi ascendancy because the Worker Photographer Movement in Germany was officially crushed and obtaining usable (socialist) imagery from mainstream agencies was impossible. Only through photomontage—the ironic juxtaposition of realities in the service of polemics—could the magazine continue to convey strong messages.

Heartfield published masterful pieces during these years. But *AIZ* went from a circulation of 500,000 copies in Germany to around 12,000 in Prague. Attempts to circulate a smuggled miniature version into Germany were problematic and unsuccessful. In 1936 *AIZ* was renamed *Volks Illustrierte* ("People's Illustrated") and two years later, when the German occupation of Czechoslovakia was imminent, the magazine was moved to France, publishing only one issue. Most of the picture stories are now forgotten, but Heartfield's photomontages are celebrated as prime documents of agitation and protest.

AIZ influenced *USSR in Construction*, which published monthly between 1930 and 1940. Founded by Maxim Gorky, its declared editorial mission was to "reflect in photography the whole scope and variety of the construction work now going on in the USSR." Toward this aim *USSR in Construction* was published in five different language editions: German, English, French, Spanish, and Russian. As rotogravure magazines go, with its multiple die-cut inserts and gatefolds it was exceedingly lush and inventive compared to others of its genre. The magazine employed leading Soviet documentary photographers, including Max Alpert and Georgy Petrusov, and the most prominent graphic designers, notably Lazar (El) Lissitzky and Alexander Rodchenko (with Varvara Stepanova). The Constructivist typographer Solomon Telingater was also brought in on occasion to design the type.

Early issues contained unremarkable pictorial sequences with expanded captions. But in 1931, when John Heartfield arrived in Moscow for an extended visit, he was invited to design an issue on the Soviet petroleum industry. His photographic cover showing oil derricks cropped on a dynamic incline was a stunning departure from the previous, somewhat bland, typographic treatments. The magazine's nameplate (or title) was composed in a dynamic manner, using sans serif letters thrusting, like a gusher of the oil itself, toward the sky. Heartfield showed that a graphic designer was capable of transforming the most common photographs into dramatic tableaux. Nevertheless, another two years passed before the editors allowed El Lissitzky the freedom to make radical changes in layout and typography.

Both Heartfield and Lissitzky contributed something that had been missing in the magazine: a sense of narrative. Lissitzky, who had been practicing book design, seamlessly integrated pictures and text, and allowed generous space for mammoth blow-ups of documentary photos and heroic photomontages across spreads and

▲ *USSR IN CONSTRUCTION*, 1935, front cover

▲ *USSR IN CONSTRUCTION*, 1940, front cover. Design: Alexander Rodchenko

gatefolds. Juxtaposing unaltered and manipulated images told the story of Stalin's "glorious" regime and the progress that technology and industry had brought to the post-revolutionary state. Gradually, *USSR in Construction* evolved a style of visual rhetoric that shared the characteristics of Socialist Realism. Maxim Gorky introduced the concept of "romantic realism," which addressed the idyllic future of the Soviet Union. But even as Socialist Realism, *USSR in Construction* pushed the boundaries of the genre and became a paradigm of pictorial propaganda that was later used in magazines published in Fascist Italy and Nazi Germany. Indeed many of the tropes—overlapping pictures, multiple duotones on

a spread, mortised inserts, etc.—have ultimately been used in commercial catalogs and corporate annual reports. The magazine folded during the war years, and returned afterward in a smaller size and with more mundane layouts.

Photography is a uniquely viable medium (and inexhaustible art form), but as practiced in these pioneer picture magazines the journalistic photo essay is all but extinct (except in coffee-table art books). And despite more recent attempts, such as *Double-Take* and *Blind Spot*, the photography magazine—that weekly window on news and views—is an anomaly today.

3. TYPOGRAPHY: TALKING TYPE 1930 STYLE

In 1929 *Vanity Fair* magazine, the jewel in the crown of Condé Nast's publishing empire, edited by Frank Crowninshield, made typographic history. Influenced by Modern design trends throughout Europe, art director Dr Mehemed Fehmy Agha introduced Futura and did away with all capital letters in head-lines. The result was at once jarring and elegant: modern, with both lower-and upper-case "M"s. It was also an indication that Crowninshield, a highly respected literary editor and a social bon vivant, and Nast, one of the most powerful men in mainstream publishing, trusted their Ukraine-born art director (who also spearheaded *Vogue* and *House & Garden*) enough to let him challenge convention.

▲ *VANITY FAIR*, December 1931
Front cover. Illustration: Paolo Garretto

The lower-case "experiment" certainly helped to define *Vanity Fair* as a progressive force on the publishing scene for years to follow. However, in truth, its legend lasted longer than the reality. After only a year or so, just as suddenly as capitals disappeared they reappeared in the March 1930 issue, and the editors published a full-page editorial titled "A Note on Typography." Such an explanation of design policy was unique in American magazines. That Frank Crowninshield decided to present "the case pro and con capital letters in titles, writing finis to an experiment," was evidence of the stature of art direction and design in the Condé Nast empire. Today the text is a model of design erudition and a textbook example of how graphic design can be discussed on a public stage.

A Note on Typography

Vanity Fair *presents the case pro and con capital letters in titles, writing finis to an experiment.*

Vanity Fair has for the past several months omitted capital letters in the titles and subtitles of its articles and illustrations. The hawk-eyed reader will note that this issue of *Vanity Fair* returns to capital letters. Posterity anyway will be grateful for a review of the considerations that have led *Vanity Fair*, first to dispense with capital letters in its headings and now, after a trial period of five issues, to return to them.

Typography without capital letters was introduced in Europe soon after the Great War and has been working westward ever since. It has not been used so much in text, but in all situations where the value of display is paramount it has been extremely popular. Thus, the intense competition of advertising, where the least optical advantage makes itself felt at once, has already made some modern typography familiar to Americans.

Capital letters are obviously Roman in origin, going back to the beginnings of our era. Small letters, on the other hand, are derived from the alphabet of medieval script, of scholarly longhand, dating from the time of Charlemagne, about 800 AD. Its characteristics are governed by the natural movements of freehand writing and therefore in stylistic opposition to the simple stone-engraved capitals of the Roman alphabet. With the Renaissance and the revival of classical learning in the fifteenth century, the Roman alphabet was merged into writing, and later into printing, wherever capital letters were indicated. It would now seem illogical to continue to submit to what was simply an historical accident, a symbol for the conceit the Renaissance felt in its newly acquired sophistication in the culture of Rome. Probably, as a matter of fact, the mere omission of a capital letter to indicate the beginning of a sentence or a title is the least significant or permanent item in the program of the new typography.

▲ *VANITY FAIR*, December 1931, table of contents

▲ *VANITY FAIR*, December 1931, headline

VANITY FAIR

Imaginary interviews—no. 1

Aimée Semple McPherson
vs. Mahatma (Stick) Gandhi

SISTER AIMÉE: "I got it all figured out, Mahatma. It's a natural. Come to America and I'll make you as famous as I am. Do what I tell you, kid, we'll stack 'em in the aisles. It's a cinch. It's like taking Gandhi from a baby—" (*The Mahatma says nothing*). SISTER AIMÉE: "In the first place, Mahatma, you haven't got Appeal. That's what you need to put over your act in America! Passive resistance never makes the tabloids, like a good

kidnapping. A new husband is worth more space than all our economic problems! Give 'em Hell, Salvation, and a little Sex. Lift your voice! Lift your soul! Lift your face—" (*The Mahatma says nothing*). SISTER AIMÉE (*gesturing excitedly*): "Here's my proposition! Let's you and me combine! You bring 'em in, I'll take 'em over! If you could preach like me, and I could dress like you, we'd fill the Angelus Temple every day. Think of the possibilities! With your mind and my body—" THE EDITOR (*tactfully stepping up and tapping Sister Aimée on the elbow*): "I am sorry, but this is Mr. Gandhi's day of silence."

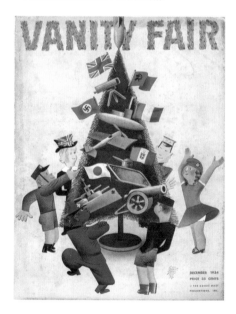

Any art, particularly any art with a function as utilitarian as that of typography, consciously or unconsciously conforms itself in the peculiar temper of the living and contemporary civilization.

The realization of this end takes the form of the arrangement of pictures on the page, of various kinds of type, of new methods of photography, of decorative treatment, of the massing of type on the page, and so forth. And incidentally the omission of capital letters in titles. All this is really compulsory for any magazine that pretends at all to a place in the modern parade. Nothing would amuse and shock the

modern reader more than to pick up a current magazine composed in the fussy and dignified convention of magazines of the 1880s.

The eye and the mind can adapt themselves to new forms with surprising ease. An innovation stands out at first like a sore thumb but before it has passed its infancy it has become invisible to the conscious eye. The unconscious eye, however, is another matter. It is vaguely dulled by the stale and hackneyed, it is antagonized by the tasteless and inept, and it is completely stopped by the involved and illegible. The unconscious eye is a remorseless critic of

"An innovation stands out at first like a sore thumb but before it has passed its infancy it has become invisible to the conscious eye."

all art forms, it awards the final fame and final oblivion. Thus, the conscious eye may endorse at the very moment that the unconscious eye is absolutely condemning. And, on the other hand, the conscious eye may continue to complain irascibly of innovations for some time after the unconscious eye has given them its final approval.

In using, and continuing to use, the new typography, *Vanity Fair* believes that it knows very well what it is doing. In modifying one of the conventions of the new typography by returning to the use of capital letters in titles, it is obeying considerations that outlast any mere "revolution in style."

Three main factors dominate typography: first, appropriateness, as affected by the time, the place, and the function of the material; second, attractiveness, ingratiating the eye and so the mind; and finally and most importantly, legibility. The page may look as handsome as you please but if there is to be any authority in words and ideas the page must be read. A title set entirely in small letters is unquestionably more attractive than one beginning with a capital or with every word beginning with a capital, but, at the present time, it is also unquestionably harder to read because the eye of the reader is not yet educated to it. The issue is thus one between attractiveness and legibility, or between form and content, and *Vanity Fair*, not wishing to undertake a campaign of education, casts its vote by returning to the use of capital letters in titles, to legibility, and to the cause of content above form.

It may be said here that *Vanity Fair* has always and will always cast its vote in that way. While it has tried to perfect its appearance, it has continued to believe that to refuse to be a Magazine of Opinion is not necessarily to be frivolous. Better things are said in one moment of even-tempered gaiety than in a lifetime of spleen.

The notes on this page are not alone to announce a change in typographic style, an event sufficiently self-evident and hardly worth announcing. They are even more particularly to re-affirm some old pledges of *Vanity Fair* and to submit to the final tribunal of its readers the credo of present policies. The assumption of its readers' interest may be naïve but *Vanity Fair* rests in the belief that it is not unwarranted and subscribes itself, your very obedient servant.

Vanity Fair, March 1930.

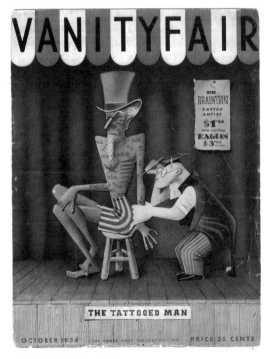

▲ *VANITY FAIR*, October 1934
Front cover. Illustration: Paolo Garretto

4. ILLUSTRATION: PASTICHE—THE THIN LINE BETWEEN RIGHT AND WRONG

This is a tale of how design and illustration are sometimes slaves to the past. So, to get into the mood, think of art direction as a soccer match between two teams—the Contempos (short for contemporaries) and the Retros (short for retro)—slugging it out for the World Style Cup. Okay, maybe art direction can't really be broken neatly down into these two distinct teams but, for the purpose of getting the point across, cut us some slack.

Art directors choose designers and illustrators to work with. And designers and illustrators often choose between modernity and antimodernity. Usually those who design "for the moment" refuse to reference the past and those who design "as though it were yesterday" refuse to be wed to up-to-the-minute fashion (which is something of a fallacy).

Nonetheless, Contempos may deign to borrow tropes from the past if they contribute to the cause of newness. That means said tropes have to be so totally integrated into the new that only an expert aficionado will be able to detect where the past is hidden. For the Contempos, any picking from the past is akin to grave robbing because design should be of its time. Conversely, Retros

are entirely transparent. They don't care who knows where their references come from, and revel in the fact that they've recreated styles from respective periods with exactitude and flair.

Retro style goes in and out of fashion but, as night usually follows day (on planet Earth at any rate), it returns at regular intervals. There is something extremely comforting about harking back to the past. On the one hand it is safe. On the other it is a little mischievous.

Back during the late 1970s and early 1980s scores of designers and illustrators reprised Russian Constructivism because it was at once a startling way to create eye-catching typography and imagery and a subversive means of attacking the status quo. The

Retro

Involving, relating to, or reminiscent of things past; retrospective; a fashion, decor, design, or style reminiscent of things past.

Pastiche

a. *A dramatic, literary, or musical piece openly imitating the previous works of other artists, often with satirical intent.*

b. *A pasticcio of incongruous parts; a hodgepodge.*

general public had no idea what the style signified, but they found it alluring. When, in the US at least, they learned that it was "Communist" they were taken aback. Although most designers and illustrators who adopted the Constructivist (or, for that matter, the Bauhaus or De Stijl) mannerism did not do so to make sociopolitical statements, Retro sometimes came with more symbolic baggage than Contempo.

Before going any further with this discussion about the virtues (and foibles) of both retro and pastiche it is useful to refer to the definitions of the terms on page 41.

Apart from being "comforting," why would an art director use, or for that matter a client accept, retro or pastiche? One reason is that borrowing existing mannerisms provides familiar codes that are easily recognizable. Another is that these strategies are designed to tap into some ersatz nostalgia for sensibilities popular long before most of the audience was even born. Maybe there is a primal sensation that only the power of retro can unlock, or maybe it's just conditioning.

In any case, pastiche is one of the art director's frequently used tools. Whether for an advertisement, magazine cover, book jacket, or anything else, using historical symbols and signs to convey or illustrate a message has great communicative power —and when done well, looks good too.

Q AND A

Mr X is the pseudonym of an art director who commonly employs designers and illustrators who use pastiche. She (or maybe he) prefers not to use his (or possibly her) name or show his (you get the picture) work for personal reasons. Nonetheless, she has agreed to answer questions about his use (and abuse) of the form:

What appeals to you about historical graphic design?
I enjoy many past eras—Victorian, Art Nouveau, Deco, etc.—and I see no reason why I cannot introduce them in my own work, as long as it is appropriate to do so.

What makes using or reusing historical material contemporary?
Interesting question. I'd say it is contemporary when it is not used exactly as it comes out of the box (or the history book). For historical form to work you've got to twist and tweak it so that you, the art director or designer or illustrator, take some ownership.

Is using historical material always going to be pastiche?
No. It's what you use it for and make of it. Sometimes I want to evoke a bygone sensibility, and then I favor pastiche. Other times, I'm making an entirely unique visual statement; I just choose to use elements of the past. It's like musical arrangers who inject a piece of Bach into a pop song—isn't it?

How do you make historical icons, type, etc., into *your* signature?
I have a tool kit of my own unique mannerisms. I simply combine the old and the personal. I suppose some people might see, well, Ludwig Hohlwein or A.M. Cassandre in what I do, but compare them to my work and they'll see me.

What are the historical pieces you prefer most?
I answered that with Hohlwein and Cassandre, but the fact is my preference goes to a lot of good and bad design of the past. I guess the only thing I can't see referencing is Swiss Modern because it is so cool.

Has there ever been a problem in using historical scrap?
The only times I've felt a problem is when I copy line-for-line something I've found. I don't do it maliciously, though, I simply see something 100 years old and figure I can use it in an ironic way. Sometimes I forget the design is not really mine. There must be some integrity (at least a wink and a nod to the originator).

How do you reference history?
Like most designers, I collect a lot of source material.

The same questions were asked of Seymour Chwast, historicist par excellence, and he didn't mind using his name.

What appeals to you about historical graphic design?
It often has charm, vigor, and personality. I like the quirky and awkward nature of much of it.

What makes using or reusing historical material contemporary?
It happens when the historical material helps to define the contemporary idea of the piece.

Is using historical material always going to be pastiche?
No. The style of any piece should be pure for that period. Don't mix styles in any one piece.

How do you make historical icons, type, etc., into *your* signature?
My signature needs incongruity and humor in the image and type.

What are the historical pieces you prefer most?
I like anything from the 1930s. The cars, comics, movies: so innocent and nostalgic for me.

Has there ever been a problem in using historical scrap?
If you mean legal problem, the answer is not yet.

How do you reference history?
Posters mostly. They expose the material world, the style, typography, and spirit of the period.

Ultimately the use or not of pastiche is a personal preference that needn't be judged as right or wrong, although it could be judged as "now or then." If as an art director one employs such methods—and the designers and illustrators who practice them—just make sure the result is smart, sophisticated, and not a line-for-line copy of a well-known original work. That, in fact, is called plagiarism.

5. EDITING: THE ART DIRECTOR AS EDITOR

Magazine art directors who become editors are like rock-band drummers who become lead singers. No offense meant to Phil Collins and Don Henley, but it is rare that someone playing in the background fronts the group (isn't it hard to be percussive, sing, and look sexy all at the same time? Bass players like Sting look so much better). Since art directors maintain the look in much the same way that drummers keep the beat, they don't usually sing, or administer the content, except as back-up. Nonetheless, there are exceptions that reveal art directors with the versatility to take command. While in most scenarios art directors' roles are clearly delineated, occasionally they come to the front of the stage to run the show.

In the early twentieth century the celebrated American illustrator Charles Dana Gibson (known for his stylish "Gibson Girl" franchise) published, edited, and "art directed" the early *Life* magazine (decades before Henry Luce affixed the name to his renowned photo magazine). In the 1960s Alexander Liberman rose from the art directorial ranks to become editorial director of Condé Nast from 1962 to 1994, responsible for the creative critical mass of a dozen magazines. Likewise, Frank Zachary, who was art director of *Holiday* magazine, became the editor-in-chief of *Town & Country* in 1972. Although Zachary began his career as an editor of *Portfolio* (art directed by Alexey Brodovitch), and then assumed the art directorial role at

Holiday, he ultimately switched and spent the better part of his career overseeing an entire magazine, from editors to art directors.

Incidentally, both authors of this book have switched roles too. Twice in her career Véronique Vienne moved from art director to editor. The first time was on *San Francisco* magazine, in the 1980s, and the second time for a magazine called *MODE*, in the 1990s, where she was the editor for the first few issues, "presumably because I was the right size!!!," she says. You see, the magazine was for full-figured women. "In both cases I had a lot of fun. Really loved every minute of it. And I think that I was a pretty good editor." Unfortunately, she was stigmatized as a "former art director" and

"A talented art director is an acute conceiver of ideas and manager of content."

▲ *HOLIDAY,* April 1953, front cover
Design: Frank Zachary

somehow it weakened her authority with the business and publishing department. Steven Heller, who was a senior art director at the *New York Times* for 33 years, was the editor of a number of small magazines while also writing and serving as their art director (as an auteur, so to speak). Later in his career he was editor of the *AIGA Journal of Graphic Design* and, after it had stopped publishing in a printed paper format, editor of *VOICE: The AIGA Online Journal of Design.* In both cases, having been an art director gave him a greater appreciation and sympathy for the designers who worked for him. It also, of course, made Heller more constructively critical of the art direction process.

Most art directors are content to work at their assigned stations. Indeed, by virtue of their talent and influence some art directors and creative directors have veritable parity with editors—Milton Glaser at *New York* magazine in the 1970s comes to mind, and the ubiquitous Roger Black was routinely influential in every magazine he art directed, as was Willy Fleckhaus, the legendary art director of *Twen.* But others, notably those mentioned above, understood that even in the most liberal environments, where the longest of creative leashes is extended to the art director, there are limits to art directorial power. To be free from creative restraint means being one's own boss.

So how is this accomplished? Just having ambition is a good start. There are no rules that govern how an art director is elevated from the art department to the editorial boardroom. In some cases it is as simple as befriending the publisher; in other cases it is as laborious as proving oneself integral to the process on all levels of the publishing venture. Editors-in-chief usually come from the ranks of editors (or writers)—as Vienne notes there is a stigma in emerging from that netherworld known as the art department. Yet a talented art director is an acute conceiver of ideas and manager of content, and there is little fundamental difference between achieving the end result visually or textually. The more integrated these abilities are, the better for the overall publication.

With "integration" the new buzzword and "cross-platform" the new practice, art directors are finding that their job descriptions are changing to include a wider range of content generation. They are

▲ *PORTFOLIO,* 1949, front cover
Design: Alexey Brodovitch

becoming authors, producers, even entrepreneurs. Sometimes their official title is merely semantic (what's the difference between an art director and art editor?), but other times it makes a world of difference in terms of how much control can be exercised over the total publishing entity. While it is not necessary for every art director to be an "editorial dictator," it doesn't hurt to beat a different drum.

6. TAKE THE ART DIRECTOR TEST

It won't ensure you will be a great art director, but it will determine whether you're good at taking tests.

1 As an art director you must be:

(A) A Designer
(B) A Photographer
(C) An Illustrator
(D) All of the above
(E) None of the above

2 How much control should you have over the content of what you are art directing?

(A) A lot
(B) A little
(C) None
(D) Whatever you can scrape together

3 Should an art director be an expert typographer?

(A) Yes
(B) No
(C) It can't hurt
(D) It can hurt

4 What is the best medium in which to practice art direction?

(A) Editorial
(B) Advertising
(C) Web
(D) Motion
(E) Corporate
(F) Depends on the client

5 Should an art director take a heavy hand in the design of a project?

(A) Yes
(B) No
(C) Depends who is working with them

6 Which art director had the most influence on magazine art directors?

(A) Milton Glaser
(B) Alexey Brodovitch
(C) Henry Wolf
(D) Bea Feitler
(E) Rudy VanderLans
(F) Willy Fleckhaus
(G) George Lois
(H) All of the above

⑦ Match the typeface to the art director:

- Ⓐ Egyptian
- Ⓑ Bodoni
- Ⓒ Avant Garde
- Ⓓ New York Times Cheltenham
- Ⓔ Nicolas Cochin
- Ⓕ Peignot

- ① Franco Maria Ricci / Fabien Baron
- ② Roger Black
- ③ Fred Woodward
- ④ Tom Bodkin
- ⑤ Charles Peignot
- ⑥ Herb Lubalin

⑧ Art direction is to design what _____.

- Ⓐ military music is to music
- Ⓑ painting is to sculpture
- Ⓒ love is to lust
- Ⓓ directing is to acting
- Ⓔ mothering is to fathering
- Ⓕ Huh?

⑨ What is the most valuable attribute of an art director?

- Ⓐ Wisdom
- Ⓑ Loyalty
- Ⓒ Taste
- Ⓓ Knowledge
- Ⓔ The gift of the gab
- Ⓕ All of the above
- Ⓖ None of the above

⑩ What is the least attractive trait of an art director?

- Ⓐ No historical memory
- Ⓑ Kowtowing
- Ⓒ Poor taste
- Ⓓ Bad typography
- Ⓔ Terrible ideas
- Ⓕ All of the above
- Ⓖ None of the above

⑪ An art director is a teacher.

- Ⓐ True
- Ⓑ False

ANSWERS: 1. d and e. It is useful to be all these things, but not necessary as long as you can manage to get the best work out of them. **2.** a. The more the better if you have a real point of view. **3.** c. Art directors don't have to be typographers, but every little bit of knowledge is useful in commanding the total picture. **4.** f. The medium is just a vehicle. The client (be it an editor or producer or CEO) is the ultimate arbiter. **5.** c. A good art director should know when to let good designers do their jobs. **6.** h. All of these art directors have had a major impact on their fields. If you don't know who they are, you should learn about them. **7.** a/2; b/1; c/6; d/4; e/3; f/5. **8.** f. **9.** f. While it sounds trite, all these attributes are important in communicating with clients and guiding employees. **10.** f, of course. **11.** What do you think?

SECTION TWO:
CREATIVE TENSION 101

(WHAT MAKES ART DIRECTION WORK)

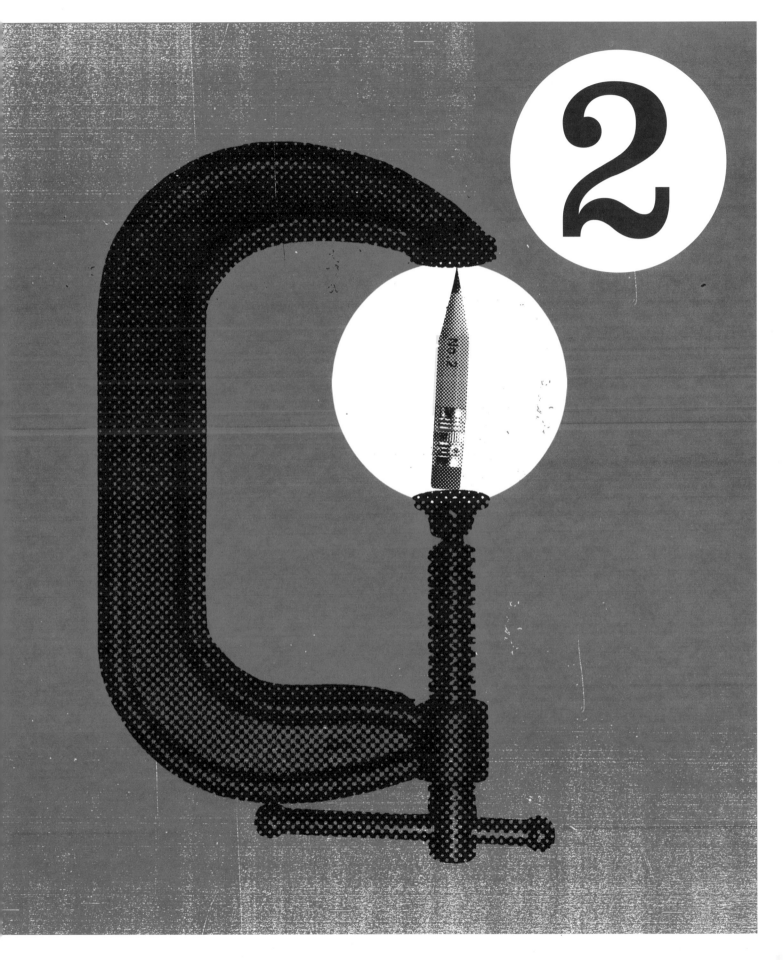

THE THEATRICS OF SCALE
CASE STUDY: *The Drawbridge*

You might say scale is an art director's best friend. The ability to make design elements big or small, fat or thin, vertical or horizontal is key to making vigorous designs in any format and in any medium. Nonetheless, the newspaper is probably the most challenging medium wherein playing with scale is imperative (even though it is not always exploited to the fullest).

Now that many newspapers are radically reducing their size to tabloid or the slightly larger "Berliner," working with the traditionally massive broadsheet is increasingly rare. Stephen Coates, the design director for *The Drawbridge*, an art and cultural newspaper that was launched in Britain in 2006, revels in the scope and large format of the publication. The size contributes to its personality and also enables astonishing visual content. Coates is happy to explain the motivation for retaining this anomalous format as well as the challenges involved in keeping it fresh.

The initial idea for *The Drawbridge*'s broadsheet format grew out of discussions with its publisher, Giuseppe Mascoli, and its editor, Bigna Pfenninger, as "an antidote to the conventions of the contemporary literary magazine," Coates reveals. "But we didn't only want to be bigger than our peer magazines; we also wanted to be broader in scope." So it publishes writing from philosophers (Slavoj Zizek, Noam Chomsky), politicians (Gerry Adams, Hugo Chavez), historians (Eric Hobsbawm), as well contemporary fiction by authors ranging from Isabel Allende to Irvine Welsh. On the front page of a recent issue there was a specially commissioned music score composed by Ryuichi Sakamoto.

Engaging intelligent readers in the text was imperative, but making the paper a visual treat was also essential. "From the outset we intended to give equal space and billing to image-makers and writers," Coates says, referring to his unique commissioning method. "Contributors are simply given the theme of the issue and asked to respond. For illustrators especially, this is a great chance to express themselves on a bigger canvas than commercial commissions normally allow." Paul Davis and Millie Simpson, the drawings editor and photography editor respectively, court the artists and give them their respective heads.

Coates is conscious that most contemporary newspapers are leaving the broadsheet format behind. This made it more attractive for *The Drawbridge* to buck the trend, although he insists "it was in no way a reactionary move on our part." In fact, Coates had worked on a few newspaper redesigns where publishers were downsizing their papers, which piqued his interest in the larger scale. "They had hardly ever used their size advantage unless there was a really big news story, so the opportunity had usually been wasted. Only the advertisers used the format to their advantage and benefited from the impact of full-page imagery," he says.

▲ *THE DRAWBRIDGE*, Autumn 2007, issue 6, front page
Photograph: Jackie Nickerson; Design Director: Stephen Coates

▲ *THE DRAWBRIDGE*, Winter 2007, issue 7, front page
Illustration: Brian Cronin; Design Director: Stephen Coates

In terms of layout *The Drawbridge* is quite a puzzle to put together and the constraints are different to standard newspaper make-up. Many of the texts, for instance, are short stories and cannot be cut. And yet "we try never to crop imagery and there are only two headline sizes to play with. So even though the pages are big, they are rather inflexible."

Proportionally, the display typography will occupy less area on the page than with a smaller format—for example, a 36-point headline on a broadsheet page as opposed to a 36-point headline on an A4 page—which poses certain design problems for Coates. "When you are designing on a screen at a reduced scale, you are tempted to enlarge the article headlines for greater impact. Yet, in fact, more restrained typography makes the scale of the illustrative material stand out more distinctly due to the contrast. The very meaning of the word 'graphic' is an effect resulting from contrasts: light and dark, thick and thin, big and small. Contrast is a fundamental visual tool."

Illustration, surprisingly enough, is a lot less flexible than it would seem and more difficult to use at a bigger scale than photography, "because you have to allow for the size of the original. Illustrations have to be specifically commissioned for our double-page spread slot (for example, Paul Davis's in issue 4). In photography the only original is reality. The majority of photographic imagery we use—no matter how big we reproduce it—is a reduction in scale of what it depicts. Take a look through any newspaper, and the same will be true. So you have a lot more scope in using contrasting scales with photography and I'd like to explore this further in future issues."

The feedback on *The Drawbridge*'s large format from both its readers and its contributors has been very positive. "Of course it creates problems for distribution," Coates admits, "some bookshops find it awkward, shelves don't cater for it, but I think this is far outweighed by its distinctiveness and the loyalty of its increasing number of fans."

ART DIRECTION EXPLAINED, AT LAST!

THE BELIEVER

'80s TEEN SEX COMEDIES

A tour of the witless ache of early VHS.

by ANDY SELSBERG

THE GREAT WRONG PLACE

Los Angeles's reputation for filthy sprawl makes it the ideal place to write about nature.

by JENNY PRICE

MAY 2006 ★ $8

LONG-ESQUE INTERVIEWS WITH:

★ JIM WHITE ★
[THE FLANNERY O'CONNOR OF ALT-COUNTRY]

★ ORHAN PAMUK ★
[EXCELLENT TURKISH NOVELIST]

★ NICOLE HOLOFCENER ★
[FRIENDS WITH MONEY, LOVELY AND AMAZING]

★ ARNOLD DAVIDSON ★
[PROF. OF DIVINITY & PHILOSOPHY, MONSTER SCHOLAR]

& NICK HORNBY ON ONDAATJE'S
FEVERISH OPTIMISM AND
VONNEGUT'S QUIRKY
HUMANISM

REPO MAN

Reliving Alex Cox's punk-rock-sci-fi-action-comedy in an L.A. scavenger hunt

by JIM RULAND

QUEER PUNK TAXIDERMY

Undercover in Sioux Falls, South Dakota

by MICHELLE TEA

ALSO:
A cavalcade of cookbook-blurb puns and hyperbole (p. 62)

AND:
Fred Armisen fills in for Amy Sedaris's advice column (p. 31)

PLUS:
Totally incompetent cartoons (p. 52)

▲ *THE BELIEVER,* May 2006, front cover. Design Director: Dave Eggers; Designer: Alvaro Villanueva; Illustration: Charles Burns

THE VALUE OF MULTIPLE ENTRY POINTS

CASE STUDY: *McSweeney's Quarterly Concern*

Readers of magazines do not read. They skim, scan, leaf, and peruse. A combination of factors may be responsible for this phenomenon: the unwieldy size of the pages, the amount of information on them, the often perplexing mix of words and images, and the typographical clutter. Add to this the timeliness of the published articles, which fosters a sense of urgency and eggs you on. The same texts, published in a book, would encourage you to settle down, find a chair, and read quietly; but laid out in a magazine format they are likely to increase your blood pressure. Are art directors to blame—or be congratulated—for this state of affairs? How do they manage to turn printed matter into pep pills and body copy into Benzedrine?

Dave Eggers, an art director/author/publisher, has figured out a way to design magazines to look like books—thus encouraging readers to read—without his periodicals losing any of the euphoria-producing side effects of traditional magazines. *McSweeney's Quarterly Concern*, published in San Francisco since 1998, comes out roughly four times a year, each bookish-looking issue producing the kind of buzz one would expect from the latest copy of Italian *Vogue* or British *Vanity Fair*.

Eggers's methodology is simple: he safeguards the textual integrity of each single page, presenting the articles, interviews, essays, and short stories of *McSweeney's* as he would chapters of a book. At the same time he gives readers multiple entry points, diverting their attention here and there with intriguing and well-crafted details. The magazine looks, at first glance, like an artist's book. Issue number 22, for example, presents itself as a rigid binder in which three slim paperbacks are stacked together, their perfect-bound spines held in place against the binder's own magnetized spine. Issue number 24 is a handsome cloth-bound notebook, with two front covers opening right and left, each giving access to two different parts of the book. Issues number 13 and 23 are wrapped in

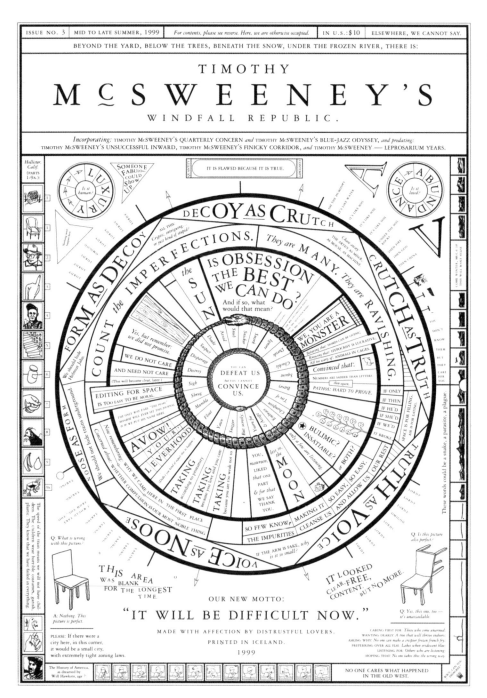

▲ *MCSWEENEY'S QUARTERLY CONCERN*, 1999, issue 3, front cover. Art Director: Dave Eggers

MCSWEENEY'S QUARTERLY CONCERN, 2007 ▶
Issue 23, inside cover (folded poster, detail)
Designers: Dave Eggers and Brian McMullen
Text, drawings, and concept: Dave Eggers

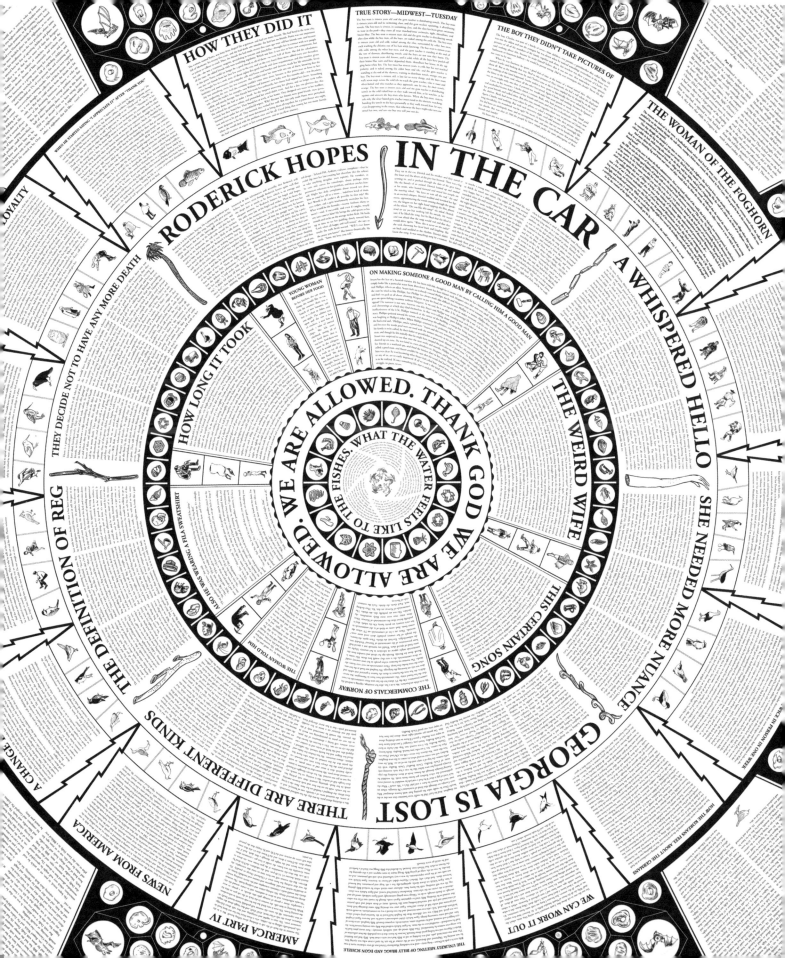

thick origami that opens up into posters as large and cumbersome as Rand-McNally maps. But that's just the beginning. As you thumb through the pages you are likely to come upon tipped-in booklets, full-bleed illustrated spreads, colorful section dividers, or *trompe l'œil* inserts. Though less extravagantly produced, earlier issues of the magazine provided the same visual excitement through typographical eccentricities, such as tiny badges, cabalistic-looking signs, or mysterious aphorisms treated like decorative elements, tucked inside borders.

Born in Chicago in 1970, Eggers is better known as the author of best-selling *A Heartbreaking Work of Staggering Genius*, published in 2000. Before his literary breakthrough, however, he supported himself as a graphic designer. He had studied painting and journalism at the University of Illinois, while taking courses in illustration at the Academy of Art in Chicago. He developed a passion for publishing while collecting antiquarian books, especially bibles and manuals for medical students. It was these collector's items that later inspired him and served as his models when he set up his own publishing house. *McSweeney's Quarterly Concern* was conceived originally as a protest-oriented endeavor more than as a literary enterprise, since at first Eggers published manuscripts rejected by other publishers only. A veritable *salon des refusés*, the magazine quickly stood out through its design—each issue gives Eggers the chance to fashion the equivalent of a handsome original edition.

When asked why he doesn't publish *McSweeney's* as a traditional magazine, Eggers explains that its visual appearance prompts readers to spend more time with each issue. "The reason we put so much effort into the design and production of the journals is that we figure that if we add that extra touch to make the issues collectible the journals might stave off the junk heap or recycling bin a bit longer, thus giving the contents inside a better chance to be read. We're trying to honor the work inside, and give it a longer shelf life."

The elements of surprise, he believes, capture readers' attention and invite them to investigate further the content of each article.

No two issues are ever alike, and news-stand perusers as well as subscribers are kept guessing, wondering what the next visual trick the publication is going to foist on them will be.

The only recurring visual theme that could serve as a brand image for *McSweeney's* is a weird circular motif called a volvelle, a calculating wheel whose esoteric origins date back to the Middle Ages. As a decorative motif it first appeared on the cover of issue 2 of *McSweeney's* in 1999. The mysterious dial has since been featured in issues 3, 11, 12, 19, and 23, on the covers or inside. Versions of this circular design (roulette wheels, gears, medallions, badges, coats of arms, flywheels, and rosettes) are also used on the covers of other publications sponsored by Eggers, such as *The Believer*, a literary journal, and *Wholphin*, a quarterly DVD featuring intriguing short films and edgy video clips. Based on the same logarithmic principles as the dials developed to calculate the position of the stars, volvelles are multiple-entry-point devices that afford users a glimpse at the mysteries of the universe. In the same way, the quarterlies published under the *McSweeney's* label are interactive objects designed to give readers more than one way to apprehend the world.

Indeed, the purpose of the magazines, regardless of their topics, is to give readers as many leads as possible so that they can try to find their way around the world of ideas, trends, people, and products. Art direction is the art of presenting this dizzying array of information in such a way as to make it look a little less confusing than it really is—without simplifying it beyond recognition. As mathematical physicist John D. Barrow once remarked: "Any universe simple enough to be understood is too simple to produce a mind able to understand it."

The talent of Dave Eggers (and of his designers Eli Horowitz and Brian McMullen) has been to turn this existential bafflement into a visual form readers can enjoy. Issue 23 of *McSweeney's*, published in 2007, included a huge volvelle that, once unfolded, was the size of a very large poster. The document, featuring some 40 short stories written by Eggers, described a scary and moving world in which

everything happens to everyone at once, in which every life is a story worth being told well, and where nothing happens that is not important or edifying. Few readers will venture into this great spider's web to unravel its content. But that is not the point of the experiment. For Eggers it is the graphic equivalent of *a heartbreaking work of staggering genius*.

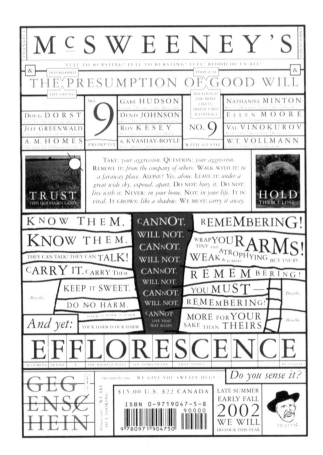

▲ *MCSWEENEY'S QUARTERLY CONCERN*, 2002
Issue 9, front cover
Art Director: Dave Eggers

▲ *WHOLPHIN*, 2006
Issue 3, front cover
Art Director: Dave Eggers; Designer: Chris Ying

THE ALLURING ART OF ALLURE

CASE STUDY: Kiehl's Cosmetic Packages

Allure is a slippery term. For some it connotes elegance in the extreme, for others it means sublime simplicity. Kiehl's, the quirky cosmetic and sundry brand, builds its allure on tradition—an old-style drugstore approach to packaging that is almost antidesign. So how does Victoria Maddocks, creative director for Kiehl's, art direct for allure?

First and foremost, she says, "I know my subject thoroughly." Having this innate understanding allows her to work more instinctively, and ultimately gives her more freedom in the communication of the overall message. "After all," she adds, "it's simply about hiring the best talent, be it photographer, stylist, or postproduction specialist." Then she focuses on the details. "When concepting ideas, I always consider such things as composition, color, and lighting—ultimately assessing the overall impact of every aspect of the look and feel."

Are there any tricks or tropes that Maddocks has mastered to make Kiehl's products alluring? The straightforward, educational —almost medicinal—appearance of Kiehl's products represents a primary means of communication, and is important in appealing visually to customers. Using materials such as stainless steel for caps and necks gives, for example, the anti-ageing range of formulas an element of prestige. Even practical and functional additions such as pumps add allure. As do better evacuation and dispensing systems that help preserve formulas. And, ultimately, more use of color in packaging across the board sometimes helps to seduce, while copy, though generally serious, is sometimes playful.

Kiehl's has a distinct, low-key, virtually non-design style. But this has changed over the past five years to increase the allure factor.

▲ FOREST RAIN
Designer: Darren Kuhnau; Creative Director: Victoria Maddocks

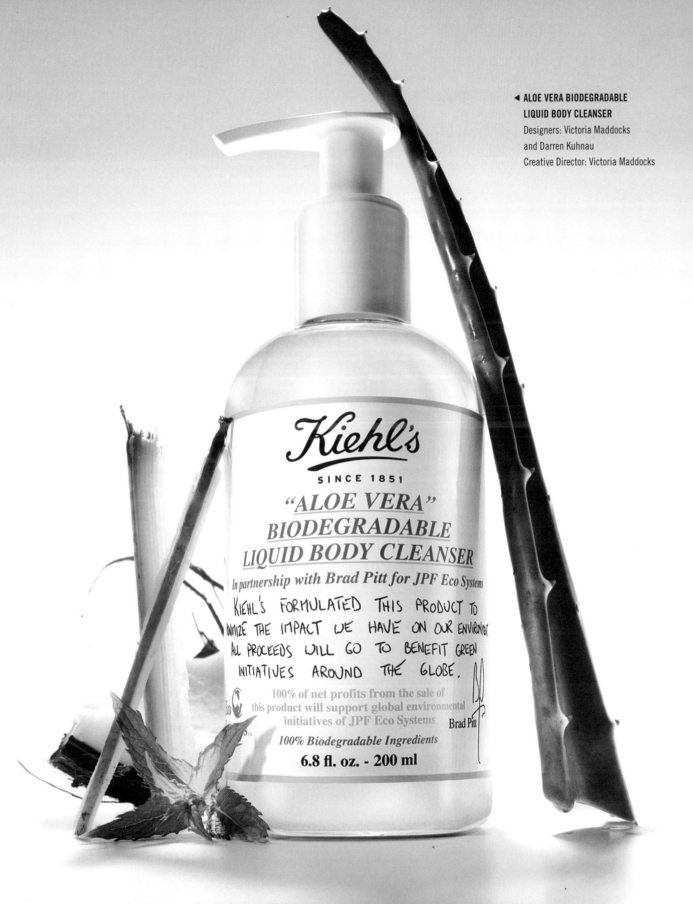

Kiehl's

SINCE 1851

"ALOE VERA"
BIODEGRADABLE
LIQUID BODY CLEANSER

In partnership with Brad Pitt for JPF Eco Systems

KIEHL'S FORMULATED THIS PRODUCT TO
MINIMIZE THE IMPACT WE HAVE ON OUR ENVIRONMENT.
ALL PROCEEDS WILL GO TO BENEFIT GREEN
INITIATIVES AROUND THE GLOBE.

Brad Pitt

100% of net profits from the sale of
this product will support global environmental
initiatives of JPF Eco Systems

100% Biodegradable Ingredients

6.8 fl. oz. - 200 ml

805987XX

Kiehl's LIP
BALM #1

*SPF 4 Sunscreen
Petrolatum Skin
Protectant*

Temporarily protects and
helps relieve chapped
or cracked lips. Helps
protect lips from the
drying effects of wind
and cold weather. Apply
liberally to lips and allow
an excess of the balm to
be absorbed.

KIEHL'S SINCE 1851 LLC
NEW YORK, NY 10014
MADE IN U.S.A.
www.kiehls.com
0.5 fl. oz. - 15 ml

With the introduction of new products and categories "we have simultaneously opened up our design palette and allowed for a bit less rigid or uniform look to our packaging," explains Maddocks. "We are even touching the very iconic Lip Balm #1 tube package, in that we're adding a red ribbon to honor World AIDS Day, with the proceeds from all the sales of this product benefiting local AIDS charities around the world."

What typefaces say allure? Maddocks believes there are typefaces that are most definitely more alluring or beautiful than others. "Of course everything working together in harmony in any piece of design is what makes something really alluring. We consider our written communication to our customers—on our product labels as well as our in-store collateral and signage—to be an important means of messaging to them about our company, so it is also imperative that we always strike a balance between consistencies and design in the typefaces we select."

As for alluring products, Maddox admits the fragrances are extremely alluring, and the packaging for Forest Rain, the company's newest fragrance, communicates that allure—along with the tradition of the original Kiehl Pharmacy—in a most modern and evocative manner.

◀ **KIEHL'S LIP BALM #1**
Designer: Darren Kuhnau
Creative Director: Victoria Maddocks

But what is the least alluring? "Ultra Moisturizing Eye Stick SPF 30," she says. "While the product itself is perfectly functional and is apparently well loved by athletes and sailors around the world, I'd love to redesign its packaging. I see opportunities to better communicate our history of supporting adventurous and athletic endeavors, as well as our commitment to educating our customers on the importance of using sun protection regularly."

What makes Maddocks's art direction different? "I understand business. Having this strong commercial instinct partnered with a highly creative storytelling capacity is more unique than common, and I consider this left-brain, right-brain combination to be a distinctive attribute. Having a very clear picture of the business objectives in sight while listening to multiple ideas is a trait an art director must hone."

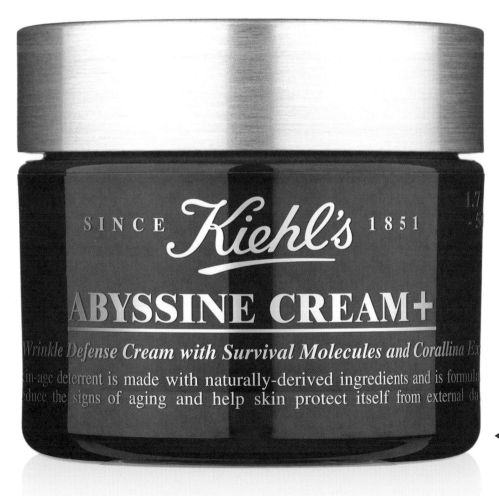

◀ KIEHL'S ABYSSINE CREAM +
Designer: Darren Kuhnau
Creative Director: Victoria Maddocks

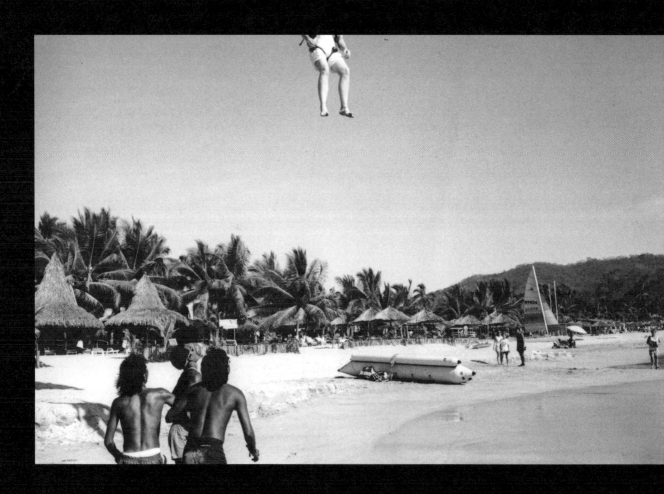

▲ *SKY PARACHUTIST*, 1990
Zihuatanejo, Mexico
Photographer: Lloyd Ziff
Client: *Discovery*, Cathay Pacific in-flight magazine

THE REWARDS OF BLACK-AND-WHITE
CASE STUDY: Lloyd Ziff's Travel Photography

Almost twenty years separate Ansel Adams's famous 1944 gelatin silver print of Yosemite Valley from its commercial replica, a huge 18 x 60 foot (5.5 x 18 meter) Kodak color transparency taken from the same vantage point showing an all-American family admiring the same view. Twenty years during which globetrotters, backpackers, adventurers, and sightseers were recast as mere tourists. Twenty years of growing prosperity that convinced amateur photographers to abandon their tried-and-true Kodak Tri-X black-and-white film and switch to costly rolls of Kodachrome.

The color photograph of Yosemite was one of the 565 "World's Largest Photographs" displayed between 1950 and 1990 on the famous Kodak billboard in New York's Grand Central Terminal. Clean and cheery, it reduced Adams's epic landscape to a garish cliché. Comparing the two images is something of a heartbreak: so much mystery and poetry was lost when color photography was allowed to mediate our travel experiences. Yet, as utterly predictable as they were, the color landscapes staged by Kodak "permanently affected our notions of past and present," as Alison Nordström wrote in her introduction to *Colorama*, a book on the influential Kodak campaign (Aperture, New York, 2004). "The memory of [these] images continues to purvey some shining idea of what families, mountains, and exotic places are supposed to look like."

Lloyd Ziff, former art director of *House & Garden*, *Vanity Fair*, and *Travel & Leisure* magazines, and now a travel photographer, knows all too well how difficult it is for readers to erase from their collective unconscious the sense of false euphoria associated with the blue skies, green lawns, yellow daffodils, red barns, and white clouds favored by Kodak. Back when he was an art director, in the 1980s and 1990s, he used all his ingenuity to propose alternative solutions to the postcard views of the great sights, vistas, and landmarks his magazines promoted. He encouraged photographers to shoot in muted colors and instructed them to avoid "picturesque" details that made the most enigmatic places on earth look like tourist attractions. Though he shot in black-and-white for his own sake as an amateur photographer, he felt that as an art director he had to stick to color on the pages of magazines to fulfill the expectations of both readers and advertisers who associated pleasure, discovery, and travel with bright and sunny destinations. "Only on occasion was I able to sneak in a black-and-white story in the magazines

I art directed," he says. "I would get away with it by using a 'big name' photographer like Helmut Newton or Robert Mapplethorpe, whose credentials as artists had already been established."

Today he has found his niche as a black-and-white landscape photographer, his lyrical pictures published in travel magazines that no longer consider that color is the only way to entice readers and fuel their travel fantasies. The breathtaking silver prints of Ansel Adams, Ziff believes, are just as much part of our collective unconscious as the brilliant Kodachrome slides our parents used to bring back from their vacation trips. He would rather tap into the nostalgia of a time when monochromatic images of the American wilderness elicited a quasi-religious sentiment than try to fight against an equally strong prejudice that still associates bright color with upbeat commercial values.

Introduced in 1935, Kodachrome is the oldest mass-marketed film for still images. Yet the public was slow to adopt it, in part because it was expensive but also because color photography was, for a long time, regarded as "unreal" or "less than truthful." In one of his essays on photography, John Szarkowski remarked that in *The Wizard of Oz*, released in 1939, the reality of Kansas was shown in black-and-white whereas the fantasy of Oz was shown in color. In magazines in the 1940s and 1950s only advertisements were in color, he added. "Those magazines that believed that it was their function to tell the truth did not consider the possibility that the truth might be told in color," he wrote, referring to *Life* magazine. It took the relentless Kodak advertising campaigns to change people's perception and to impose color photography as an acceptable reporting medium.

Lloyd Ziff's travel photographs are not as carefully orchestrated as Ansel Adams's pictures. He doesn't pretend to compete with the master, even though many of his landscapes, particularly those of the Alaskan wilderness, are somewhat reminiscent of Adams's photographs of Jasper National Park. "When there was a rainstorm gathering in front of me, I could not *not* take the picture just because it looked like one of Adams's famous shots," he says. "It was simply beautiful, and I had to record it." What makes Ziff's images modern, though, is the fact that he often includes people in them, people who, almost invariably, stand with their back to the camera. Unobtrusive, and yet present, the figures bring the viewer into the picture. One "feels" part of the landscape, along with the people posed inside the frame.

Some of the most compelling landscape paintings and photographs from the past portray their subject from behind. Most famous perhaps is Andrew Wyeth's emotionally charged *Christina's World*, in which a young girl sits in a field and looks up at a farmhouse. Inspired by this 1948 masterpiece, photographer Clifford Coffin created, a year later, a striking *Vogue* magazine cover that featured four models in swimsuits sitting on a sand dune, their bare backs the only sensual elements in a desolate landscape. Old masters knew how to create tension in a landscape by positioning in the foreground figures seen from the rear, who seemed to be only slightly ahead of viewers. Pieter Bruegel the Elder's *Fall of Icarus* (c.1555) and *Hunters in the Snow* (c.1565) are examples. Jean-Antoine Watteau was another painter who could transform a pastoral tableau into a poignant landscape with the silhouette of a woman turning away as if ready to leave, the sweeping folds of her heavy satin frock indicating her intention to withdraw from the scene.

Ziff's landscapes have a similar effect on the psyche of readers. On the pages of a magazine his photographs are invitations to follow him quietly as he moves closer, eager to get a better view, yet careful not to disturb the people he encounters. You sneak with him behind the scenes, and what you see is the silvery reflection of a fleeting moment that is not meant to last more than a second.

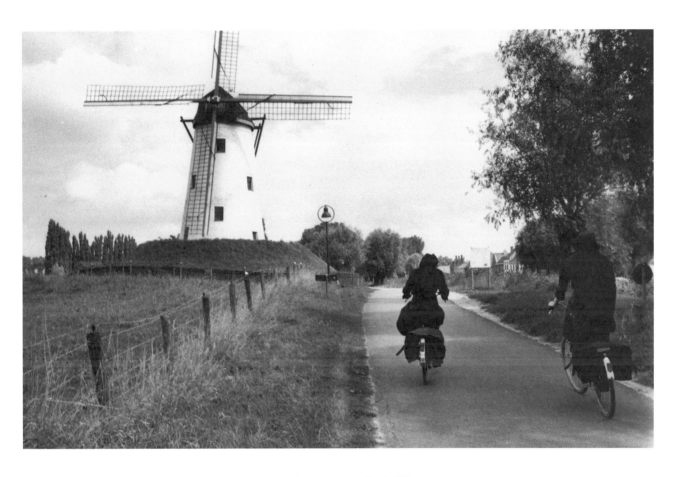

▲ *NUNS ON BIKES*, 2002. Near Bruges, Belgium. Photographer: Lloyd Ziff; Client: *Condé Nast Traveler* (US)

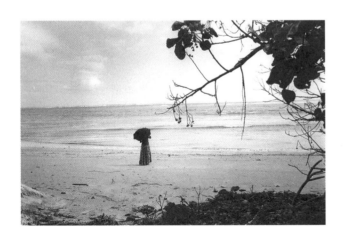

▲ *WOMAN WITH UMBRELLA*, 2002. Oahu, Hawaii
 Photographer: Lloyd Ziff; Client: *Discovery*, Cathay Pacific in-flight magazine

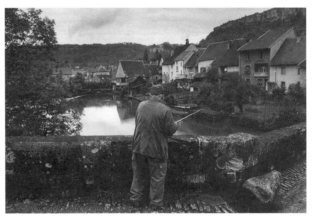

▲ *FISHERMAN*, 2001. Ornans, France
 Photographer: Lloyd Ziff; Client: *Condé Nast Traveler* (US)

THE USE OF PARALLEL NARRATIVES
CASE STUDY: Robert Delpire's *Les Américains*

The function of an art director is to make you feel smarter the minute you lay eyes on a page. There is a quickening in your brain even before you take in the full scope of the information spread in front of you. "Come on, art direction is not brain surgery," an editor I knew used to say when I was complaining about the difficulties of designing a weekly magazine on a tiny budget and with a small staff. He was wrong. Art direction *is* brain surgery. When well done, it acts directly on your neurons.

The case in point, *Les Américains* ("The Americans"), was published in France by Robert Delpire in 1958. This small book quietly demonstrated how a deceptively simple layout can be an effective mind opener. Delpire was a medical student when he discovered, while editing his college magazine, that he had a taste for art direction. He made a brilliant career out of what was initially just a hobby. Not only did he become one of the most influential publishers in postwar France, he was also able to use his visual flair working as a successful adman.

Les Américains showcased the work of the still unknown Swiss photographer Robert Frank, whom Delpire had discovered and befriended. But Delpire decided to put on the cover of Frank's book a minimalist pen-and-ink drawing by American artist Saul Steinberg, also a very good friend. No one before—or since—has deemed it appropriate to use a drawing to advertise a photography book! Frank was taken aback at first, but Delpire promised to put on the cover of the second edition a print of one of the gritty street scenes Frank had captured during his two years of trips across the United States. Delpire's counterintuitive choice was exacerbated by the fact that the drawing he picked had little to do, stylistically or substantially, with Frank's pictures. It represented a Manhattan sidewalk, with the tiny silhouettes of pedestrians dwarfed by the huge graph-paper façade of a chic apartment building. Almost totally white, the cover was in stark contrast to the journalistic quality of the photographs inside. It made no sense, yet it was a brilliant art directional move. It drew attention to the disparity between perception and reality—between the pristine façade of prosperity as depicted by Steinberg's drawing and the soul-stirring realism of Robert Frank's grainy photographs.

Creating a deliberate tension between two narratives is one of the most effective techniques an art director has at his or her disposal to energize a layout—the least effective technique being the straightforward illustrative approach, in which all the visual and verbal elements on the page are striving to tell the same story.

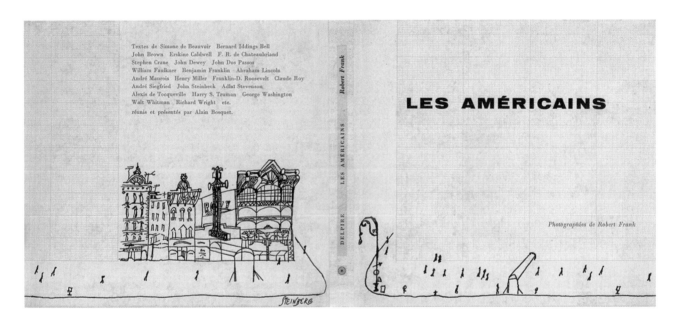

Textes de Simone de Beauvoir Bernard Iddings Bell
John Brown Erskine Caldwell F. R. de Chateaubriand
Stephen Crane John Dewey John Dos Passos
William Faulkner Benjamin Franklin Abraham Lincoln
André Maurois Henry Miller Franklin-D. Roosevelt Claude Roy
André Siegfried John Steinbeck Adlaï Stevenson
Alexis de Tocqueville Harry S. Truman George Washington
Walt Whitman Richard Wright etc.

réunis et présentés par Alain Bosquet.

STEINBERG

Robert Frank

LES AMERICAINS

DELPIRE

LES AMÉRICAINS

Photographies de Robert Frank

LES AMÉRICAINS, 1958 ▲
Front and back covers
Art Director: Robert Delpire
Artist: Saul Steinberg

Instinctively, Delpire felt that he needed to trigger a disconnect in the mind of readers in order to convey the idea that Frank's photographs were about "the other America."

The book became a "must have" for a small coterie of French photography lovers. More than its subject matter, its design caught people's attention. Slightly undersized compared to the coffee-table art books popular back then, it had a stylish horizontal format and an elegant typographical treatment. Its text also represented a departure from the norm: instead of an erudite essay, it was a long litany of excerpts by a mixed bag of authors including Simone de Beauvoir, Franklin D. Roosevelt, Mary McCarthy, Fernand Léger, and Henry Miller. The resulting impression was of a syncopated collage of thoughts and remarks about Americans that yet again made no reference to the mood or poignancy of Frank's photographs.

For better or for worse, art direction is as much about context as it is about content. Inadvertently Delpire had stumbled upon what would today be considered a conceptual approach. In postwar France never before had an art book been treated as a cultural artifact. Yet, that's what *Les Américains* turned out to be. As well as presenting the work of a talented young photographer, it captured the zeitgest of the moment and as such it became a landmark publication. Though modestly successful at first, it launched Delpire's and Frank's careers, the former as an innovative publisher and the latter as a major photojournalist.

Published a year later in the United States, but not art directed by Delpire, with a photograph by Frank on the cover, the book featured a short introduction by Beat poet Jack Kerouac, whose *On The Road* sensibility was a perfect match with that of Frank's photographs. The American edition did not get the critical acclaim the book had received in France. It lacked the magical *je ne sais quoi* that had drawn French readers to it. "The press in the US panned it," recalls Delpire. "They said, 'Who is this obscure Swiss photographer

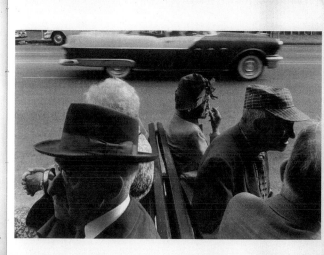

relatives à la presse, les Etats-Unis envoyèrent ce seul texte, à l'exclusion de tout autre : " Le Congrès ne fera aucune loi restreignant la liberté de la parole ou de la presse. "

En 1900, 115 hommes furent lynchés, 130 en 1901, 2 en 1950.

LES INDIENS

George Washington dans un message au Congrès : " Nous sommes plus éclairés et plus puissants que les nations indiennes; il est de notre honneur de les traiter avec bonté et même avec générosité. "

Pétition des Chérokis au Congrès, en novembre 1829 : " Par la volonté de notre Père céleste qui gouverne l'univers, la race des hommes rouges d'Amérique est devenue petite; la race blanche est devenue grande et renommée. Lorsque vos ancêtres arrivèrent sur nos rivages, l'homme rouge était fort, et quoiqu'il fût ignorant et sauvage, il les reçut avec bonté et leur permit de reposer leurs pieds engourdis sur la terre sèche. Nos pères et les vôtres se donnèrent la main en signe d'amitié, et vécurent en paix. Tout ce que demanda l'homme blanc pour satisfaire ses besoins, l'Indien s'empressa de le lui accorder. L'Indien était alors le maître et l'homme blanc le suppliant. Aujourd'hui, la scène est changée; la force de l'homme rouge est devenue faiblesse. A mesure que ses voisins croissaient en nombre son pouvoir diminuait de plus en plus; et maintenant, de tant de tribus puissantes qui couvraient la surface de ce que vous appelez les Etats-Unis, à peine en reste-t-il quelques-unes que le désastre universel ait épargnées. Les tribus du Nord, si renommées jadis parmi nous pour leur puissance, ont déjà à peu près disparu. Nous voici les derniers de notre race, nous faut-il aussi mourir ? Depuis un temps immémorial notre Père commun, qui est au ciel, a donné à nos ancêtres la terre que nous occupons; nos ancêtres nous l'ont transmise comme leur héritage. Nous l'avons conservée avec respect, car elle contient leurs cendres. Cet héritage, l'avons-nous jamais cédé ou perdu ? Permettez-nous de vous demander

70

St.Petersburg, Florida.

▲ *LES AMÉRICAINS*, 1958. Art director: Robert Delpire; Photographer: Robert Frank

who came here to teach us a lesson?'" In fact, the book created a minor scandal. What if Delpire had been allowed to art direct the US edition? Peter Galassi, head of the photography department at MoMA, New York, does not think it would have worked. He does not approve of art direction that interferes with the work presented on the page, nor does he believe that a text showcasing excerpts by famous authors is the appropriate way to kick off the work of an unknown photographer. "When I look at photographs by Robert Frank, I don't want to have to deal with Alexis de Tocqueville or FDR," he says. "Pairing celebrities with pathos smacks of commercialism."

Coming to the defense of Delpire is Milton Glaser, another art director not easily intimidated by conventional editorial precepts,

and who likewise has proved himself as a graphic artist/editor/ publisher. Glaser himself advocates juxtaposing parallel narratives to create apparently unlikely visual non sequiturs. "I'm convinced that there is a link between all things," he says. "Everything is connected one way or another. So you could take two of the most random objects, whatever they happen to be, a chair and a skyscraper, let's say, and you'll discover an uncanny series of relationships between them." In fact, for Glaser, free associating in order to uncover hidden interconnections is a creative methodology.

Like Glaser, Delpire was able to parlay his art direction talent into a series of fortuitous enterprises that included the creation of

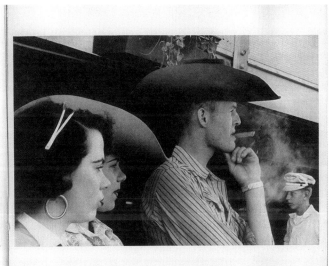

▲ **LES AMÉRICAINS**, 1958. Art director: Robert Delpire; Photographer: Robert Frank

a landmark advertising campaign for Citroën, the French car com-
pany; producing art films with American photographer William Klein;
establishing a Paris design studio with Herb Lubalin; sponsoring
gallery shows for photographers and illustrators, among them Henri
Cartier-Bresson and Push Pin Studio; and launching "Photo Poche,"
an internationally distributed pocket-size anthology of photography
that has more than 150 titles today.

But, somehow, Delpire will forever be known as the publisher of
Les Américains and of the subsequent "Essential Encyclopedia"
series—a popular collection of equally unconventional books
designed, he says, "to entertain as much as edify." Topics such
as hands, birds, trees, gold, insects, volcanoes, writing, evolution,
and Baroque art were treated by Delpire as opportunities to
"astonish the eye." He explains: "These books are essential
only for readers who are looking for something both thought-
provoking and pleasurable." Key to the success of these collect-
ible albums was the fact that they never underestimated the
intelligence of their readers. Art directed to trigger a sense of
wonder, they systematically presented three parallel narratives
side by side—the main text, the captions, and the visuals—a
heady combo of food for thought, brain candies, and feasts for
the eye.

THE PANACHE OF DOO-DADS
CASE STUDY: Gail Anderson's Posters

Although it is not a professional term, the common "doo-dad" is essential for the art director and designer in steering the recipient through the maze of information, whether it is an advertisement, editorial spread or cover, book design, or any other form of designed visual communication.

But what exactly is a doo-dad? In typography it can be a swash (the curlicue appended to a letterform), a ligature (intersecting letterforms that create a single icon), a fleuron (decorative material used to ornament a typographic composition), or a dingbat (a graphic image that serves as an accent for a word or words). In general, doo-dads are those things that are not necessarily indispensable but are nonetheless necessary for injecting visual personality. A silhouetted photograph can be a doo-dad, just as an illustrative icon can do the mnemonic job. The doo-dad can be a tool—like an adjective in a sentence, it is used as a graphic signifier.

Gail Anderson, senior art director for SpotCo, New York, says: "I'm all about the wood-type bits and pieces. I love making those crunchy little objects into other things, like faces. Broadway's not looking for many decorative wood-type posters with bells and whistles (we couldn't do it for a Johnny Cash musical a few years ago, and if you can't do it for *that*…). Volume 8 of Aridi's disks has a great collection of Elvis Swift-style ornaments, and Design Elements has some really useful vector files, too. There are even some fleurons and swashes that you can get from YouWorkforThem. Nicely drawn, all vector. Heaven."

But Anderson notes, "Doo-dad-ery is not easy on the posters we do at SpotCo." More often than not, the ornamentation is peeled off little by little because there is a concern that consumers will get mesmerized or confused by the detailing and forget to buy tickets. Still, she is passionate about the look, feel, and dimension doo-dads provide. "Left to me, they'd play a role in almost everything. I'm always looking for that little visual wink or tiny gesture of extra care. I enjoy a fancy border, and I love detailed extras. I'd ask the designers I work with to put them on everything, if I could. Of course, it's not always appropriate and sometimes the more straightforward approach is more confident or what's called for. But any little bit of extra attention is always welcomed, and I just hope that the client won't ask for it to be removed."

Love has a lot to do in the doo-dad world: "I fall in love and I want to do the same thing over and over. In my head, it becomes part of the signature of what we do, and I have to fight my instinct to dig into my same old bag of tricks all the time. But I'd love for the institutional work we do to have more of those distinctive marks that are used only for those projects. I'm still working on that."

Nonetheless, a balance must be maintained between using and abusing the doo-dad: "It fails when it overwhelms the message, and gets in the way of the emotional promise of the poster. Of course, I can't cite a specific example, as I've systematically blocked them all out. For the most part, unless it's key to the overall idea of the poster and the show, it just ends up being more of a little vanity moment or a way to salvage a just-OK solution. I've had to cut back

◄ *SVA POSTER*, 2008
Designer: Gail Anderson
Writer: Jim McNicholas

on the decorating and go for the smarty-pants business more and more, and that's been a tremendous challenge. But ultimately, it's pretty rewarding when the bright idea jumps out at you more than the bonus items."

Doo-dads should sit in the background most of the time, or, as Anderson says, they should be "waiting for someone to ask them to dance. But if they're done right, they should be as much a part of the overall design as the image. They should be doing a foxtrot across the poster and it just isn't the same without them tearing up the floor."

But when should one (or more) be retired? "When I was at *Rolling Stone*, we started to use the >> (looks like two "greater than" signs) as a pointer, and I remember a designer at a competition-judging sort of rolling his eyes at the idea of using them. I guess they're some sort of foreign symbol, *not* pointers, and he seemed to feel we'd started another bad, ignorant-designer trend. He was probably right. It didn't occur to us that this symbol had an identity that most (smart) people were aware of. And clearly, I still don't know what >> actually stands for off the top of my head."

Anderson always thinks of that moment whenever she sees an asterisk employed as a doo-dad. "The fake pointers have probably seen better days at this stage, but I'm guessing it's time to let go of the asterisk on magazine covers. I remember loving them on *Wallpaper** covers years back, and then they popped up everywhere. But I can see their allure; they're pretty swell. I'd probably be adding them to my cover lines, too, if I was still doing magazines! They're perfect call-outs."

Some typefaces come with jewels, fleurons, dingbats, and other doo-dads, but the question of encumbering type is the elephant in the room. Still, Anderson admits, "I love when fonts come with lots of bonus items. The more, the better. However, you have to exercise restraint when decorating with all of those tasty morsels. You've got to make sure you add some custom touches to personalize the fonts you're cannibalizing. You absolutely have to go the extra mile, convert to outlines, and start tweaking. I love to examine fonts for the extras, and I appreciate every international dot, dash, and money symbol. My dear Jonathan Hoefler adds them all, and that makes him my very special friend."

◀ *NEW VINTAGE TYPE*, 2007
Steven Heller and Gail Anderson
Designer: Gail Anderson

▲ *BAREFOOT IN THE PARK*, 2006
 Art director: Gail Anderson
 Designers: Jessica Disbrow and Bo Lundberg

▲ *A CHRISTMAS CAROL*, 2006
 Art director: Gail Anderson
 Designer: Frank Gargiulo

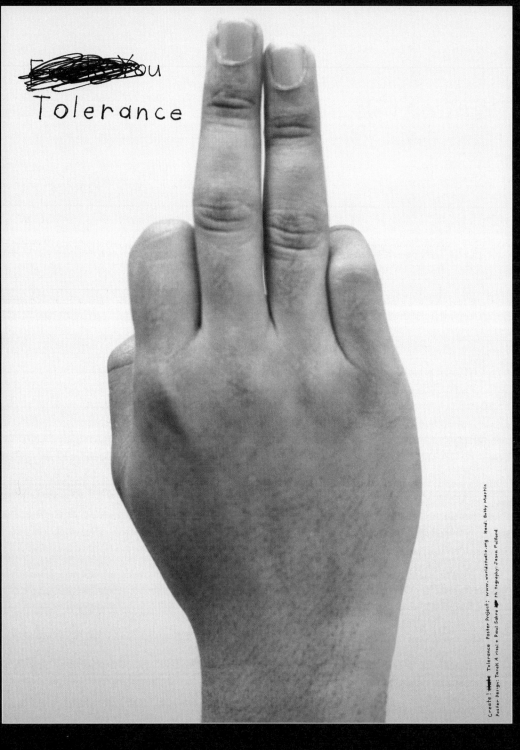

▲ *TOLERANCE*, 2002. Art Director: Paul Sahre; Designer: Tarek Atrissi; Client: Sphere/World Studio Foundation

THE IMPACT OF STRIKETHROUGHS

CASE STUDY: Paul Sahre's *Tolerance* Poster

Crossing out words is not the same thing as deleting them. While the "undo" option on the edit menu removes text without leaving a trace, the "strikethrough" effect gets readers involved, solicits their opinion, and engages in a dialogue with them. Striking a word out is always perceived as a dramatic action—it is a deliberate gesture that imparts a sense of urgency to the message.

Few graphic designers, however, use strikethroughs as a communication tool. Even though they don't hesitate to deface, mangle, mutilate, torture, or otherwise tamper with letterforms, they seldom get hold of a pen, a brush, or a magic marker to simply cross out words. The equivalent of typographical capital punishment, the crossing out of words makes some of us feel squeamish. An innate respect for print prevents graphic designers from shaming text publicly. If they did resolve to show their hand in this way, though, their layouts would acquire a temporal dimension. Visible corrections expose the soul-searching process that separates the imprinting of a word from its obliteration.

Paul Sahre is a rare art director who knows how to capitalize on the written and the "unwritten" word. A 2002 poster he did for World Studio Foundation (in collaboration with student Tarek Atrissi) is a simple demonstration of how effective a scribble can be when it obscures an important piece of information. To promote tolerance, Sahre tried to visualize how easy it might be to turn hate into acceptance. The most eye-catching element of his poster is a scratched-out "Fuck You" barely readable under a black scrawl, with, right under it, the word "Tolerance" carefully spelled out.

The image on the poster is a variation on "giving the finger." In place of the obscene hand gesture is a hand with not one but two erected fingers. Pressed against each other, the digits look like they are hugging, their closeness evoking the joint effort required to foster tolerance.

"Unwritten" messages are a Sahre trademark. He has crossed out, screened, masked, or erased more words than most during his career as an art director. He has obstructed the announcement for a lecture he delivered at Rutgers University, New Jersey, in 2004 and obscured the text advertising a talk he gave in a San Francisco in 2005—holding the posters to the light was the only way one could read what was written on them. For a New Orleans fundraising project he has immersed the name of the city in thick blue ink. For *Solid Gold*, a book on award-winning designs, he has buried the title under opaque gold blocks. And once he even had the audacity to cross out the name of one of his clients.

Sahre uses strikethroughs whimsically, choosing playful colors, textures, or shapes. Most designers, when they elect to cross words out, do so in order to express controversy or denounce injustice, and they invariably opt for black bars. For the cover of *The Design*

of Dissent, Milton Glaser and Mirko Ilic used two thick black bars to eradicate parts of the book's title. For a campaign expressing his outrage at the genocide in Darfur, Glaser lacerated the names of family members (brothers, aunts, nieces, husbands, etc.) with black slashes that looked as deadly as the murderous acts committed by terrorists in Africa. In France, Pierre Bernard also used black slashes effectively in a poster for Secours Populaire Français, an organization of volunteers that promotes human rights and social equality. In Switzerland, Marcus Kraft decried the hypocrisy of French law regarding immigration by crossing out a famous quote from the French constitution that promises "equality for all" with strips of black-and-white press photos documenting social uprisings. For a recent international students' poster contest on the theme of gender differences, two students decided to cross out every single word of their entry form, save for the word "WE"—the only word, they believed, that did justice to the topic. In all these examples the background images are not as memorable as the eradicated words themselves: relentless horizontal black lines that slice the page, sending a powerful message on their own.

Sometimes, though, strikethroughs can be upbeat. Deletion is not always a negative thing. In 1996, Pierre Bernard turned obliteration into a monumental street installation. On a huge white billboard covering the façade of the Pompidou Center in Paris (the building was under renovation), he listed in black capital letters the names and dates of all the exhibitions in the coming season. As soon as a particular exhibition was over, two professional mountaineers suspended on ropes painted red, blue, or yellow diagonal lines over each letter of the terminated show. The color, length, and position of each stripe was determined in advance for maximum impact and dynamism. Visually, the letters that had been struck out had a greater presence than the black letters. The resulting impression was festive, as if past exhibitions were still alive in the memory of visitors who'd had a chance to see them.

Diagonal lines do wonders across texts, but they work just as well across images. The illustration of Paul Sahre's cover for Killing the Buddha, a quirky biblical sequel by Jeff Sharlet and Peter Manseau, is a brilliant design solution. The title of the book appears only on the spine. On the front of the jacket a bright red "X" is applied on a photograph of a blue sky, its silhouette canceling out a fluffy white cloud. As is often the case when something is deliberately crossed out, what is beneath the cancelation mark is more intriguing than anything else on the cover.

◄ THE WAR WITHIN, 2008
Art Director: Paul Sahre
Photographer: William Philpott/Reuters
Client: New York Times

◄ KILLING THE BUDDHA:
A HERETIC'S BIBLE, 2004
Art director: Paul Sahre
Photographer: Jason Fulford
Client: Free Press

O.O.P.S.

◄ *SITTING IN MY OFFICE...*, 2005
Art Director: Paul Sahre
Client: AIGA San Francisco Chapter

Paul Sahre

◀ *HELLO RUTGERS*, 2004
Art Director: Paul Sahre
Client: Rutgers University

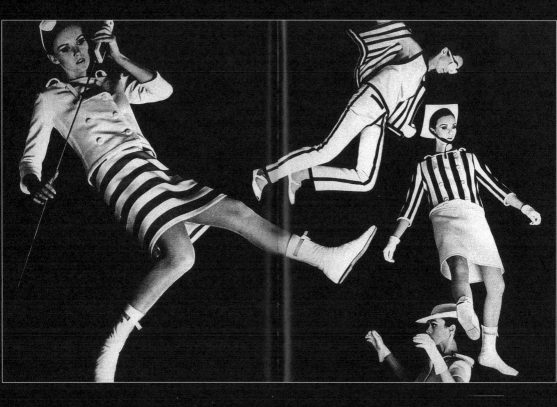

▲ **ELLE**, March 4, 1965, inside spread. Outfits: André Courrèges; Art Direction: Peter Knapp; Photographer: Peter Knapp

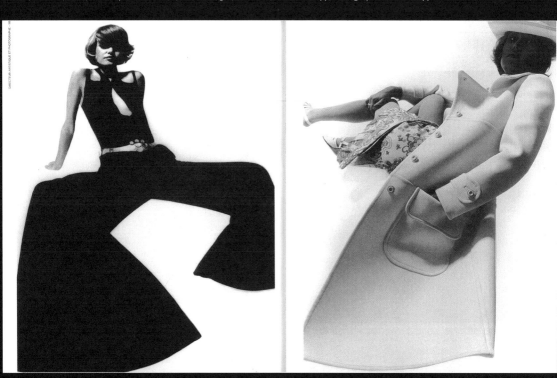

▲ **STERN**, 1980, inside spread. Outfits: Emanuel Ungaro; Photographer: Peter Knapp

THE POWER OF THE DIAGONAL
CASE STUDY: Peter Knapp's Courrèges spread, *ELLE* magazine, 1965

The cover of a magazine is a front door that opens into an interior world. As a reader, you are supposed to come in through this main entrance and proceed forward into the preordained environment of the magazine, each rectangular page suggesting a room, a niche, or a picture in its frame. The presence of a grid—implicit or explicit—reinforces the readability of this two-dimensional space.

To some this constructed universe is reassuring, while to others it is slightly oppressive. In fact, many of us prefer to ruffle through the pages of a magazine backward, behaving like intruders who slip into a house through a rear window. This desire to subvert the careful sequence of articles can be seen as an attempt to restore a sense of spontaneity to what might otherwise be a didactic and predictable exercise.

"Gutenberg's metal-type composition imposed a typographical grid that was made of horizontal and vertical lines at a perpendicular angle," says Peter Knapp, who, as art director of *ELLE* magazine in France in the 1960s, broke away from the rigid interiority of boxed-in pages with his memorable layouts set at weird angles. "I used diagonal motifs because I could, thanks to the photogravure printing process used at the magazine." In photogravure, typography is scanned as dots, like screened images. The result is a greater flexibility in the spatial relationship between words and images. Though trained in Switzerland at the famous Zurich Kunstgewerbeschule (School of Applied Arts), and well acquainted with the principles of the Bauhaus and the rigorous rules of traditional typography, Knapp understood the advantages of photogravure and was quick to capitalize

on them. One of his most famous spreads, a 1965 photographic collage of models wearing black-and-white Courrèges miniskirts, demonstrates what happens when diagonal lines crisscross inside a box. Exploding out of their rectilinear frame, the visual elements on the page looked as if they had been blown into outer space. Fittingly, the Courrèges spread was supposed to evoke a gravity-defying space walk. In their futuristic outfits, the models gave the impression of having escaped from the confinement of the layout.

Here they were, as unfettered as astronauts frolicking in the blue yonder.

Knapp made diagonal layouts his trademark. A photographer as well as an art director, he knew how to transform Dior, Saint Laurent, or Chanel

◀ *ELLE*, November 8, 1963, front cover
Art Direction: Peter Knapp
Photographer: Peter Knapp

couture frocks into abstract graphic forms that he could then splash across a spread. No longer turned inward, the pages of his fashion magazine began to look like big windows wide open onto the world. "From Paul Klee I learned that the upward diagonal line energizes a composition," says Knapp. "It's like waving a flag."

With full-bleed photographs of pretty girls bursting in every direction, *ELLE* was seemingly encouraging its readers to release their inhibitions. Though not a self-proclaimed feminist, its editor-in-chief, Hélène Gordon Lazareff, was a free spirit. Every Monday morning the weekly magazine would flaunt photographs of women as energetic, self-confident, and vibrant as she was. So powerful were these portraits of women leaping out of the frame that French women began to emulate the flair and panache of the models, convinced that an ability to jump and twirl like them was a sign of being "liberated."

In fact, under Lazareff's stewardship, *ELLE* was doing very little to promote women's emancipation. Only later, after 1972, with new editor Daisy de Galard, did the magazine embrace the women's movement. But as early as 1960 the design of its pages, with their oblique compositions, slanted figures, and triangular patterns, had made the magazine look a lot more progressive than it really was. No wonder. Unwittingly perhaps, Peter Knapp was borrowing the visual vocabulary of avant-garde artists such as El Lissitzky and Alexander Rodchenko, creating pages as strikingly radical as the propaganda posters and experimental collages of the Constructivist era.

Knapp was not a student of the Russian Revolution, though. His art directional sensibility, he says, had been formed by looking at the work of Alexey Brodovitch in *Harper's Bazaar*. When Knapp was just a child his mother received *Bazaar* on a regular basis, thanks to one of her aunts who lived in America. The young boy would pore over the Brodovitch layouts and absorb their aesthetics,

assuming that the vitality of their designs was an expression of American ingenuity. But the Russian-born Brodovitch was an émigré, deeply influenced by European vanguard movements. His sensibility had strong affinities with that of Russian Constructivists whose use of photography he had admired, even though he did not share their political views and anti-bourgeois stance.

Brodovitch owed a lot to Rodchenko in particular. Brodovitch's fashion layouts, featuring women on the move often photographed from below, had the same kind of edginess as Rodchenko's own photographs. But Rodchenko, who was famous for taking pictures at a steep angle, did so as a political act. His majestic photographs of factory workers and industrial buildings seen from unfamiliar perspectives were supposed to "reveal the unusual in something absolutely usual…express the innovations of the Socialist reality …and become the source of pride and happiness in the industrial-ization of the country of the Soviets." Mere propaganda? As far as we are concerned, Rodchenko's extreme photographs are simply the work of a brilliant artist. We interpret his angular covers for *LEF* or his posters with arrows zigzagging every which way as evidence of his astonishing creativity. Yet, whether or not we care to acknow-ledge it, these images, which fascinate us on their own merits, are characteristic of an era steeped in controversy.

Today, diagonal layouts are few and far apart. Graphic programs for desktop publishing and templates used by web designers favor compositions with vertical and horizontal lines meeting at a 90-degree angle. Breaking out of the digital box might prove as difficult as challenging the traditional rules of typesetting. But, to quote Rodchenko, the time may come again when "we will have to revolutionize our way of seeing"—a breakthrough that will require that once more "we remove from our eyes the habit of looking at things straight on."

La jeunesse du cuir

Cuir grand sport. Lisse. Brillant.
Noir toujours, éclaboussé
d'accessoires violents. Le blouson
court a un pli creux dans le
dos et une fermeture à pressions (295 F).
Le pantalon large à une découpe
au-dessus du genou (250 F).
Débardeur à larges rayures (49 F).
Pulls fins à col roulé (69 F). Gants en
laine unis (8 F) ou rayés (12 F).
Bottes cavalières (Daniel Hechter, 330 F).

Tous ces modèles et accessoires sont
en vente à Paris, au Printemps
Haussmann, au Printemps Nation, au
Printemps Party 2, ainsi que dans les
magasins dont vous trouverez
la liste page 142.

▲ *STYLE ELLE,* September 1971
Inside spread
Art Direction: Peter Knapp
Photographer: Peter Knapp

◄ *VOGUE,* 1967
Model: Rita Scherer
Art Director: Antoine Kieffer
Photographer: Peter Knapp

THE DIFFERENCE BETWEEN WHAT AND HOW
CASE STUDY: Rmn.fr Website, Designed By Vier5

"What on earth am I looking at?" we often wonder when navigating a commercial website for the first time. Before proceeding further, we need to answer this first question: What is it? Is this site conceived as a big menu, a game board, an obstacle course, a spider web, a map, a floor plan, a Möbius strip, a genealogy chart, or some other novel configuration whose form will soon be revealed?

Fueled by the growing quantity and complexity of information available to us today, *what*—as opposed to *how*—is turning out to be a gripping question. According to a recent study conducted for the Danish Authority for Enterprise and Construction, responding to global challenges now requires a *what* approach to problem solving. Design companies in particular seek answers to the question *"what is it?"*—"to find solutions to problems that have not yet been solved or which so far have been solved in an unsatisfactory way." Until now, answering the *what* question was a job for high-profile strategy consultants, whereas figuring out *how* to do something (a matter of simple tactics) was a task for experts, specialists—and design professionals.

But things are now changing fast. An increasing number of art directors in design studios and advertising agencies are waking up to the fact that there are many more opportunities if they can get involved earlier in the creative process, at the strategic rather than the tactical level. Vier5, a small design entity in Paris, has joined this "what" generation. "The *what* of a thing is very important for us," says Marco Fiedler, one of the partners. "We try to find the clearest answer to this simple question. We never stop short of it.

We push and push until we know for sure. Once we've got it, our design work becomes easy."

Fiedler and Achim Reichert, both formerly from Frankfurt, Germany, are getting assignments from museums and art galleries, designing posters, catalogs, signage, and websites. Their design for Rmn.fr, the site of the Réunion des Musées Nationaux, a French cultural organization set up to run museums' commercial enterprises, is a straightforward demonstration of what happens when *what*, not *how*, drives the design process. Minimalist and understated, the architecture of the Rmn.fr website is clearly visible at first glance, and surprisingly engaging too. Organized on a three-column grid, the information is delivered in one typeface only, a specially designed Courier letterform. Every line of type is practically the same size, with only a slight variation in weight or color. Far from being boring, the site, on the contrary, triggers a delightful sense of

WWW.RMN.FR, 2008 ▶
Art Direction: Vier5
Designers: Marco Fielder and Achim Reichert
Client: Réunion des Musées Nationaux

[Rmn] Acheter

http://www.rmn.fr/Acheter

Q▾ Google

Visiter

>Acheter
-un billet
-un Sésame
-un livre
 Un catalogue
 d'exposition
 Un guide de musée
 Un beau livre
 Un livre jeunesse
-un objet
-une image
-un produit
 multimédia
-le Petit Journal
 et les revues

Découvrir
l'histoire
de l'art

Mieux connaître
la Rmn

Professionnels

Jeunesse

Le saviez-vous ?
Recherche
Contacts
Lettre d'information
Les sites internet
Recrutement
Questions/Réponses
RSS
Plan du site
Mentions légales

Acheter > **un livre**

Catalogues d'exposition, beaux livres, guides de musée, livres jeunesse... Avec plus de 130 nouvelles publications chaque année, la Rmn vous invite à parcourir toute l'histoire de l'art en suivant l'actualité des plus belles manifestations culturelles et des plus importants musées. Découvrez notre sélection et retrouvez l'intégralité de l'offre en ligne sur boutiquesdemusees.fr !

Le triomphe de saint Thomas d'Aquin, Gozzoli Benozzo (dit), Benozzo di Lese di Sandro © Photo RMN - ©Hervé Lewandowski

Un catalogue d'exposition
>

Un guide de musée
>

Un beau livre
>

Un livre jeunesse
>

une image
>

un produit multimédia
>

le Petit Journal et les revues
>

Retrouvez notre offre d'ouvrages sur boutiquesdemusees.fr
>

Visitez l'exposition Marc Chagall, un peintre à la fenêtre
>

Visitez le musée de l'Orangerie
>

Consultez notre catalogue des moulages pour vos cadeaux d'affaires
>

Découvrez l'histoire de l'art par période
>

Consultez notre agenda

euphoria—one associated with clarity and understanding. "There is something positively magic when at long last you understand what something is all about," says Fiedler.

But plenty of soul-searching is involved before everyone agrees on *what* that thing is. For a poster promoting an exhibition of the work of conceptual media artist David Lamelas, the Vier5 team decided that the *what* solution was to promote the identity of the center for contemporary art that sponsored the show, not the work of the artist. Using a Lamelas film-still as a background image, they obscured it with so many graphic layers that only the faintest silhouette of a woman remained visible from the original image. "David was angry at first," explains Reichert, "but then he showed the poster to a friend. The guy told him that the design was fabulous because it gave the impression that Lamelas was a very very famous artist since it didn't bother to show any of his work." Satisfied, Lamelas approved the poster, reinforcing Fiedler and Reichert in their conviction that they had identified the correct answer to the *what* question.

One wonders though: were they correct, or were they just lucky? Finding the *what* involves some sort of luck. The FORA report acknowledges there is a phase in this particular design-solution discovery process that they call "pattern recognition," and which is "often referred to as the phase during which *magic happens.*" And what's that magic exactly? Dave Eggers's best-selling novel *What is the What: The Autobiography of Valentino Achak Deng* alludes to this mystery. It refers to an African creation myth in which God gives Man a choice between a happy life as a cattle rancher in Africa and "What"—but God refuses to define what that elusive "What" is. It's up to Man to figure it out. Those who choose to pursue this question must leave their ancestral Africa forever, the same way Adam and Eve had to leave the Garden of Eden.

Defining the *what* is not easy. It can be construed as either a spiritual or a materialistic pursuit. In our day and age, the *what* often turns out to be the "it" thing of the moment: the latest Vuitton bag, the Rolex watch worn by a movie star, or the state-of-the-art cellphone. Some of the most effective advertising campaigns ever devised by art directors capitalize on this deep-seated yearning, and present products as ultimate objects of desire. Bill Bernbach's "Think Small" advertising campaign established the Volkswagen Bug as the archetypal smart car, while Michel Roux's trendsetting Absolut Vodka campaign showcased the aptly named bottle as the *absolute* answer to sophistication. In these types of advertisement the goods are displayed by themselves, against a plain background, without models, styling, or visual context, as Holy Grail icons.

But for Fiedler and Reicher, *what* a thing is should never be confused with *how* it is represented. They believe that most of the stuff we look at falls under the "*This is not a pipe*" heading. Magritte would have agreed with them that an image of a poster is not a poster, the same way an image of a pipe is not a pipe. "After looking at a poster on a screen most of us assume that we have seen the real thing," they say. "But we are being deceived. That's why, when we design a poster, we show our clients a hard copy, on paper, in its actual size, posted on a wall, as it is meant to be seen."

And what happens when they design a website? "A website is not a decorative representation of a web of facts," they say. "We design websites to be seen plainly on a small screen, by someone sitting down 18 inches away, in such a way as to make information immediately intelligible and intelligent."

WWW.RMN.FR, 2008 ▶
Art Direction: Vier5
Designers: Marco Fielder and Achim Reichert
Client: Réunion des Musées Nationaux

Visiter

Acheter

Découvrir
l'histoire
de l'art

Mieux connaître
la Rmn

Professionnels

Jeunesse

Expositions, musées, activités, livres, objets, images...
La Rmn vous invite à partager l'actualité culturelle, à préparer
votre visite en découvrant ses services en ligne, et à entrer
dans l'histoire de l'art. Bienvenue.

>Visiter
-une exposition
maintenant
bientôt
en archives

-un musée
-agenda
-un catalogue
en ligne

Acheter

Découvrir
l'histoire
de l'art

Mieux connaître
la Rmn

Professionnels

Jeunesse

Recherche
Contacts
Lettre d'information
Les sites internet

Visiter > une exposition > **maintenant**

Marie-Antoinette a toujours fait l'objet
d'interprétations et de représentations
fantasmées. Personnage historique, son
portrait a souvent été brossé de façon
caricaturale. Du Palais de Schönbrunn à
Versailles, de Trianon à la Conciergerie,
l'exposition éclaire sous un nouveau jour
cette personnalité contrastée et fascinante,
à travers 300 œuvres venues de toutes
l'Europe. Une exposition évènement !

Marie-Antoinette

Galeries nationales du Grand Palais

15.03.08 - 30.06.08

Découvrir l'exposition /
Come visit the
exhibition !
>

Achetez votre
billet en ligne

Achetez le
catalogue de
l'exposition

Visiter

Acheter

Découvrir
l'histoire
de l'art

>Mieux connaître
la Rmn
-ses missions
et métiers
-ses partenaires
-devenir mécène
et partenaire
-rejoindre la Rmn
-contacter la Rmn

Professionnels

Jeunesse

Recherche
Contacts
Lettre d'information
Les sites internet
Recrutement
Questions/réponses

Exposer, éditer, diffuser, promouvoir,
valoriser, acquérir...
La Réunion des musées nationaux (Rmn)
contribue à l'enrichissement et à la
meilleure connaissance du patrimoine
culturel, en facilitant sa découverte par
tous les publics. La Rmn est un
établissement public à caractère industriel
et commercial (EPIC), placé sous la tutelle
du ministère de la Culture et de la
Communication.

Mieux connaître la Rmn

ses missions et métiers

>

ses partenaires

>

Visitez
l'exposition Marie-
Antoinette
>

Gagnez du temps
grâce au laissez-
passer des Galeries
nationales du Grand

Sésame

SECTION THREE:
AUTO
ART DIRECTION

AUTO ART DIRECTION

We asked ten art directors (and three illustrators*) to art direct themselves. Could they do it? Would they even want to try? Some art directors refused to be part of the experiment: they didn't want us to turn the tables on them. Others, on the contrary, welcomed this opportunity to hone their authorial skills, come up with quirky ideas, and boldly self-commission their own assignments.

The individuals who contributed visual essays to this book did not all call themselves "art directors." Some insisted they were a creative director, or graphic designer, or agency head, or illustrator. But, regardless of their job description, they all practiced the same craft: that of facilitating a highly sensitive creative process that involves lots of very talented people with big egos.

Each contributor explored what mattered most to him or her at the time. And because all of them cared so much, it was not quite as easy as they had expected at first. In fact, overcoming their misgivings turned out to be the main obstacle. Finding themselves in the position of many of the artists to whom they usually assign work, some of them even had trouble meeting their own self-appointed deadlines.

It all worked out in the end, and the result is a series of original pieces that are surprisingly sincere, insightful, and distinctive. Each narrative gives a glimpse of what it's like to practice art direction as a profession: how we learn it, how we practice it, what we love about it, what we hate about it, how we'd like it to evolve, and what makes it ultimately rewarding. The forms chosen by the art directors to tell their story include collages, reportages, manifestos, typographical exercises, photo essays, and comic strips.

* Christoph Niemann & Nicholas Blechman, Laurie Rosenwald, Ross MacDonald

THE TOPICS COVERED

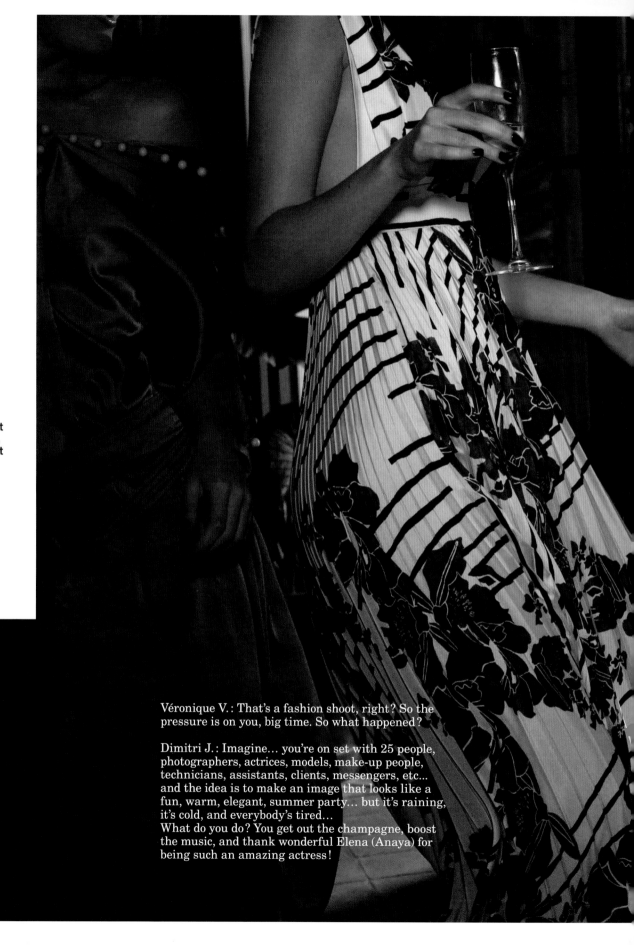

Base
& Loewe

Fashion

Dimitri Jeurissen,
creative director
Pierre Daras,
art director
Olga Perez,
production manager
Jenny Gage,
photographer
Tom Betterton,
photographer
Inge Grognard,
make-up artist
Peter Gray,
hair stylist
Mattias Karlsson,
stylist
John McCarthy,
stylist's assistant
Elena Anaya,
actress model
Olya Ivanisevic,
model
Liliane Ferrerezzi,
model
Kelly Rippy,
model
Hugo Sauzay,
model
Anna Bauer,
photographer's assistant
Jean-christophe Vincent,
photographer's assistant
John Andrew Engstrom,
digital assistant
Clara Valero,
Charles London,
producers
Dushan,
location scout

Art direction?
Gathering people.
Directing people.

Véronique V.: That's a fashion shoot, right? So the pressure is on you, big time. So what happened?

Dimitri J.: Imagine… you're on set with 25 people, photographers, actrices, models, make-up people, technicians, assistants, clients, messengers, etc… and the idea is to make an image that looks like a fun, warm, elegant, summer party… but it's raining, it's cold, and everybody's tired…
What do you do? You get out the champagne, boost the music, and thank wonderful Elena (Anaya) for being such an amazing actress!

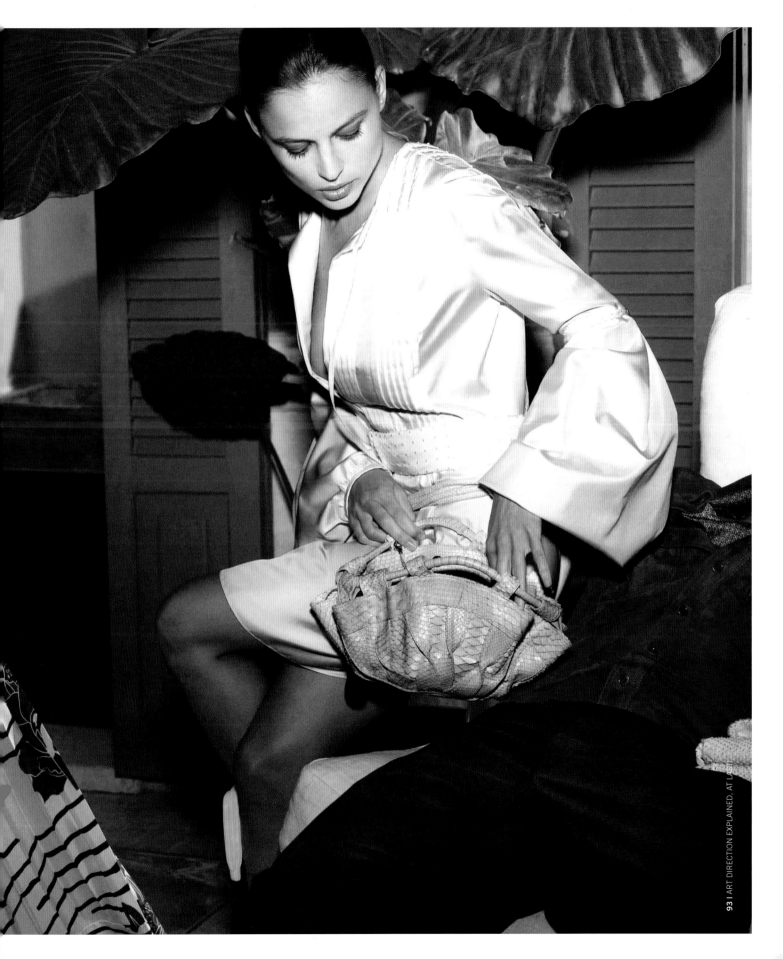

Base
& BozarShop

Museum shop

Dimitri Jeurissen,
creative director
Marc Panero,
creative director
Thierry Brunfaut,
creative director
Arno Baudin,
art director
Pierre Lefèvre,
manager
Pablo Lhoas,
Pierre Lhoas,
architects
Barbara Vanderwee,
architect
Geoff Cook,
consultant
Juliette Cavenaile,
producer
Jordi Prat,
consultant
Ramon Prat,
consultant
Paul Dujardin,
consultant
Leen Gysen,
consultant
Luc Dubrulle,
coordinator
Rebecca Cuglietta,
coordinator
Arno Baudin,
Gregory Decock,
designers
Tom Greenwood,
copywriter
Jean-Marc Joseph,
film director
Frédéric Lefèvre,
film-maker
Gregory Decock,
Jacques de Neuville,
Pierre Lefèvre,
Rebecca Cuglietta
models

Art direction?
Gathering people.
Directing people.

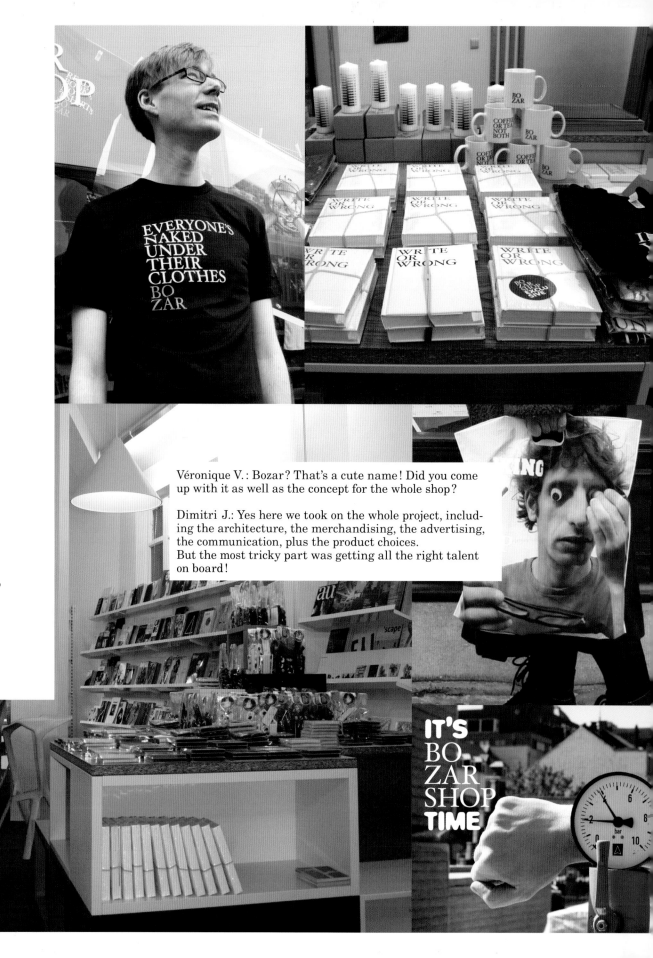

Véronique V.: Bozar? That's a cute name! Did you come up with it as well as the concept for the whole shop?

Dimitri J.: Yes here we took on the whole project, including the architecture, the merchandising, the advertising, the communication, plus the product choices.
But the most tricky part was getting all the right talent on board!

IT'S
BO
ZAR
SHOP
TIME

GIVE ME
FIVE
BO
ZAR
SHOP

BO
ZAR
SHOP
SMELLS
LIKE
CHRIST
MAS

IT'S NOT
SHOPPING
IT'S
BO
ZAR
SHOPING

COFFEE
OR TEA,
NOT
BOTH

Base
& Kendell Geers

Monograph

Kendell Geers,
artist
Dimitri Jeurissen,
creative director
Philippe Galowitch,
art director & design
Ela Bialkowska,
Jean-Christophe Hanché,
Lydie Nesvadba,
Stephen White,
photographers
Lopke Bom,
coordinator
Juliette Cavenaile,
producer
Javier Gorri,
printer
Lieven De Cauter,
Paulo Herkenhoff,
Rudi Laermans,
Christine Macel,
Warren Siebrits,
authors

Art direction?
Gathering people.
Directing people.

SP—
T—

Veronique Y.: Books and artists... not an easy combo!

Dimitri J.: And it's time consuming... but it's so mentally stimulating! A big part of art direction in this situation is a matter of organization... getting the right images, the right authors for the various chapters, the right plastic for the cover, etc... and through it all, you keep wondering whether you are making the right decisions.

Base
& Mobistar

Mobile phone operator

Thierry Brunfaut,
creative director
Dimitri Jeurissen,
art director
Martien Mulder,
photographer
Florian Moser,
photographer's assistant
Robert Cotte,
digital assistant
Nicholas Sirot,
Nathalie Devillers,
stylist & props stylist
Inge Grognard,
hair & make-up artist
Georges De zutter,
production
Olivier Van Clemput,
shoot manager & location
Alexandra Carrée,
casting director
Amaryllis Jacobs,
producer
Arno Baudin,
Fumi Congan,
Koen Malfait,
designers
Olivia Daver,
Gaël Ide,
Céline H.,
Ian Jeurissen,
Jasper Jeurissen,
Maurice Jeurissen,
Raphaël Lohier,
models

Art direction?
Gathering people.
Directing people.

Mobistar

☐ Flying?
☐ Landing?
☐ Breaking?

Work Play

Love

☐ Hamlet?
☐ Macbeth?
☐ Shrek?

Love

Work

Play

Mobistar

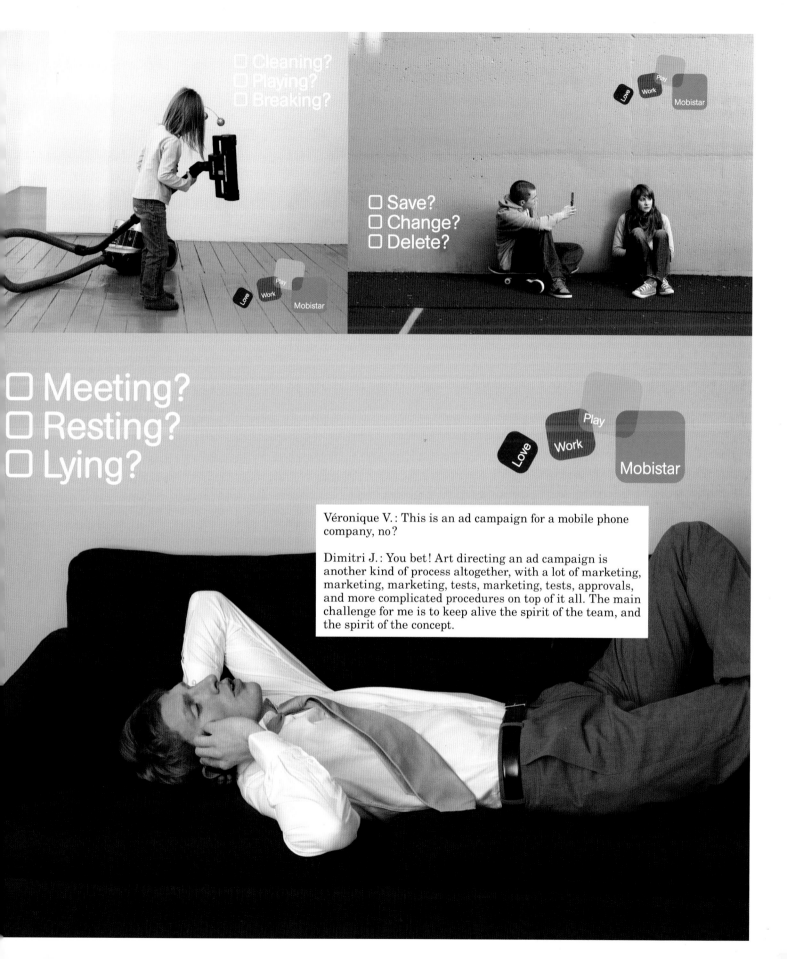

□ Cleaning?
□ Playing?
□ Breaking?

□ Save?
□ Change?
□ Delete?

□ Meeting?
□ Resting?
□ Lying?

Véronique V. : This is an ad campaign for a mobile phone company, no?

Dimitri J. : You bet! Art directing an ad campaign is another kind of process altogether, with a lot of marketing, marketing, marketing, tests, marketing, tests, approvals, and more complicated procedures on top of it all. The main challenge for me is to keep alive the spirit of the team, and the spirit of the concept.

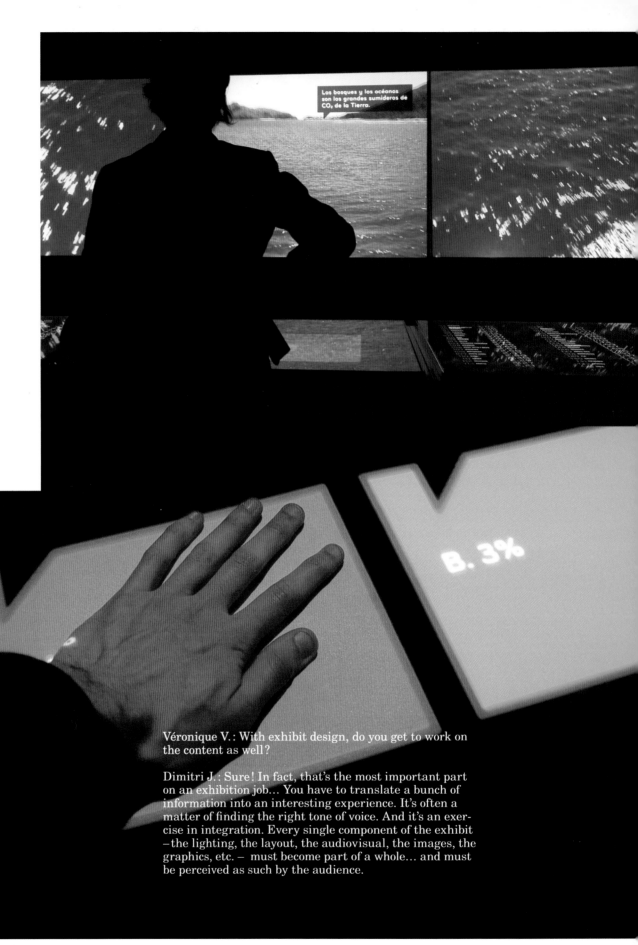

Base
& Exposición Cambio
Climático

Exhibition

ERF,
concept & script
Ramon Folch,
curator
Guri_Casajuana
architects,
architecture &
space design
Marc Panero,
art director
Aleix Artigal,
Hana Sedelmayer,
Alvaro Torrents,
Joao Machado,
graphic design &
illustrations
Irene Ferrer-Mayol,
coordinator
CSS Web Group
with collaboration of
Pandora Box TV,
interactive games
& programming
Mercuri, movies
Relluc, SL,
construction

Art direction?
Gathering people.
Directing people.

Véronique V.: With exhibit design, do you get to work on
the content as well?

Dimitri J.: Sure! In fact, that's the most important part
on an exhibition job... You have to translate a bunch of
information into an interesting experience. It's often a
matter of finding the right tone of voice. And it's an exer-
cise in integration. Every single component of the exhibit
–the lighting, the layout, the audiovisual, the images, the
graphics, etc. – must become part of a whole... and must
be perceived as such by the audience.

CAMBIO CLIMÁTICO
Preguntas

y respuestas

¿DÓNDE SE HABLA DE CAMBIO CLIMÁTICO?

¿Y TÚ, TE COMPROMETES?

¿QUÉ SON LOS GASES DE EFECTO INVERNADERO?

¿CÓMO PERCIBIMOS EL CAMBIO CLIMÁTICO?

¿QUIÉN HA CALENTADO LA TIERRA?

¿QUÉ ES EL PROTOCOLO DE KYOTO?

¿Y YO, QUÉ PUEDO HACER?

¿ES CIERTO QUE EL CLIMA CAMBIA?

¿TENDREMOS QUE DEJAR NUESTROS HOGARES?

¿EN QUÉ SE CONSUME MÁS ENERGÍA EN UN HOGAR?

THE ILLUSTRATOR'S GUIDE TO ART DIRECTION

Christoph Niemann & Nicholas Blechman

THE THREE MOST IMPORTANT PEOPLE TO AN ILLUSTRATOR ARE:

1. The Muse
She's easy. You close your eyes, she arrives, taps you on the head with her magic wand and *BLAM!* you have five terrific ideas. End of story.

2. The Coffee Guy
Most illustrators have a spiritual connection with their coffee guy at their local deli/diner/Starbucks. It's simple: you tip them well and they keep you alive.

3. The Art Director
They are small people who live in your telephone. They call to give you work. They call to say they have a small budget. And sometimes (and this is the worst scenario), they don't call you at all.

ONE OF THE BIGGEST sources for grief is when there is confusion over what the $%#& the art director wants. That's why it's important to look closer at the art director, to explore how they think, what makes them hire us, and why they are so annoying at times.

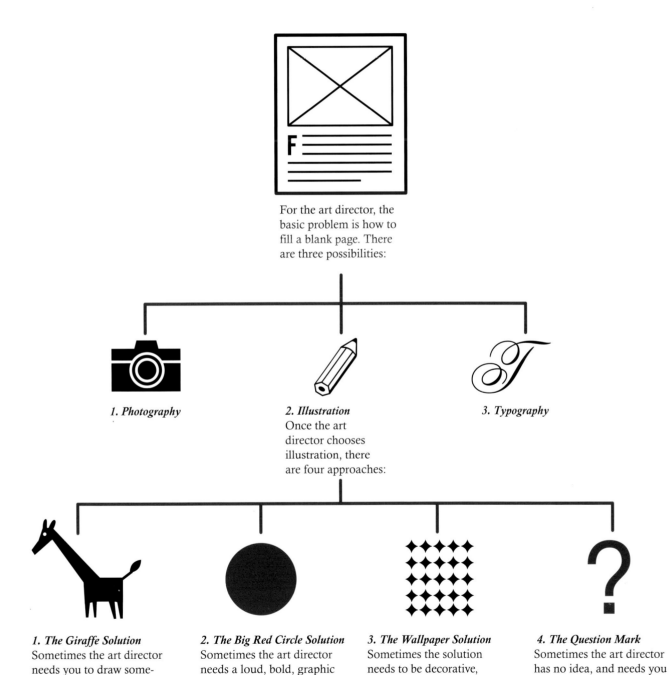

For the art director, the basic problem is how to fill a blank page. There are three possibilities:

1. Photography

2. Illustration
Once the art director chooses illustration, there are four approaches:

3. Typography

1. The Giraffe Solution
Sometimes the art director needs you to draw something specific, like a giraffe.

2. The Big Red Circle Solution
Sometimes the art director needs a loud, bold, graphic solution.

3. The Wallpaper Solution
Sometimes the solution needs to be decorative, like eye candy.

4. The Question Mark
Sometimes the art director has no idea, and needs you to provide the solution.

1. Superstar
These are the rock stars of the profession. They are hard to book, and usually a little more expensive, but they deliver amazing work.

2. Thinker
The conceptual illustrator can tackle any problem and deliver an intelligent solution for even the most abstract business article.

3. Old School
These are the pros. They may work in a slightly outdated style, but they are 100% reliable.

4. Copycat
Every field has its imitators, and sometimes you can't get the real thing, so you hire someone stylistically similar.

Who?
How do art directors decide who to use? There are eight species of illustrator.

5. Humorist
Some illustrators think like cartoonists. Often overlooked, wit is often essential to good illustration.

6. Caricaturist
Being able to draw a convincing portrait is a skill in and of itself. Not everyone is a caricaturist.

7. Specialist
Sometimes an art director needs a map, an icon, or some other specific illustration.

8. Student
It's important to take risks, and for that there is nothing better than a student fresh out of art school.

II. TALENT vs. TEMPER

WHY IS IT THAT SOME illustrators have a reputation for being difficult, but get lots of work, whereas some very nice people struggle for jobs? This chart shows that temperament, as well as talent, plays a role in the number of jobs one gets.

III. DINING OUT

FROM THE ART DIRECTOR'S perspective, choosing an illustrator is much like choosing a restaurant. Illustrators provide a service, just like a restaurant provides a certain cuisine, or ambiance. Here is a quick guide to what's out there:

ZAGAT'S OF ILLUSTRATION

Chez Monet

Food	Decor	Service	Cost
20	14	3	$$$$

■ Four-star French restaurant: you tolerate arrogant waiters but the food is superb *every single time*. You have to reserve in advance, dinner takes a few hours, and it blows your budget, but you leave satisfied.

Hip Ribs

Food	Decor	Service	Cost
15	20	2	$$$

■ Two-star, hip new bar: it will probably close in five years but right now it is really hot, and each time you call they say they are too busy. Music is too loud for conversation anyway, cash only...

Joe's Pub

Food	Decor	Service	Cost
12	8	20	$$

■ One-star, family joint around the corner: service is prompt, food may be a little boring yet it is very consistent, and the staff are VERY NICE. Specials tend to be the same, but quality is always good.

Easy Greasy

Food	Decor	Service	Cost
5	7	18	$

■ Unrated, 24-hour diner: the food is cheap and FAST. Staff don't care much but work hard, and are VERY reliable. Lots of clichés on its menu, but it DELIVERS!

IV. THE WILD WEST

ILLUSTRATORS ARE pioneers. They are cowboys with a vision of a better world. They are tough, they don't talk much, and are loners. An irresistible inner voice has called them to be out here, drink bad coffee, and draw funny little people with big noses. The journey isn't easy, and not everybody makes it. But if you are a fighter, and you can handle bad coffee, it's worth it. Here are the rules of the Wild West.

ILLUSTRATOR

1. You have to be extremely good at what you do in order to survive. Art directors usually hire you because they saw your extraordinary work, so you must be able to produce work of similar quality on demand.

2. If the situation requires it, you must be able to perform your skills even under the most challenging circumstances. Whether it's a changing size, a tight deadline, or bad art direction, you must always score.

3. DON'T WHINE! You won't die if somebody crops your art too tightly. So keep your despair for the big issues in life.

4. You must also be smart about anticipating disasters. Sometimes it it is better to run before it is too late.

ART DIRECTOR

WRONG!

5. Unfortunately a lot of us see the art director as their natural enemy. But this view is not accurate.

6. Art directors are your friends. Approach them carefully, as they may be more afraid of you than you are of them!

7. You must be aware though that no two art directors are alike. They all have their personalities and must be handled differently.

8. And, as we all know, they are not all equally good either. Whereas some lack the skills to be good art directors, some don't have the character to be helpful, while still others seem to be in the wrong profession altogether.

ART DIRECTOR

RIGHT!

9. To the illustrator, the art director is more like what the horse is to the cowboy.

10. Whether you like it or not, they simply are indispensable to move about in the Wild West.

11. Sometimes they need a little convincing ...

12. And sometimes they don't! Never forget, these are wild creatures, and you have to keep up your guard.

13. Cowboy without horse is like an illustrator without an art director.

14. With a good and trusted art director at your side you will go places and climb mountains that would otherwise have been utterly out of reach.

THE END

JJOO I NN
TT HH EE
HH OO RR JJT

I often question why I am such a demanding person and why I have such high expectations, especially of the people that I work with. I think it's because I really trust and believe in them. Openness, courage, respect, and passion are very important to me, and this is what I receive from them every day.

When I first receive a job, I read the brief to myself and then let it brew a little. Once that's done, I begin my initial reflection. This is a really important step for me, as every job is different. It's at this point that I decide how the job should be treated.

I compare the job to what already exists and to what we have already done. For example, was there learning gained from a previous project that I could take on board for the new project?
↳

Once I've gathered my thoughts and have a general scope on the whole project, I start to think about who I want to work with. Which HORT personality/ies best suits the job?

I really enjoy working with young designers. I know quite quickly who possesses which talent, and how that talent can strengthen the group. But of course, in saying this, working with young designers can also have its disadvantages. Young designers tend to switch off too early. They are easily satisfied with what they have done, and forget to step back and look at the project as a whole. Their fears get the better of them, which can block their train of thought. It's my job to motivate them, jump around, get behind their ideas, sing, dance, encourage them to reflect, to question, to view things from a different perspective.
↳

I believe it's important to open yourself toward the
process of working with other people. I don't consider
myself as "the boss" but rather as someone who makes
sure everything is on track. I think it's important as a
director to step back from a project and let things flow.
I only intervene when needed.

↳

Building a positive relationship with your client is a valuable thing. I want my clients to trust me. It allows you and your client not to be afraid of voicing opinions. The approval process is a lot easier when things are clear on both sides. In saying that, I've also been known to cause a little friction. Hey, what can I say, I'm a very emotional kind of guy. It's all in the name of fighting for your ideas.

I prefer presenting whole concepts, rather than previews or initial glimpses of a concept, to a client. There is a reason for this of course. Clients are less visually educated than designers and tend to take things literally. It's much easier to tell a story when you can see the whole picture, right? It also ensures, for both myself and the client, that whatever HORT creates in the end will speak for itself.

Presenting the beginnings of an idea often leads to the miscommunication of a concept. The clients have not been glancing over your shoulder during the process. They are unaware of how or why you've come to the solution presented. They can only make a judgment from what they see in front of them.

They are one step behind you. You have to hold their hand, step back to where they are, and guide them to the point where you currently are. This method often means more time, money, and work, but it's the only way to make a change.

The only way I have been able to maintain this method of working is by keeping HORT small, and not producing much money. I think this has made me more free to not accept jobs that I don't connect to.

Graphic design is a powerful tool. Like in life, designers should always be conscious of where every decision they make will eventually lead. Constant reflection is essential, and not putting yourself in front of the job is a must. Every job is a completely new situation and needs to be considered in a new way. There is no room for self-actualization, or giving your personal design profile a boost. It's about performing the task, learning from it and enjoying yourself in the process. I don't serve clichés and I'm against provoking. What's more important is what I am in favor of. Graphic designers have an educational objective. The role of a graphic designer is to inform people. Sometimes it's done more creatively, other times it's done in a way that makes information easier to understand. It's about communicating, and not telling lies.

I've always thought that quality work pays off in the end. But I have slowly begun to doubt this. Our clients more often than not demand optimization. They are the people that keep our industry alive, so we can hardly ignore their requests. This of course makes it more difficult to produce quality work. Deadlines get shorter, budgets smaller, living costs rise, and people become more anxious. This is no ideal premise for creative flourishing. Nevertheless, I am still here, still trying to develop the best visual solution, still ensuring that I fulfill the brief, and still have pride in what I do. Ich möchte, gemeinsam mit dem Kunden, gutes Grafik Design produzieren.

•

Where do I start? Where does it start and end? *It's my life.* I never knew that being a designer would lead to the role I have now. *My life.* I always knew that I wanted to make things better. I **love the daily challenge of the brief.** It gives me a massive high having to deliver solutions in what is normally not enough time or budget. **Working and growing a team with every new experience.** *It never gets any easier and in fact it can become relentless.* **You have to dig deep and quite often give every drop of life from your inner reserve.** Like most designers/art directors I never have one job going on at a time. *Dozens of projects at various*

Vince Frost
Thoughts From Sydney
January 2008

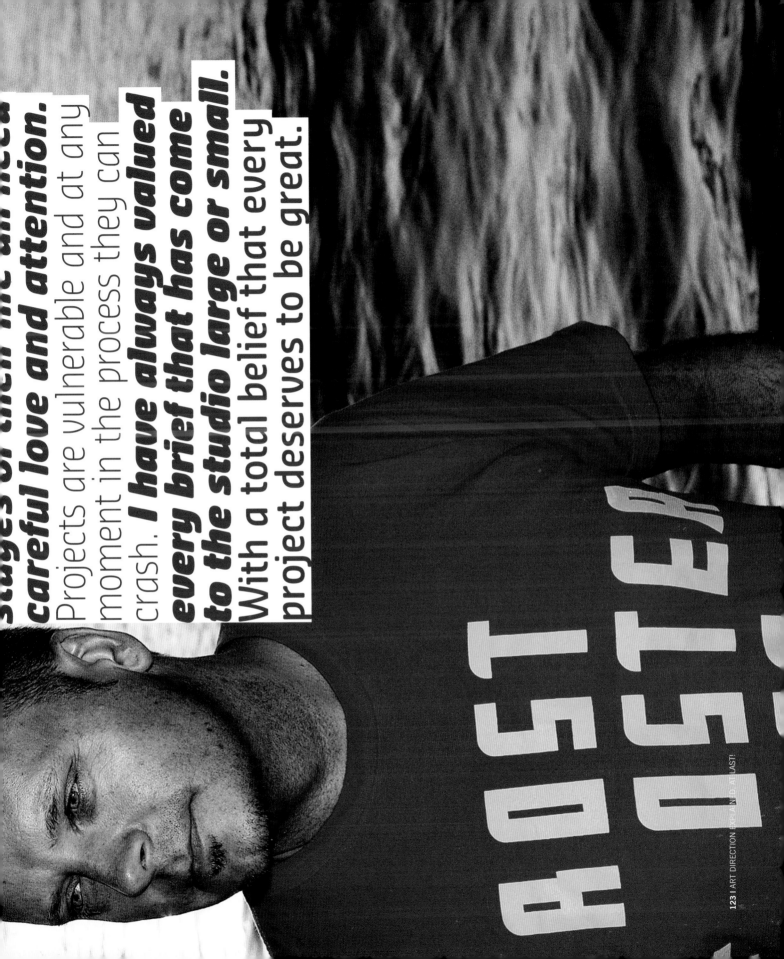

stages of their life and need careful love and attention. Projects are vulnerable and at any moment in the process they can crash. *I have always valued every brief that has come to the studio large or small.* With a total belief that every project deserves to be great.

Think laterally not literally, upsid

Let your brain fly through the maze and

The biggest and most original picture library

Visualize the scenarios in your mind. **Le**

person. This opens idea doors which ope

For years my life and career was base

rock bottom before I found the

pleasing the client it left me sick and

more relaxed way of working but

and therefore require a lot of effor

Listen. Listen **listen listen.** Don't talk

The clues are everywhere. **Any**

viewpoint that you know nothing

Sketch. Doodle over and over again

ideas book) **and fill it with ideas tha**

designing. Bit like automatic writing

freeform whatever it wants. **This ca**

that you could never plan.

own, back to front. In the dark.

he endless internal picture archive.

your head, forget Getty. *Just Imagine.*

t spin out of control like a crazy

pportunities to unique solutions.

n fear. *I had to almost die or hit*

ultimate solution. It worked, after

nackered. I have tried to find a

adly great ideas are hard to find

othing good in life comes easy.

ver your clients or your workmates.

new project starts from a

Sponge up every drop of information.

Keep a moleskin (snazzy Italian

op into your head. *Try automatic*

where you just let your hand write in

create interesting outcomes

Get to be
invisib

Collaborate. Collaborate with your clients. Bob Gill's comment "that all clients are assholes", makes me cringe. There is nothing further from the truth. In fact, I think that the designer or art director who thinks they are better than anyone else will not succeed in building relationships or a positive reputation. ***Never force ideas or solutions onto a client who instinctively feels uncomfortable with them.*** The reputation from each project and each person you come into contact with has a knock-on effect throughout your life and career.***Value it and grow with it.*** When I first started as a young designer I used to sulk and shut down if the client didn't like my ideas. That got me nowhere fast. I became closed and un-collaborative. *I now don't have to be the only person who has the final idea but it has taken me a few years to mature into that position.* **I would recommend getting there as early on in your career as possible.** Or you'll get the reputation of being an asshole. **People who think they are artists should be artists.** Art directors and designers are not artists, although just as creative. Our role is a service. ***We are paid to do a job and to find solutions.*** However the world is looking at every move you make, every dot and full stop. **Get used to being invisible.** *You love what you do passionately.* **You know every project you have worked on intimately.** Sadly the public couldn't give a toss or even think about the piece that you painstakingly created beyond face value. ***The first ever magazine which I created with every ounce of blood from my body came out one Saturday morning and within hours I saw it lying in streets, gutters and bins.*** Cast aside with no consideration for the life I gave up in the process.

Think big with every project you do. Wor

client's business is your company. Don't act as i

a favour. *Every single job large or small, fees c

potential.* **NEVER treat projects as if they**

butter'. If you get the job to design a company

at how the company wants to position itself. *It's*

layout or a print job it's the face, the aur

impression. Look at how the company conducts

potential that hasn't yet been realized. **Quite ofte**

to the brief is blatantly obvious to the

to the client, totally invisible. *Always thin*

user and their interaction with the piece you're

sign, magazine, whatever.

n it like your
ou are doing them
o fees has great
re 'bread and
usiness card look
ot simply a
nd often first
self, look for the
he solution
esigner but
bout the end
reating: website,

If you walk around with your eyes open and really see things, you wi
you are right now is amazing if you are open to seeing and really experiencing it. T
Don't get stuck on a computer. It's easy to sit there all day, day after day wit
physicality to your work, stuff that isn't already in there. *It's no longer just a tool fo*
and play, personal and professional, is greatly empowering on one hand and complet
off'. Shut off, feel and experience life with your whole body and not just your e
positive and opportunities will come your way. *Enter competitions all aroun*
what you know, be generous with your time. Be open to PR, this is a great vehic
community will never be your client. Most importantly love what you do. *Pla*
second you have on this earth and look after it. You are quite often responsi
Design a better world that truly helps people to have better lives without costing the earth.

alize that you don't have to travel anywhere to be inspired. Life where
ds of pictures every day and these will inspire you and end up getting used in your work.
e world coming to you through email, Google, and www. *Bring ideas and*
orking it's now everything. The fluidity and lack of divisions between work
ked on the other. **It's easy to drown in a new world where there is no 'shut**
d fingertips. *Clients and opportunities are everywhere.* **Keep open, keep**
world this will help people know that you exist. **Talk to colleges and teach students**
expanding your presence out there, beyond the design community. **The design**
ugh and feel it. **Make mistakes and be proud of them, learn from every**
specifying huge quantities of potential waste. ***Take care and tread lightly.***
u don't enjoy what you do, change careers.

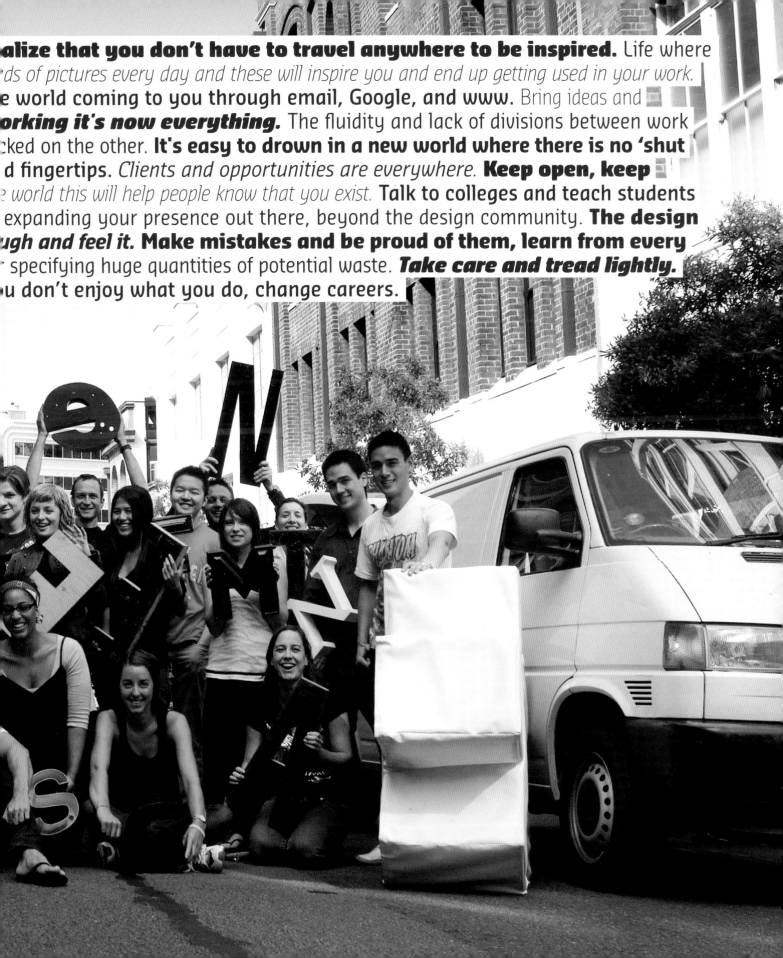

ONCE UPON A TIME...

BY JOHN FULBROOK III

THE COMPONENTS OF A NARRATIVE

1. A SETTING THAT IS DESCRIBED OR IMAGINED.

2. CHARACTERS WHO HAVE UNIQUE TRAITS, AND WHO CHANGE.

3. A PROBLEM THAT STARTS THE STORY MOVING.

4. THE DEVELOPMENT OF THE STORY / KEY EVENTS.

5. THE HEIGHT OF ACTION. (CLIMAX)

6. THE ENDING.

JF: A friend once taught me that occasionally in life there are opportunities to use work you love and show the designs nobody acknowledged. In these moments you can give life to worthy jackets that would otherwise go unnoticed. These jackets are examples of my work I love and nobody else does. I am happy to let them have a life here.

JF: I hate the idea of having to come up with ten pages about myself. The options are limitless. I know I could use it as ten pages of design masturbation but I will take the boring road and hope that it sheds some light on what I do. On the most basic level I consider myself a storyteller. I just happen to use graphic design to tell stories.

The Natural History of the Rich
Richard Conniff

A Field Guide

Douglas *Coupland*

a novel

ELEANOR RIGBY

AMY HEMPEL

STORIES

THE DOG OF THE MARRIAGE

JF: I have been lucky enough to work with so many talented designers on hundreds of great jackets. Here is a sample of five projects that I collaborated on with other designers. Sometimes I am the proper designer for a given project and I become art director and designer. As a true believer in hiring the right designers, photographers, and illustrators for projects, I chose to show the work of others.

The Setting: The majority of the plot takes place in a small office of an art department on the 12th floor of an old building in Rockefeller Center. This floor is boring and worn, with random walls painted in random colors to give the illusion of friendliness. The art department sits in an arbitrary corner of the winding maze of a floor and exists close to multiple bathrooms and a candy machine. Down the hall from the proper department suite is the last design office.

Here amidst tan file cabinets, mismatched furniture, a few posters, and a 20 dollar Ikea table is where our main character sits and works. The overhead lighting is fluorescent tubing and the carpet is blue, stained, and dull. Coffee cups cover the desk and a *New Yorker* cartoon hangs on the wall celebrating love for quiet evenings at home battling alcoholism. Above our main character's desk are shelves holding a mostly outdated design library and stacks of papers that contain sales tips and comparative titles for recently purchased books that have no jackets. A tiny white fan is humming and recirculating warm stale air. The hour is late.

Primary Characters (and their traits)

Rodrigo Corral: A steak-eating, fight-watching proprietor of his own company who creates fresh art, hits design home runs, and has an obsession with round objects.

Barbara deWilde: A freelancing dirty blonde classic beauty who has a great brain and the type to go with it.

Alan Dye: Tall, talented, and still wearing his high school wardrobe, this fruit company creative still freelances and loves anything classic.

Paul Sahre: When you look up integrity in the dictionary you will see a picture of this ground-breaking, high concept, foosball master who cuts his hair only once a year and runs his own studio.

James Victore: This truck-driving badass, poster-making, concept artist fights for his beliefs, can draw anything, and would kill me if I told the world what a bighearted sentimental guy he is.

From left to right: Q Road, original approved hardcover illustrations by Brian Rea; The Natural History of the Rich, killed design illustrations by John Pirman; Eleanor Rigby, killed design photograph by SOS Design; The Dog of the Marriage, approved hardcover photograph by William Wegman.

FIRE IN A CANEBRAKE BY LAURA WEXLER

The Problem: In the tradition of Melissa Fay Greene and her award-winning *Praying for Sheetrock,* debut author Laura Wexler tells the story of the Moore's Ford Lynching, which occurred in Walton County, Georgia in 1946—the last mass lynching in America, fully explored here for the first time.

Foreword: I learned by reading some of the text that this was a story about a writer's obsession with a very serious topic. I looked at *Praying for Sheetrock*, the main comparative title, and although I did not like the design of that jacket, it was clear to me that "a sense of place" might be the way to go. I needed a designer with an interest in history and a bit of an obsession with accuracy and detail as well as sensitivity to the delicate subject.

Key Event 1: I hired Paul Sahre. We discussed how we needed to focus on location because I thought nobody would buy a book with people hung on the front jacket. We researched the actual location of the lynching and the players involved. We found the actual photos were a bit bleak and might not be welcoming enough to a reader. We agreed that the actual location was just an ordinary dirt road in the South and such a location was the most universal launching point. Paul would now go and work on the jacket design.

Key Event 2: Paul had tried to use the real photograph of the location as he is a purist designer but I argued against it. He then started sending me sketches of trees and branches that suggested the creepiness of the location but with a bit more color and abstract beauty. He juxtaposed the images to harsh documentary typewriter type and labels. We discussed how typewriter type must appear at the correct size and gets weird when it gets larger. Paul added black boxes to some of the sketches to suggest the censorship of such a harsh subject in the news of the time. I liked how those boxes suggested menace and created

Top left: One of the comparative titles. Top right: Farmer Involved in Racial Murder in Walton County © Corbis. Bottom left: County Police Holding Rope as Evidence © Corbis. Bottom Right: Murder site © Corbis. Below: Two abstract design revisions.

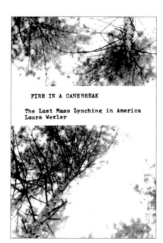

JF: One could really hate having to look at comparative titles when art directing a new book. I try and make it work for me. I often find a book that sold really well and had been designed by an artist I want to work with. I pitch the idea to my publisher by asking to use the designer of that best-selling title. This works well.

PS: I still have mixed feelings about this jacket design.

My main issue with it is the implication that the location depicted is "the" place where the lynching occurred. This isn't so. It is a very nice photograph by William Eggleston of a similar locale.

PS: After initially working with an authentic (and grainy) black-and-white file photograph we had, it was suggested that we find a way to bring some color onto the cover. After all, John reminded me, his publisher was publishing this book because it was an interesting and worthwhile subject, but also to sell books.

S: John and I had a number of discussions about this point, which is one of the reasons I like working with John, he is willing to have these types of discussions within a very bottom-line environment of a large publishing concern like Simon & Schuster. This is virtually unique in my experience with other cover art directors.

I eventually understood and agreed with his point and went about trying to find a way to work with images that would not suggest a specific location.

When this failed, our next thought was to commission a new photograph of the actual location, but by that time money and time ganged up on us, making that impossible.

JF: I think this might be the last Eggleston photo ever licensed for a book that is not about only photography. It is a constant effort to try and find great art that can be licensed for book covers; rights can be harder and harder to obtain when photographers or artists become famous.

PS: We ended up with one of my favorite covers and at the same time we ended up with a lie. One might argue that within the context in which this cover was created, we were able to create a cover that communicated something essential AND sellable, but I am not so sure.

curiosity for the reader as to what really happened there. Although I liked where we were going, I still felt they were too cold and forbidding and I pushed Paul to go further and try and really capture "everyman's South." He argued with me as that might take away from the real location and facts of the book, and I argued back that I needed to sell a few copies.

Key Event 3: Paul sent me several color photos of the South that were everyday streets anything could happen on and I was on board. He then tried some of the labeling we had done before but he wanted more tension. Ultimately he sent me a version where the type was set in actual cutouts of the photos . The photo was a William Eggleston, the type was dynamic, the jacket was colorful, and I was ready to show it at a meeting.

Climax: I presented the jacket to my publishers and discussed our long process. I also argued that the jacket art was an amazing photo. I met some resistance but when I showed some of the real lynching photos it was clear how much more commercial our package was. After that, the jacket design was approved with ease. Paul and I had built a solid case that was hard to dispute.

Ending: Paul used an authentic photo from the story on the spine to give the package a bit more reality and we were both happy with the cover. However, I must state for the record that even after approval Paul continually argued with me about the jacket not being accurate enough and how he wanted to go back to those real photos. I stood my ground and told him it was a great cover and that we should celebrate getting it approved! But it was exactly his obsessive nature that made Paul the perfect hire for this jacket.

Left: A type option on the final photo. Right: Imagine other Southern roads that we couldn't clear rights to for this article. Below: Final design.

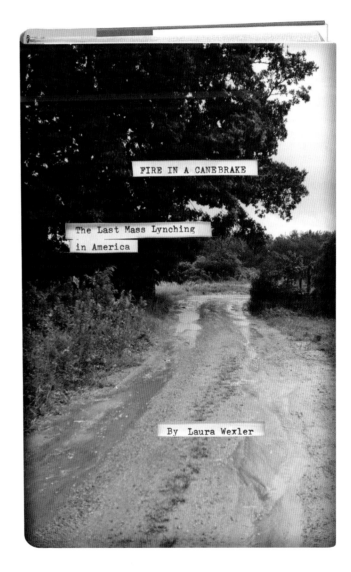

THE SECRETS OF HAPPINESS BY RICHARD SCHOCH

The Problem: A premier British historian consults with history's finest minds as he leads readers on a richly fulfilling, millennia-spanning quest to illuminate the path to happiness.

Foreword: My first take on a book like this is that it needs to be giftable. It will be a small book and lend itself to being a present and a book you keep around and refer to time and again. It requires a smart, simple solution and more of a package then just a front jacket. I needed a designer with a good head, packaging experience, and the range to make something giftworthy.

Key Event 1: I hired Alan Dye to design this jacket. He was working as a creative at Kate Spade at the time and I thought his experience in the retail fashion market would be the perfect combo for this great little project. I also consider Alan to be a happy guy in a world of many jaded cranky designers. I told him that I wanted something smart and not super-obvious and that the jacket needed to be classic.

Key Event 2: Alan sent me three variations. They were all minimal and attractive. I liked the idea of the smile-only version. However, I knew that the "no title on the cover" angle was not going to work. I told Alan I liked the black background a lot and thought it was counterintuitive to the title and made it seem like a serious book about happiness. Moreover, it gave it a feeling of authority and permanence that would stand out on the bookshelf. I requested a revision that would have the strong graphic impact of the smile in conjunction with the strong label type of his first direction. I felt these requests were both reasonable and worth seeing.

The first two of three sketches sent to me by the designer. Below: The third sketch and the spine to go with it. All illustrations by Alan Dye.

JF: The kind of work a designer is doing often influences his overall style. I can't help but notice the similarity between this jacket design color and "Kate Spade" green. Alan was working for Kate Spade at the time I assigned this jacket and it is only in retrospect that I can make the connection.

AD: Whether I like it or not, my process tends to remain the same. Ultimately, I have to make a lot of (often times terrible) work until something good happens. This project was no different. While I sure was in love with the "smile only" version (what can I say, I'm a designer—I can't help myself), I feel like the final selected version worked quite well and—most importantly— we had a lot of fun making it.

Key Event 3: Alan sent me two revisions. I loved the arrow and thought it was similar to the smile, yet fresher and less expected. I made him comp one up on a bookbinding board as we both thought it would be great to break form and not do a conventional four-color printed jacket. We wanted to make it a black cloth case with a foil stamping with the white label glued on, to give the cover a tactile quality and keep going down the gift package road. I was happy with both directions and the comp and proceeded to take them into a jacket meeting.

Climax: I presented the jackets and argued for the arrow direction as my favorite. Although my opinion was respected I lost the fight and had to go with the star burst as the arrow seemed too businesslike to my publishing team and a bit colder than the gold star. This is the time when I need to step back and look at the overall product and its merits. My publisher was willing to approve the jacket but not the version I really wanted. I think the publisher's cover choice was strong, and maintained a lot of my initial desires for it, as well as having integrity and class. I am a big-picture kind of person and let it end, here, with a compromise. Alan was happy and it was all, of course, about happiness.

Ending: Budgets would not allow us to produce the cloth-over-board case we wanted so we had to "fake it." We used a photo of cloth and a dual lamination to achieve a tactile effect, yet we were allowed a foil stamp to create the case look and it turned out strong.

JF: I still like the arrow best and wonder if it would have made a difference in sales. I read recently in a *Publisher's Weekly* survey that the jacket design of any given book is the least effective sales tool when compared with publicity and other marketing tools.

Above: First revision.
Below: Second revision and final jacket.

FIRST BIG CRUSH BY ERIC ARNOLD

Left and below: First two rough sketches. Bottom: Revision with proper color grapes and subtitle.

The Problem: A budding and hilarious young writer—now an editor at *Wine Spectator*—spends a year working at a vineyard in New Zealand and writing about it.

Foreword: The words I remember most from this author are "Vineyard work sucks!" This book was irreverent, funny, and not your normal boring wine story. I needed a designer who loved wine and had a good sense of humor. Moreover, the designer had to think differently than the average book jacket designer as this art needed to stand out in an almost iconic way.

Key Event 1: I hired James Victore. He was perfect for this job. I discussed my thoughts with him and told him to have fun with it.

Key Event 2: James sent me two directions. I loved the foot crushing the grapes idea! I felt it was playful, fresh, and like a mini poster. We discussed how green grapes were more appropriate to the story, and I asked him to revise the foot a bit and add the subtitle.

Key Event 3: James sent me the revision, it was just perfect and I mounted that and the original blue sky sketch and presented them at a meeting. I usually try and bring at least two comps into a jacket meeting. It is easier to defend and fight for one but allow the publisher to feel she has more involvement and choice. Occasionally I will bring something bad in as a diversion; then that comp is the one everyone hates right away. Selling good design, unfortunately, requires some strategy and planning.

JV: I was very attached to the photographic treatment of one of the first sketches. The story showed an aspect of winemaking that was honest, funny, and nerve-wrackingly scary. I thought our photo had the quirky and surreal quality the book had. But, alas and alack, it was not meant to be.

As a rule, I try to stay away from hand-drawn type and/or images. But sometimes it just makes sense and adds the humorous and daft quality the subject calls for.

JF: I just learned a designer named Anthony Jagoda worked on the sketches with James. Thank you, Anthony!

JF: James, in my mind, is a big-picture thinker. He makes bold and strong brush strokes as a designer and is not the type to fuss about style details on a first round. I am glad I know his work as I could easily critique him about things like him not adding the subtitle or the first foot he drew being a bit weird. But I know that the details will all work out if we agree on a great idea. It is very important to know designers and their process well.

JV: I especially love the grapes—we labored over the grapes. Anthony labored over the grapes. I watched.

Climax: I presented the jackets and got the foot version approved in-house. I then proceeded to send it to the author who was on board with the idea but really concerned that it did not say "New Zealand."

Key Event 4 (anti-climactic): I asked James to add a bit of New Zealand (whatever that means) and we tried to include various maps in different places to no avail. Days pass. Finally, James came up with using kiwis on the spine and we changed the subtitle to reflect the location (Down Under) and everyone was agreed.

Ending: Even though the jacket was approved by all involved, from the publisher to the author, there is always time for more opinions. From bookstore buyers to sales associates, there are often more opinions that I try to fight off in order to keep the jacket as pure as I can. Ultimately, I lost a battle and a quote was added at the last minute to this fun hardcover. I hate quotes on hardcover! Quotes are for paperbacks. This rule of thumb is industry standard, but seems to be broken more and more these days in an effort to sell more books in an overpublished world. In protest I refuse to show the cover with the quote. If you want to see that version go buy it!

JF: This key event is the point where I feel like I am micro-managing the designer and making too many tiny changes.

JV: Kiwis? The shape of New Zealand? Huh? At some point during some jobs, the lilting and mellifluous voice of subtlety is smacked to and fro by the heavy hand of "Make it Bigger." In our case it was the cry of, "Will they know it's New Zealand?" Yikes.

Above: One of the "New Zealand" revisions and spine with kiwis. Below: The final jacket with no quote and the kiwi we used on the spine.

THE WIFE BY MEG WOLITZER

The Problem: A witty, intelligent, and provocative story about the evolution of marriage—the nature of partnership, the difference between male and female sensibility, and the place for an ambitious woman in a man's world.

Foreword: I wanted something really smart. This jacket design needed to have many layers to it in order to capture the wit of the manuscript. I had a hunch that an all-typography solution was the best way to go to make this look neither feminine nor masculine.

Key Event 1: I hired Barbara deWilde. I think Barbara is very witty and a really good reader of books like *The Wife*. Moreover, I always thought her all-type covers were strong, and after her redesign of *Martha Stewart Living* I was convinced she was a brilliant typographer. I asked her for a cover that straddled the line of male/female, was smart, funny, and iconic.

Key Event 2: Barbara sent me only one sketch. Perfect. I remember my conversation with her. She called after emailing it to me and I picked up the phone and said something like this in a coffee-driven rant: "I got it, I got it, M, W, man, women, Meg, Wolitzer, Knees, and the dingbat, I get it, it's lips, it's an open book, it's red, strong, memorable, thank you! Bye." She still makes fun of me.

Climax: I showed the jacket and raved about it. It met with instant approval. Nobody could deny the wit of the design.

Ending: The book sold well, and we even tried to design a sister for it on the next Wolitzer book called *The Position*. I worked with Barbara again and we looked at a few designs this time and eventually nailed it. Or so I thought. Commercial pressure was against the witty cover and they wanted the cliché human element on it instead. Barbara's great sequel was killed. However, I am thrilled to show it here and give it a small life in this design book.

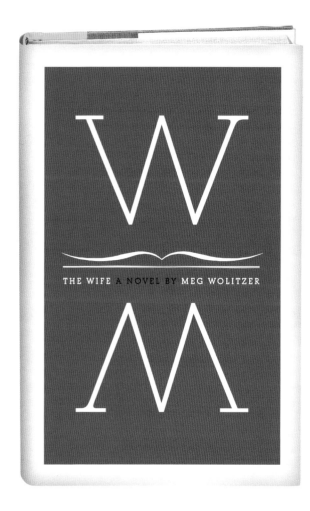

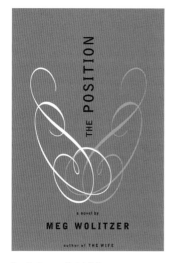

Top: Final approved jacket. Bottom: Presented and killed jacket idea for the next book by Meg Wolitzer.

JF: I think all-type jackets are some of the hardest to execute. People think they are easy because you don't have to find an image or illustration, etc. I trust very few freelancers with this category of design.

BdW: Wolitzer's next novel involved characters who author an explicit book on adult sexuality. The challenge was to make some coital typography and then sell it. The hardest thing an art director has to do is to sell someone else's work and I think John is a master of this. He is overwhelmingly enthusiastic about design and if he can't persuade his crowd, no one can. Though this jacket never saw the light of day, I feel like we solved it, and it's the sexiest type design I've ever done that didn't use multiple x's

HIM HER HIM AGAIN THE END OF HIM BY PATRICIA MARX

The Problem: A funny novel about a single woman's unhealthy relationship and protracted obsession with her first boyfriend by a humor writer for the *New Yorker*.

Foreword: There are books that require one to read the entire manuscript for a specific moment to use on the cover. There are books that are about specific topics and require a photograph of that subject. And then there are books that are all about the overall humor and feeling of the story. This type requires one to take a leap of faith, abandon specifics, and go for a home-run cover. Marx's story needed a hit and I needed an iconic best-selling jacket.

Key Event 1: I hired Rodrigo Corral. I have worked with Rodrigo for years. Sometimes he can overshoot, or go for something too bold, or push the envelope too far. However, when Rodrigo hits the mark, like he did for this jacket, I think he knocks it out of the park.

Key Event 2: Working closely with designers allows me to save a lot of time by going through fewer rounds. Rodrigo and I speak all the time about a project and can move quickly through the sketch phase. He sent me three roughs for this jacket rather quickly. We discussed how the knife was really the one that popped and although the others had merit we should concentrate on the big look of the yellow jacket.

Climax: I showed the directions and argued for the yellow one. I met with some resistance and offered to try another color. Rodrigo was amenable and changed it to orange. Approved.

Ending: You can see the quote on the bottom of the hardcover image. I fought this but I lost the battle and Rodrigo was a true professional and added it. The book sold well and the paperback allowed us to push the design even further. If you want to see it go to Barnes & Noble.

Original three sketches with illustrations by Tamara Shopsin.

HIM HER HIM *Again* THE END *of* HIM

PATRICIA MARX

"I laughed at its audacity, and cried that I didn't write it."
— STEVE MARTIN, AUTHOR OF *SHOPGIRL*

Sylvia Tournerie
Gilles Poplin

02 is the name of a French contemporary art criticism
quarterly, launched in 1997, and distributed for free.
For 12 issues, from 2004 to 2006, Sylvia Tournerie and Gilles Poplin
art directed the magazine and created 12 original typefaces
for it, one for each new issue.

n°30
Original font type Balboa bold
Upper case only

... HOW SHOULD WE APPROACH THE ART DIRECTION OF A MAGAZINE ABOUT CONTEMPORARY ART, WE WONDERED?

IT SOON BECAME CLEAR THAT WE COULD INTRODUCE A STRONG TYPOGRAPHICAL POINT OF VIEW,

BUT THAT WE SHOULD LEAVE THE VISUALS ALONE IN ORDER NOT TO INTERFERE WITH THE CONTEMPORARY ART DISCOURSE.

n°36
Original font type Contrat thin and Contrat black
Upper and lower case

... to give the magazine its
distinctive character, we exploited
the contrast
between the
exacting
layout and
the wild
letterforms.

TOBY PATERSON

L'architecture par l'oblique

Par Pierre Tillet

RETRO ENGINEE RING

STRUCTURES PRIMAIRES

VINCENT LAMOUROUX
Cubes et fragments

GUILLAUME LEBLON

78 DOSSIER **JOHN BALDESSARI**

ou comment faire de l'art conceptuel avec ses doigts

STRI TAT PRIr C&O

40. 2MANYBOOK

ART NOU

n°34
Original font type Copland
Upper case only

... THE CHOICE OF TYPEFACE, WE FELT, WAS THE ONE AND ONLY GRAPHIC EXPRESSION THAT WOULD NOT COMPETE WITH WHAT **THE AUTHORS, THE ARTISTS & THE CRITICS** HAD TO SAY

n°37
Original font type Helfin
Upper and lower case

... Were we inspired by the visuals?
That was not the point. In fact, we ignored
the images as far as the layout was concerned.
Our grid forced us to respect the integrity
of the visuals.

The cover was the
only place where
words and images
were allowed
to influence each
other...

.DOSSIER

LE CURATOR

50. JPS DAVID ALTMEJD THE BUILDERS

50. JPS DAVID AL THE BUI

Par Judicaël Lavrador

...s côtés des plates-formes, c'est qu...
...ts foutraques san...

24.DOSSIER 20.INVENTIER CHARPENTIER

O2#35

n°32
Original font type Apollo One
Upper and lower case

...BY RESTRICTING THE POSITION OF THE HEADLINES ON THE LAYOUT,

we limited our freedom, voluntarily distancing ourselves from the other contributors. Yet, this rigor brought all the elements on the page together.

16

Notes on Life as a Museum Art Director

Tim Hossler

I studied architecture at Kansas State University, moved to New York City, worked in several design offices, freelanced, became Annie Leibovitz's in-house art director, attended Cranbrook Academy of Art, became design director at MASS MoCA, and finally, moved to Miami to become the art director at The Wolfsonian–FIU. I also teach.

2 FROM ARCHITECTURE TO POSTCARDS

My background includes design, architecture, and photography. Working as an in-house museum art director utilizes all of these experiences: architecture, exhibition design, book design, event branding, organizational branding, web direction, and advertising. I also design posters, postcards, newsletters, brochures, invitations, store products, presentation graphics, and way-finding elements. My work directs the visual look of the museum.

1 IT HELPS TO LIKE MUSEUMS

Maybe it was inevitable living in a tourist trap town to become interested in tourist destinations. I grew up in the famous Wild West town of Dodge City, Kansas … of *Gunsmoke*, Wyatt Earp, and "get the hell out of Dodge" fame. The local tourist attraction was Boot Hill Museum, complete with a junkie gift shop and gunfight reenactments. At some point the "museum" underwent a renovation to become an education center with nice displays, lengthy descriptions, and historic artifacts. I was proud to be from Kansas.

1 POSTCARD for an exhibition of Cranbrook student work in Berlin (never produced) 2 DEGREE SHOW GRAPHICS for Cranbrook Class of 2005 3 ACADEMY NEWSLETTER (never produced) 4 GRAD BOOK for Cranbrook Class of 2005 (designed with Jess Morphew) 5+6 LECTURE POSTERS for Tom Wedell + Nancy Skolos and Ruth Ansel 7 SERIOUS MOONLIGHT GALA INVITATION 8 MOVIE POSTER for Found Film Festival 9 ADVERTISING GRAPHIC (never produced) next page 10 CRANBROOK LOOK BOOK (never produced) 11 WEBSITE (never produced)

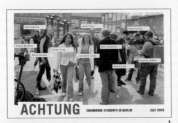

1

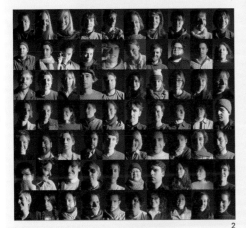

2

3

4

RUTH ANSEL
VISITS CRANBROOK APRIL 28 AND 29

2D

TOM wedell AND NANCY skolos
VISIT CRANBROOK MARCH 24 AND 25

2D

5+6

SERIOUS
MOONLIGHT
ON THE GROUNDS OF CRANBROOK ART MUSEUM

EARLY ARTS Saturday, July 16, 2005
6:30 pm Patron Party 8:00 pm until midnight Main Event
silent auction throughout the evening

CRANBROOK Knoll

7

▼ Preview

Name: FOUND FILM FESTIVAL
Kind: QuickTime Movie
Size: Really Big
Show: Wednesday 11/17/04
Place:
Time: 8:30 PM
Duration: 01:27:46

8

3 ONE BIG BRAND ...
MANY LITTLE BRANDS

I think I remember hearing Tibor
Kalman suggest "choose a typeface
and use it" as a guide for corporate
identity. When I began my graduate
studies at Cranbrook, I daringly
proclaimed that I would use a
single typeface. For two years I
only used Trade Gothic. With some
exceptions I've used the same "one
typeface" idea as a design strategy
for giving the museums I've worked
with an overall look. Most museum
graphics involve creating brand
IDs for events or shows and then
applying those brands to posters,
emails, invitations, and other
collateral materials.

CRANBROOK
ACADEMY OF ART
WHERE CHARLES
MET RAY

9

153 I ART DIRECTION EXPLAINED. AT LAST!

4 MANY PROJECTS FIZZLE

As in other design fields, many museum projects are conceptualized but only a few are completed. After my graduate studies, Cranbrook asked me to help them rebrand the academy and art museum. Like many projects that seem great and marvelous at the beginning, the Cranbrook project fell apart for many reasons, leaving most of the work in the initial phases.

5 CONTENT MEANS SOMETHING

The gallery at Wayne State University in Detroit needed a small booklet for the opening of a metalsmithing show, *Proximity, The Sensory and Displacement*. My research for a project begins with the content of the show where I look for an interesting foundation for the project. The work to be displayed in the metalsmithing show was an eclectic mix that provided no outstanding design directions. The title of the show however proved the most interesting. I liked the idea of displacing everything—starting with individual layouts for each artist that I slid off the page onto the next spread. That very basic idea carried easily through on all of the other materials for the exhibition.

10

12

11

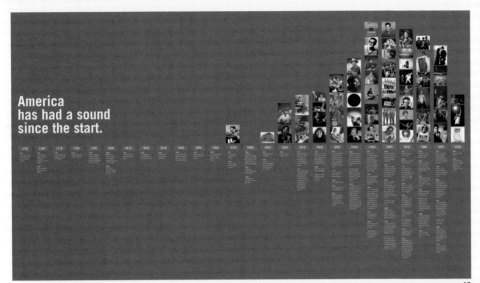

America
has had a sound
since the start.

13

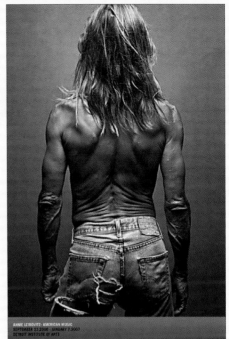

ANNIE LEIBOVITZ: AMERICAN MUSIC
SEPTEMBER 23 2006 · JANUARY 7 2007
DETROIT INSTITUTE OF ARTS

16

14

ANNIE LEIBOVITZ
AMERICAN MUSIC

17

6 BEING A CONSULTANT CAN BE MORE FUN

Not all of the museums I've worked with are small. The Detroit Institute of Arts was founded in the 1880s and is the sixth-largest art museum in the United States. I worked as an outside consultant for the *Annie Leibovitz: American Music* exhibition—much to the frustration of the D.I.A. design staff, I'm sure. During my previous experience working with Ms. Leibovitz as her in-house art director, I had designed her show, *WOMEN*, for each venue to which it traveled. For the D.I.A. project I worked directly (and remotely from Massachusetts) with the curator of the exhibition. Annie had already moved onto her next big book and show project and therefore was not involved with this exhibition as it traveled. The Experience Music Project (EMP) originated the show. As an in-house art director I would not have had the luxury or time to try out as many ideas as I did.

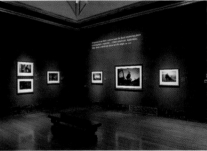

PROPOSED
ALTERNATIVE LAYOUT

15

18

HOUSE OF ORACLES:
A HUANG YONG PING RETROSPECTIVE
MARCH 18, 2006 – FEBRUARY 19, 2007
MASS MoCA

MASS MoCA
MISSION OF BURMA

SATURDAY, JULY 1ST, 8 PM

19

20

OPENING MAY 27, 2006
**AHISTORIC
OCCASION**
ARTISTS MAKING
HISTORY

PAUL CHAN
JEREMY DELLER
PEGGY DIGGS
PELIN GWELIN
KERRY JAMES MARSHALL
TREVOR PAGLEN
GRETA PRATT
DARIO ROBLETO
NEBOJSA SERIC-SHOBA
VINCA SHONIBARE
ALLISON SMITH

21 23

A.T. CABARET

MASS MoCA
Open every day Events every weekend
Summer in North Adams

JIM CARROLL

"Carroll has mesmerized standing-room-only crowds for over
twenty years with his alchemical mix of poetry, storytelling,
and history, injecting the raw energy of rock 'n' roll into
his spoken-word performances." – Philadelphia Inquirer

North Adams

SATURDAY
AUGUST 19, 2006

Sponsored by:
the PORCHES
at MASS MoCA

22

ALT CABARET

TWO TIME NATIONAL SLAM POETRY CHAMPION
ROGER BONAIR-AGARD
ELECTRIFYING AND HILARIOUS – PUBLISHER'S WEEKLY
**SATURDAY, FEBRUARY 25, 2006
3:00PM, CLUB B-10**
$14 in advance/$17 day of show
For tickets call 413.MoCA.111 or visit www.massmoca.org

North Adams

24

7 IN-HOUSE = BIG PROJECTS + RUBBISH JOBS

A museum has many graphic needs,
and as an in-house designer I
attend to those demands. My work
ranges from advertising seen across
cities and mailed everywhere to
public restroom signage.

9 WORKING DIRECTLY WITH ARTISTS IS REWARDING

Williams College offers an
internship at MASS MoCA
each year to one of its curatorial
graduate students, and MASS
MoCA allows that intern to curate
her own show. Liza Statton, a young
and up-coming curator, organized
an exhibition on the work of
Kamrooz Aram, a young and
up-coming artist. In addition to a
show of his paintings and drawings,
Kamrooz also painted a temporary
mural along an 80-foot-long
corridor wall in the galleries. The
book documented the exhibition
and mural. One of the greatest
benefits working for museums is
the opportunity to meet and work
with artists and designers who pass
through the institution.

8 IT'S A LONELY TEAM THING

I work with curators, educators,
administration staff, artists,
visiting lecturers, performers, event
planners, marketing staff, sponsors,
donors, outside advertising
agencies, exhibition designers,
contractors, photographers, and
printers, but rarely other designers.
The museum director presides
over all. For good and for bad, the
personality of the museum director
largely influences the working
culture of the institution.

25

19 PERFORMANCE POSTCARD for Mission of Burma 20 ANNOUNCEMENT CARD for *House of Oracles: A Huang Yong Ping Retrospective* 21 ANNOUNCEMENT CARD for *Ahistoric Occasion*
22 OUTFIELD FENCE SIGN for the North Adams Steeple Cats semi-pro baseball club 23 PERFORMANCE POSTER for Jim Carroll 24 PERFORMANCE POSTER for Roger Bonair-Agard
25 EXHIBITION CATALOG for *Kamrooz Aram: Realms & Reveries*

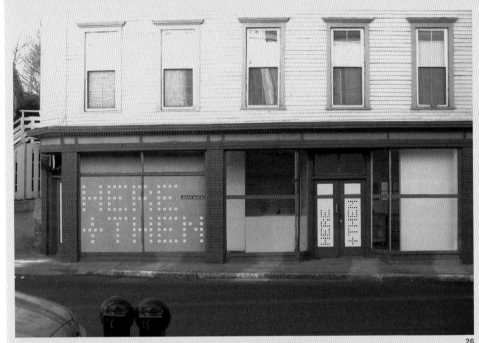

30

27

28

29

26

31

32

10 MANY THINGS TO ACCOMPLISH

Again a museum has many graphic needs … some have too many. The workload at the Massachusetts Museum of Contemporary Art was overwhelming for a tiny staff (Laura Mueller was my one intern). And because of extremely tight budgets, we did everything in-house. Besides the usual design work, we also printed, cut, and installed all of the vinyl for the exhibition graphics. We shot all of our own photography. Weekly events required posters and advertising. With so much work being executed we rarely developed more than one design direction for a project. MASS MoCA's "everyone has a say" democratic approval process made my job even more challenging.

WHAT TIME IS IT ON THE SUN? SPENCER FINCH

33

11 GREAT PROJECTS CAN HAPPEN

Occasionally everything goes perfectly. Before I left MASS MoCA I began designing a book for artist Spencer Finch's solo exhibition. Spencer was enthusiastic to work with and shared my vision for the book, and therefore I continued the project after leaving the museum. We completed the book while I was in Miami; Spencer was in Brooklyn; Susan Cross, the curator, was in Massachusetts; and the printer, whom we relied on for technical assistance from the beginning of the project, was in Belgium. Through numerous emails, pdfs of layout ideas, conference calls, meetings in Miami and New York, and finally press checks in Bruges, Belgium, we created what for me was my most rewarding project. The book improved as the process progressed. The final product, including the inserted artist projects and die-cut cover art, was better than the original idea. I gained many good friends through the experience.

MASS MoCA

WHAT TIME IS
IT ON THE SUN?
SPENCER
FINCH

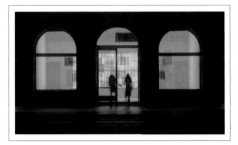

34

35+36

MARCH 03 2007

37

THE WOLFSONIAN IS ELEVEN
ON ELEVEN ELEVEN

IT'S ALL FREE.

39

CHASING THE PERFECT:
THOUGHTS ON MODERNIST
DESIGN IN OUR TIMES
NATALIA ILYIN
THURSDAY
NOVEMBER 16, 2006
LECTURE @ 7PM
BOOK SIGNING TO FOLLOW

THE WOLFSONIAN–FIU
1001 WASHINGTON AVE
MIAMI BEACH

40

12 IT'S TIME TO KILL SNAKES

The downside of being a museum
art director is that with multiple
projects running concurrently, time
and resources limit some projects'
potential. I rarely have the time or
resources to make every project as
good as it should be. Very few jobs
leave my office without something
that I feel should have been better
resolved. Joe Thompson, director
of MASS MoCA, would tell me that
I cared too much about too much.
In the back of my mind I remember
my high school history teacher
calling the need to get things done
quickly, "Killing Snakes."

CONTINUITY OF CHANGE IN SHANGHAI
XING TONG HE
CHIEF ARCHITECT OF SHANGHAI XIAN DAI
SUNDAY, DECEMBER 3, 2006, 2PM
LINCOLN THEATRE, 555 LINCOLN ROAD, MIAMI BEACH

13 LOOK AT GOOD EXAMPLES

The Wolfsonian's collection
contains almost every great piece
of graphic design from Europe,
America, and the Soviet Union
created from 1880 through 1945.
The ability to see and study real
objects from history is an amazing
learning experience.

41

120,000+ OPEN 120,000

38

43+44

STEFAN SAGMEISTER
IS SO TALL, LIKE THE
MAST OF A SHIP IN
A PLAID COAT.

HE GIVES ME PHOTOS
OF AUSTRIAN BEDROOMS
AND SAYS,

"I KNOW THESE
PHOTOGRAPHS WILL
MAKE YOU HAPPY."

SAGMEISTER + WOLFSONIAN
ART BASEL: MIAMI BEACH DECEMBER 2007

49

FELLOWSHIPS
AT THE WOLFSONIAN

45

14 I'M NOT SELLING WIDGETS

Satisfaction arrives through
my work when it contributes to
a larger good. The staff at The
Wolfsonian helped develop a
month-long event in the Miami area
when membership in one museum
allowed free entrance at other
participating museums. When I
heard the phrase "Free Museums,"
the first image that came to mind was
a group of students protesting the
need to "open the museums" and
"let everyone in." I had recently
watched Jean-Luc Godard's *Tout
va bien* and had dreams of striking
Frenchmen. After some searching
I found the images that matched
my earlier sketches, and gained
permission to use the photos.

46

LAW OF SIMPLICITY N0 1: **REDUCE**
LAW OF SIMPLICITY N0 2: **ORGANIZE**
LAW OF SIMPLICITY N0 3: **TIME**
LAW OF SIMPLICITY N0 4: **LEARN**
LAW OF SIMPLICITY N0 5: **DIFFERENCES**
LAW OF SIMPLICITY N0 6: **CONTEXT**
LAW OF SIMPLICITY N0 7: **EMOTION**
LAW OF SIMPLICITY N0 8: **TRUST**
LAW OF SIMPLICITY N0 9: **FAILURE**
LAW OF SIMPLICITY N0 10: **THE ONE**

JOHN MAEDA SIMPLICITY IS COMPLEX
THURSDAY, MARCH 22, 2007 7 PM

50

48

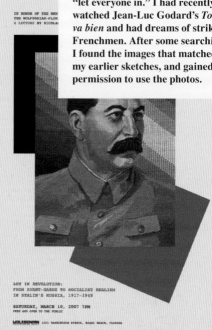

ART IN REVOLUTION:
FROM AVANT-GARDE TO SOCIALIST REALISM
IN STALIN'S RUSSIA, 1917-1945

SATURDAY, MARCH 10, 2007 7PM
FREE AND OPEN TO THE PUBLIC

WOLFSONIAN 1001 WASHINGTON AVENUE, MIAMI BEACH, FLORIDA.

47

15 WHAT WOULD THE WALKER DO?

I've never had the opportunity to
work with The Walker Art Center
in Minneapolis, but I think they
produce great and consistently
inspiring work. They set a gold
standard for museums. I became
a member many years ago just to
receive their mailings.

42 ANNOUNCEMENT POSTER for *Miami Museum Members Month 2007 (M4)* **43+44** POSTCARD+CALENDAR for *M4* **45** POSTER for Wolfsonian fellowship opportunities **46** POSTER for *Summer 07 WolfPack Design Night* **47** LECTURE POSTER for Nicolae Harsanyi and Francis Luca **48** EXHIBITION POSTER for *Soviet Graphics from Avant-Garde to Socialist Realism* **49** COMING ATTRACTION POSTER for *Stefan Sagmeister at Art Basel/Miami Beach 2007* (photo and text by Maira Kalman) **50** LECTURE POSTER for John Maeda

55

54

53

56

57

58

51 POSTCARD for *A Very Wolfsonian Weekend Gala After-Party* 52 ANNOUNCEMENT POSTCARD for *Living With War film series* 53 LECTURE POSTER for *2x4*
54 MOVIE POSTER for *Colonial Legacies in African Film series* 55 POSTER for *Fall 07 Wolf Pack Design Night* 56 BROCHURE for *Agitated Images; John Heartfield & German Photomontage*
57 LECTURE POSTER for *Elliott Earls* 58 BUILDING EXTERIOR BANNER for *Agitated Images; John Heartfield & German Photomontage*

16 RELAX WHEN YOU VISIT OTHER INSTITUTIONS

I usually take a busman's holiday whenever I travel. I still love visiting other museums, but having the knowledge of museums' inner workings makes me critical in my observations. Are the labels hung straight? Were the graphics applied correctly? Is the type big enough to read? Many times my obsession obscures enjoying the show.

Art Direction
Goes
Digital

By **Khoi Vinh**
Illustrations by **Oslo Davis**

W
to
sh
co
in
bu
ra
its

his
the
the
ele
to
dis

Art direction has traditionally meant **controlling the narrative**.

When we compliment an art director's talent, we typically mean that she is able to exercise a high level of *control* in her work—control over the imagery and typography, to be sure, but also over the work of her collaborators and staff, and over the content itself.

In fact, throughout its long history, what we've valued most in the practice of art direction is this: the ability to control the myriad elements of a design in such a way as to produce a sustained, cohesive and distinctive *narrative experience*.

Good art direction, then, is good storytelling. The very best art directors throughout history have been highly adept at creating compelling visual narratives; sometimes literally, sometimes abstractly, but almost always with a highly refined sense of control.

Examples of good storytelling

- 'Napoleon's March to Moscow' by Charles Joseph Minard

- Lucien Bernhard (reductive)

- Alexey Brodovitch

- J. Müller-Brockmann

- Paul Rand

- David Carson (designer as author)

However, the digital art director deals not just in narrative, but also in **behavior**.

Narrative, as it applies to analog content, is typically delivered in a single, fixed state.

By contrast, the fundamental principle driving design in digital media is *behavior*: how does a design respond to the actions and goals of those who use it?

And digital media, by its nature, allows for an abundance of behaviors; any given block of digital text can be enlarged or reduced, hidden and revealed, rendered in a completely different typeface, read aloud by screen reading software for the visually impaired, commented upon, quoted liberally, even edited by

users—the list goes on. What's more, many of these behaviors effectively remove the original intentions of the art director, thereby altering or even obliterating the layout, typography, imagery, often the very *design*.

Understanding this shift from narrative to behavior—and accepting this new balance between art director and audience—can require a radical departure from the framework in which most art directors operate. It's a crucial shift that is a requirement for successful online art direction.

various behaviors

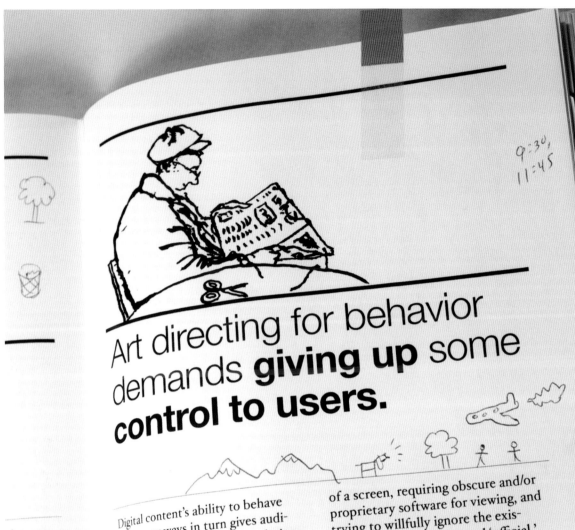

Art directing for behavior demands **giving up** some **control to users.**

It's more,
ctively
ns of the
or even
graphy,
n.
t from
accepting
rt director
a radical
ork in
perate. It's
iirement
ection.

Digital content's ability to behave in so many ways in turn gives audiences more control over how design is experienced than they've had with any prior form of mass media.

Indeed, this ever-present panoply of options transforms an audience of consumers into a constituency of *users*, as design solutions are not so much received as they are *put to use*.

It's not uncommon for many art directors to endeavor to counteract this phenomenon with unnatural and usually awkward attempts at fixity[1]: rendering type as graphics rather than as ASCII, resizing windows and viewports to command the entirety of a screen, requiring obscure and/or proprietary software for viewing, and trying to willfully ignore the existence of states not deemed 'official.'

But time and again, these methods have been rejected by users at large—users want to retain at least some level of this control for themselves. Successful digital art direction not only acknowledges but also amply provides for this.

[1] In essence, these are attempts at limiting the number of possible states which a design solution might offer.

Digital art directors must **unite multiple states** into a coherent experience for users.

Given an environment in which users routinely assume levels of control that were once the exclusive province of art directors, the question arises: *Is there a job left for art directors to do?*

The answer, unequivocally, is *yes.*

In many ways, the art director's role takes on even greater importance when presented with digital media. A multiplicity of behavioral states means the potential for a multiplicity of disjointed, fractured experiences.

The need for an art director to exert control over media is not entirely lost, then. Instead, it has been re-distributed across many different fronts. Rather than focusing on a single, fixed state for a design solution, digital art directors must bring a cohesive vision to bear across a variety of divergent behavioral states, within the context of multiple software environments, and on many variants of operating systems and even classes of hardware.

It is the digital art director's role to unite these sometimes disparate aspects of design into a coherent experience, so that the core values of the client's brand are consistently, reliably communicated.

Tha art c **conv** from

Where in analog tors develop one munications—a c approach—digita follows a many-to much more akin to Both are exchange between people, bu in that documents a controlled while con inherently unpredict

The fixed nature allows an art director knowing that it will be ing to her intentions. B it's very difficult to pre to *design* a conversation—

must
tes
erience

for a design
rectors must
to bear across
ehavioral
t of multiple
nd on many
ems and

ctor's role
isparate
erent
values
istently,

That's as different from art direction for print as a **conversation** is different from a **document**.

Where in analog media art directors develop one-to-many communications—a document-centric approach—digital media by nature follows a many-to-many paradigm much more akin to conversations. Both are exchanges of information between people, but they diverge in that documents are inherently controlled while conversations are inherently unpredictable.

The fixed nature of a document allows an art director the certainty of knowing that it will be read according to her intentions. By contrast, it's very difficult to pre-determine—to *design* a conversation—with any meaningful predictability.

This is another product of digital media's multiplicity of behaviors. Just as two people might take away very different learnings and memories from even the same conversation, so too is it true that two users can take away very different experiences from the same digital product.

Moreover, though most digital content is text-based and might suggest documentary qualities, they are in fact forms of conversation: email, instant messaging, blogs, wikis and online applications of all kinds are far closer to the dynamic, unpredictable nature of conversations.

The tension between documents and conversations is **as old as media itself**.

Though it may seem novel[2], this move away from the documentary and towards the conversational is not without precedent. In fact, the tension between the two forms has been an intrinsic part of media evolution for millennia.

The invention of writing, for example, also gave us the document. Where human affairs had previously been conducted solely through oral means, documents asserted a new authority, making codes, laws and even governments possible.

And where governments have failed and given rise to illiteracy, as happened in Medieval Europe in the wake of the Roman Empire, folkloric traditions gained new currency.

In turn, Gutenberg's press made it possible for mass communication—the ability for documents to be reproduced accurately and cheaply—to supplant folklore as conveyors of information.

Even within our digital age, we've seen the 20th century's centralized, 'cathedral' model of technology usurped by 'bazaars' of personal computing[3], which have allowed for digital conversations to happen anywhere, at any time.

[2] See also the 1967 essay, "Death of the Author" by Roland Barthes. → *intent of the author not relevant in interpretation of text*

[3] See also "The Cathedral and the Bazaar" by Eric S. Raymond.

founding ideas for open-source software

Ho
co
mu

The perp
between
us that th
exclusive.
of writing
complete
Their co-
cation th
another.

Audi
to conver
formally
informal
enhance
tive docu
And cove
are conti

However, these two concepts are in fact **mutually dependent**.

The perpetual, fluctuating tension between these two traditions tells us that they need not be mutually exclusive. In fact, since the advent of writing neither tradition has ever completely supplanted the other. Their co-existence is in fact an indication that they are reliant upon one another.

Audiences have always looked to conversational outlets—whether formally organized interest groups or informal discussions with friends—to enhance their experiences of narrative documents like films and books. And conversational events like politics are continually refracted through documentary means in an attempt to better understand them.

This duality, then, provides a guide for digital art direction: *Good narrative gives rise to great conversations.*

For art directors working in digital media, then, the challenge is to incorporate the narrative tradition into behavioral experiences, to integrate the documentary approach into platforms for conversaton. So-called 'traditional' design values, then, play a crucial role in creating superior digital experiences. There is an important place for them online; but they cannot make the transition completely untransformed.

n the
cloric

ade

o be

y—

of

al-

ation

Successfully synthesizing them means **being true to the nature of digital media.**

Users turn to art directors for online experiences that are *guided and clear*. Among other methods, they expect some incorporation of the means and practices of traditional art direction—orderly typography, rational grids, visual consistency, judicious layouts, definitive branding, selective use of photography and illustration—to conjure up elegant, trustworthy environments for interacting with data, content and other users.

With these familiar methods though comes the dangerous temptation for art directors to emulate analog media, to forge digital experiences in the image of print, ignoring fundamental differences in the way the media behave and are consumed.

This is categorically *not* the brand of clarity and guidance users are seeking, however.

What they crave instead is a shrewd synthesis of the traditional and the new that is *true to the nature of digital media*, solutions that do not ignore the constraints and limitations of digital technology but instead respect and even embrace them as opportunities. This nativist approach, and not its emulative alternative, is at the root of truly successful digital art direction.

As digital
it will pro
control o
both to th
and to th

Like
ments an
and pull
will be m
art direct
how their
real users
increasing
interpret

How
achieve s
nature of

Great digital art direction lets users shape their own experiences.

As digital media continues to evolve, it will provide greater and greater control over how it is designed— both to those creating the interfaces and to those using them.

Like the tension between documents and conversations, this push and pull between creators and users will be mutually influencing; digital art directors will learn more about how their work is experienced by real users, and users will become increasingly accustomed to digitally interpreted traditional design values.

How and when this process will achieve stability—the timing and nature of the 'sweet spot' of com-promise between the creators and users—can't be currently predicted.

One outcome is certain though: digital media is inherently user-influenced. Which is to say that whatever equilibrium we achieve between narrative and behavior, the most commercially viable and artistically successful digital art direction will always provide for some measure of control over the product to those who are using it.

ART DIRECTING MYSELF

the TERROR of the BLANK PAGE

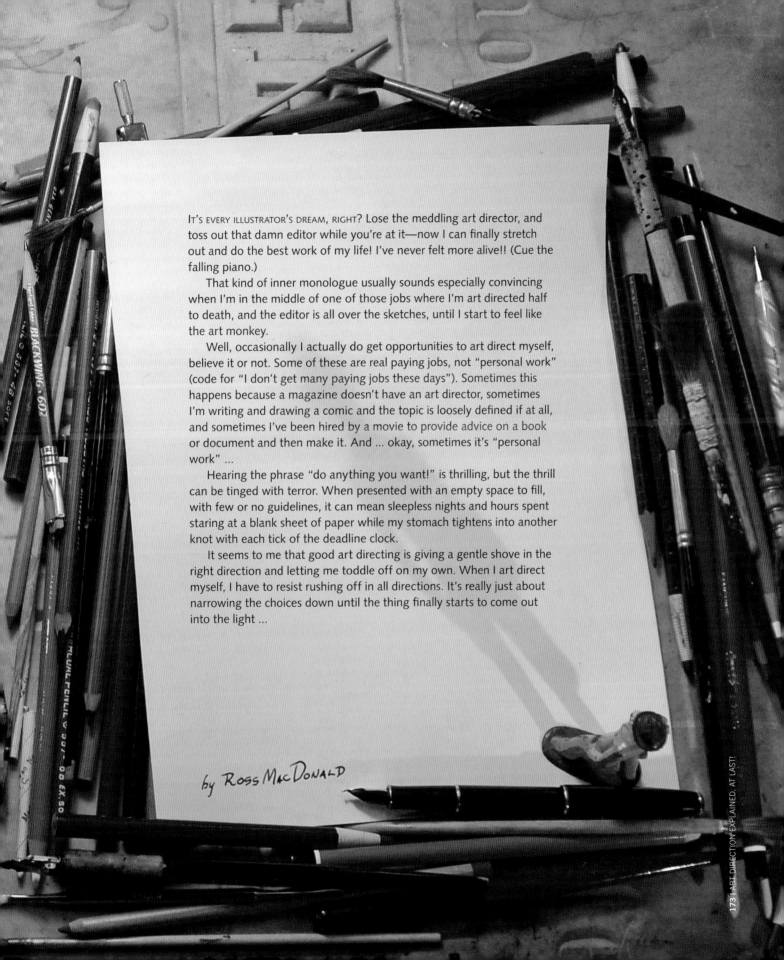

IT'S EVERY ILLUSTRATOR'S DREAM, RIGHT? Lose the meddling art director, and toss out that damn editor while you're at it—now I can finally stretch out and do the best work of my life! I've never felt more alive!! (Cue the falling piano.)

That kind of inner monologue usually sounds especially convincing when I'm in the middle of one of those jobs where I'm art directed half to death, and the editor is all over the sketches, until I start to feel like the art monkey.

Well, occasionally I actually do get opportunities to art direct myself, believe it or not. Some of these are real paying jobs, not "personal work" (code for "I don't get many paying jobs these days"). Sometimes this happens because a magazine doesn't have an art director, sometimes I'm writing and drawing a comic and the topic is loosely defined if at all, and sometimes I've been hired by a movie to provide advice on a book or document and then make it. And ... okay, sometimes it's "personal work" ...

Hearing the phrase "do anything you want!" is thrilling, but the thrill can be tinged with terror. When presented with an empty space to fill, with few or no guidelines, it can mean sleepless nights and hours spent staring at a blank sheet of paper while my stomach tightens into another knot with each tick of the deadline clock.

It seems to me that good art directing is giving a gentle shove in the right direction and letting me toddle off on my own. When I art direct myself, I have to resist rushing off in all directions. It's really just about narrowing the choices down until the thing finally starts to come out into the light ...

by Ross MacDonald

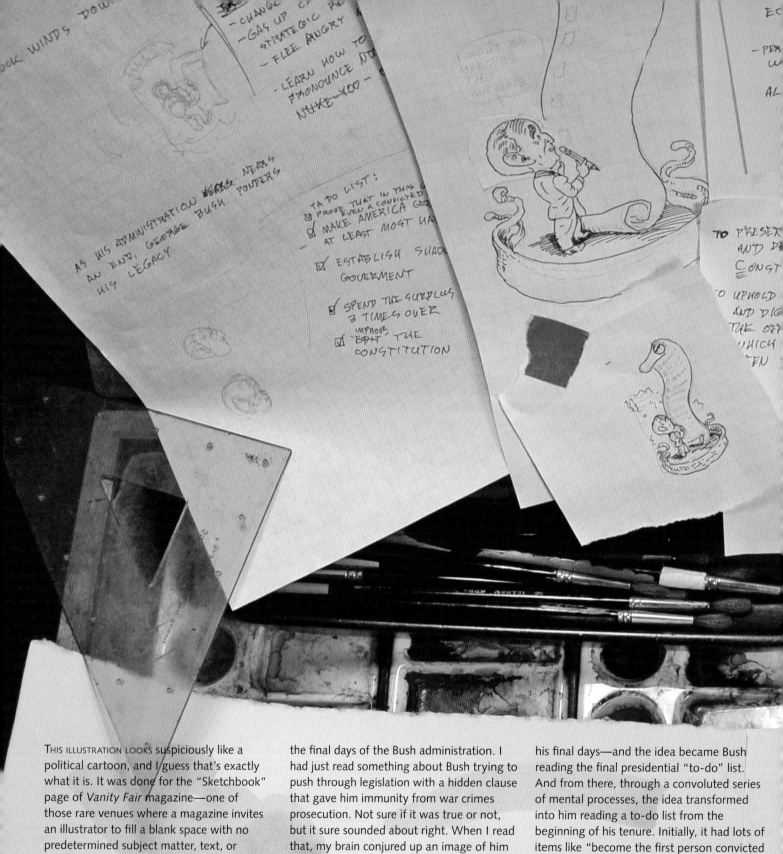

THIS ILLUSTRATION LOOKS suspiciously like a political cartoon, and I guess that's exactly what it is. It was done for the "Sketchbook" page of *Vanity Fair* magazine—one of those rare venues where a magazine invites an illustrator to fill a blank space with no predetermined subject matter, text, or anything else. When they first invited me, I drew a blank. They repeated the offer later, at a time when I, like many others, was witnessing, with a certain amount of relief, the final days of the Bush administration. I had just read something about Bush trying to push through legislation with a hidden clause that gave him immunity from war crimes prosecution. Not sure if it was true or not, but it sure sounded about right. When I read that, my brain conjured up an image of him and Cheney busily printing up "Get out of War Crimes Prosecution FREE" cards to hand out to their cronies. That got me thinking of all the other things he would need to do on his final days—and the idea became Bush reading the final presidential "to-do" list. And from there, through a convoluted series of mental processes, the idea transformed into him reading a to-do list from the beginning of his tenure. Initially, it had lots of items like "become the first person convicted of a crime to be elected president," and "run through the surplus and convert it into a multi trillion dollar deficit." But that seemed a little obvious and strident somehow, so I

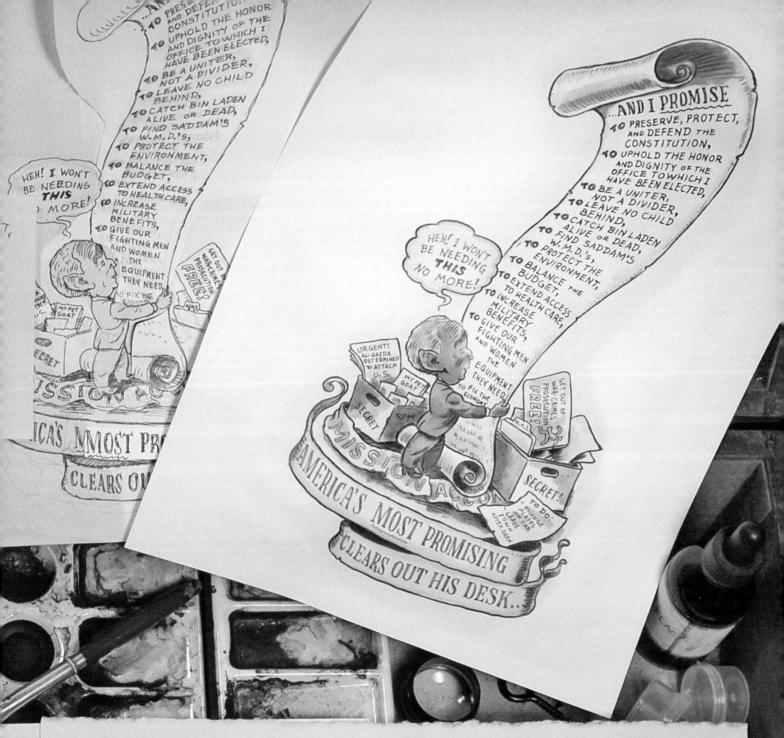

flipped that idea on its head, into the slightly subtler version you see here, which is all about the many promises that were made. I make no comment about if they were kept or not—the viewer fills in that part of the punchline. I combed through old speeches and through his swearing-in for some ideas, but most are painfully obvious to all of us.

The space for "Sketchbook" is flexible so I was free to make this whatever proportion I wanted. You can see from the doodle on the upper left that this started out with Bush and his list about the same size. When I started writing the text, it became clear that the paper would have to grow, and I came up with a much more heroically proportioned list billowing up from a little base that you see in the next two sketches. These were drawn when I was still thinking that this was going to show him composing his to-do list for his last few days on the job—you can see that Bush is holding a pencil. The next,

and final, sketch shows some of the editing involved—it's made up of three or four layers and bits of paper taped and glued together, with generous lashings of Wite-Out here and there. At first I pictured the final art as being black line with washes of blue only, but when I started painting I made the snap decision to add brown and flesh tones, and I think it makes it more approachable and less dense-seeming than the monochromatic version would have been.

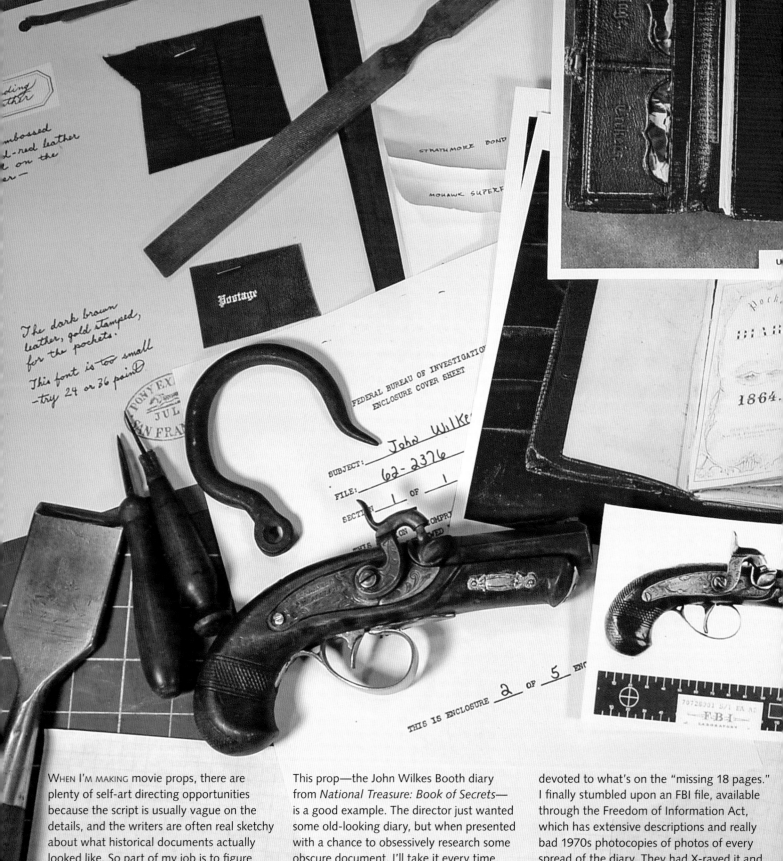

The dark brown leather, gold stamped, for the pockets.

This font is too small —try 24 or 36 point

FEDERAL BUREAU OF INVESTIGATION
ENCLOSURE COVER SHEET

SUBJECT: John Wilke

FILE: 62-2376

SECTION 1 OF 1

THIS IS ENCLOSURE 2 OF 5 ENC

WHEN I'M MAKING movie props, there are plenty of self-art directing opportunities because the script is usually vague on the details, and the writers are often real sketchy about what historical documents actually looked like. So part of my job is to figure out what this thing would look like—what would look great on the screen and what would be "period correct" as they call it.

This prop—the John Wilkes Booth diary from *National Treasure: Book of Secrets*— is a good example. The director just wanted some old-looking diary, but when presented with a chance to obsessively research some obscure document, I'll take it every time.

It turned out to be very difficult to find any details about the physical diary itself, although the web is clogged with sites

devoted to what's on the "missing 18 pages." I finally stumbled upon an FBI file, available through the Freedom of Information Act, which has extensive descriptions and really bad 1970s photocopies of photos of every spread of the diary. They had X-rayed it and shot photos in every wavelength of light. The file mentions that the photos were taken by an outside agency. With more digging,

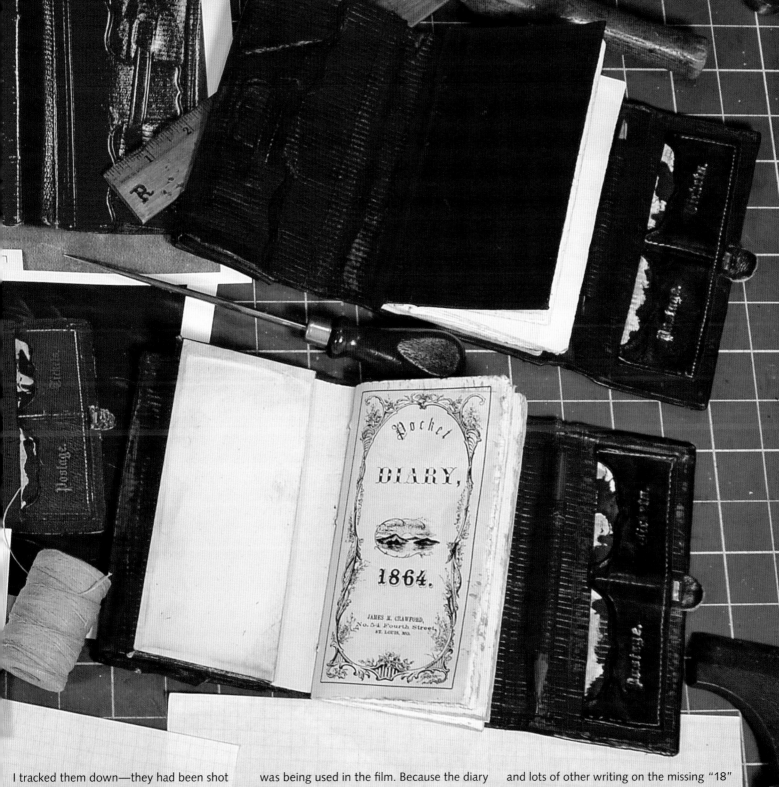

I tracked them down—they had been shot by the US Secret Service. I put together a dossier, which you see on the upper left, with drawings, leather and paper samples, the FBI file and photos, and I used that to show what my finished prop would look like. Once the director signed off on it, I created several exact duplicates of the diary, with a couple of small changes to accommodate the way it was being used in the film. Because the diary gets ripped apart during a brawl and burned, I ended up making 120 of the paper diaries.

The leather wallet is made from over 30 pieces with dozens of hand operations. The leather is hand-dyed in multiple layers, and embossed line by line with a soldering iron. The paper diary is complete, and replicates Booth's actual writing on the surviving pages, and lots of other writing on the missing "18" (actually it was really 27) pages.

Using FBI photos from another file for reference, I also built a working replica of the .45 caliber Derringer that Booth used to shoot Lincoln.

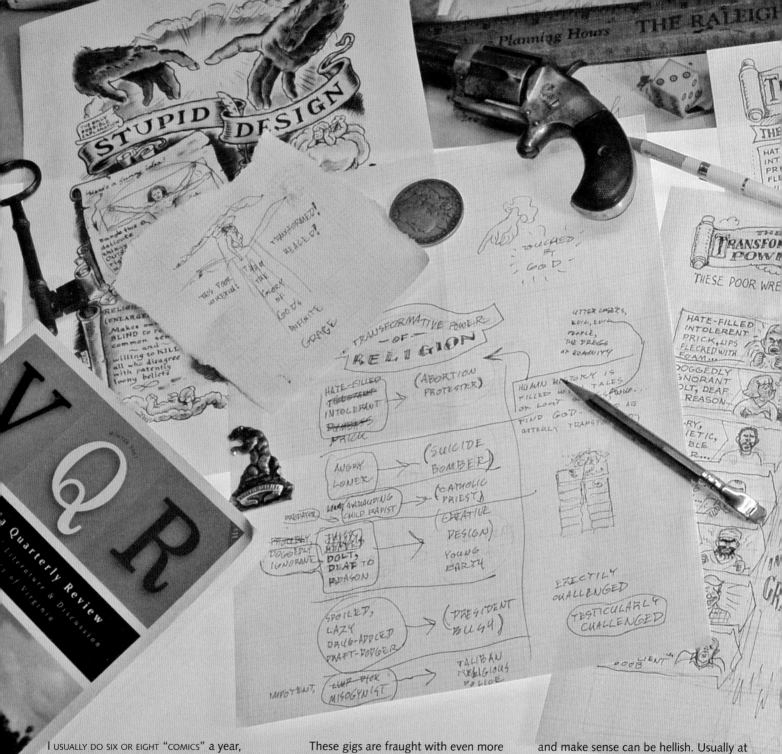

I USUALLY DO SIX OR EIGHT "COMICS" a year, including four for the great magazine *Virginia Quarterly Review*. It doesn't have an art director, but always looks great, thanks to designer Mark Reis of Percolator Design and the keen eye of its editor, Ted Genoways. Ted is a comics aficionado, and asked me to do a comic in every issue. He also told me I could do "anything I wanted." I think he's had more than one occasion to regret the poor judgment that he displayed that day.

These gigs are fraught with even more terror than usual, because the "do anything you want" extends to the writing as well as the art, and coming up with one of these is like giving birth—giving birth to a really big ugly baby. However, it does give me a chance to vent some of the rage that reading the paper causes, so that's a good thing. At any given time my brain is filled with heaps of free-floating bile, but actually gelling it into complete sentences that go together

and make sense can be hellish. Usually at some point in the process I end up writhing around on the floor, clutching my head and moaning. It doesn't help that I leave off doing it until three days before the absolute drop-dead deadline.

I usually start by looking at some of my past comics, almost as if I need to confirm that I've actually managed to pull this off before. Then a few random phrases and images begin rolling around in my head,

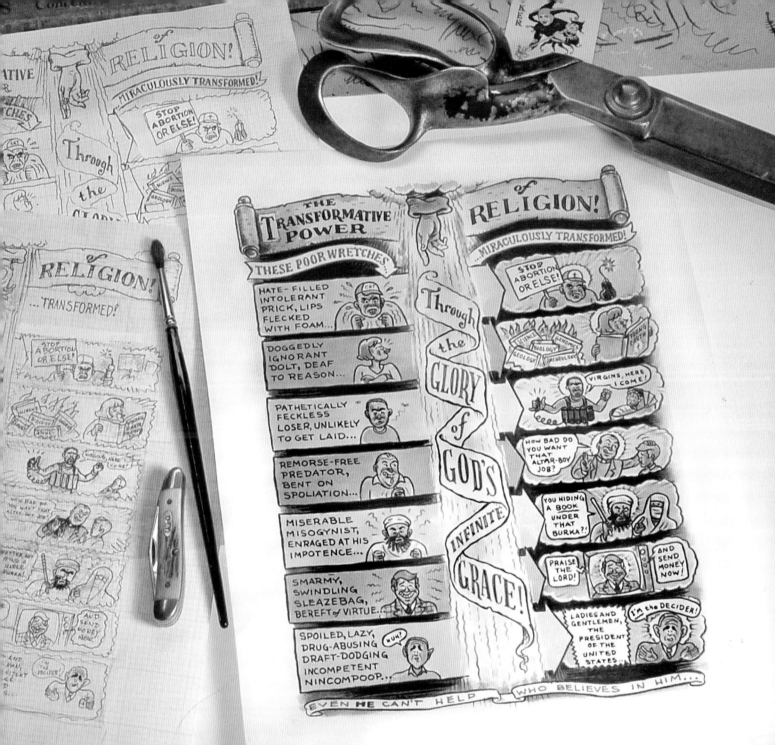

and when they seem like they might be coagulating, I start taking notes and making sketches—sometimes big chunks of copy or images pop into my head, other times lots of little phrases and words and tiny doodles. Then it's just a matter of moving things around, redrawing, rewriting, shuffling bits and pieces, blowing stuff up and down, and eventually the thing starts to come into focus. A lot of times I actually write the sketch instead of drawing it. You can see that

in the first rough on the left. These notes and doodles become a first rough sketch—which I refine and edit. Then I trace a finished sketch from that, and then the final art from the finished sketch. Sometimes I can visualize the color, other times I have to sit and mentally color it, trying different schemes. A lot of times, things will occur to me when I'm in the final art stage—like putting the halos around the people's heads. Seems obvious, but I didn't think of it till I was painting the

final washes. Same with the banner of copy across the bottom, which functions almost like a punchline.

For some reason, I like to do the comic as one complete piece of color art, with lettering right on the paper. It can be kind of nerve wracking, because if I screw up, I have to redo the whole thing, and there's never enough time to do that. It would make life a lot easier if I worked digitally, but what fun would that be?

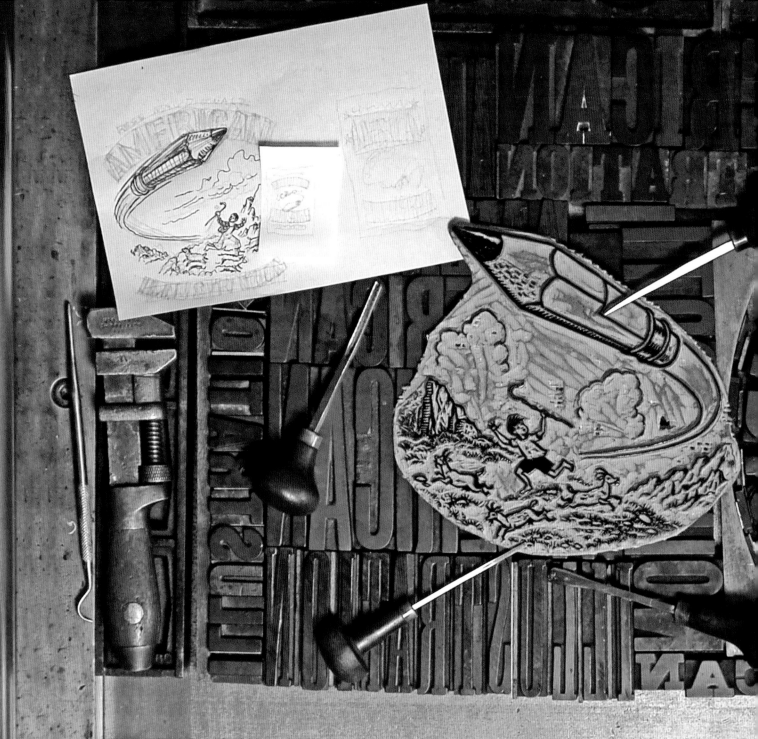

THIS IS A LETTERPRESS PIECE—a promotional broadside. My promotion pieces tend to appear calculated to drive away the paying customers, but at least I have fun doing them. I don't usually work in a linocut illustration style, and I don't really solicit letterpress printing work, so my clients can be forgiven for being confused when they get one of these. Sometimes I do a couple of promo pieces like this a year, but this is the first one I've done in three years. This was

an idea I had back in the late '90s, but it got filed away and forgotten until I found it ten years later and blew the dust off it.

It's easy to design using wood and metal type—you just have to try every conceivable combination of fonts until you find something that fits and isn't missing a letter you need. If it ends up looking good, that's a bonus! Although this is a piece I did for myself, the same process usually applies when I design a book cover or magazine piece.

You can see a few of the fonts here that didn't make the cut. I start with a rough sketch or two, but I usually design by the seat of my pants, right on the bed of the press—setting and proofing different fonts and combinations. Trying it with ornaments or rules and without. Trying some lines on curves, trying it bigger, smaller, wider, thinner. Sometimes I might try three things, sometimes 30. I'll often make a bunch of proofs in the afternoon and then hang them

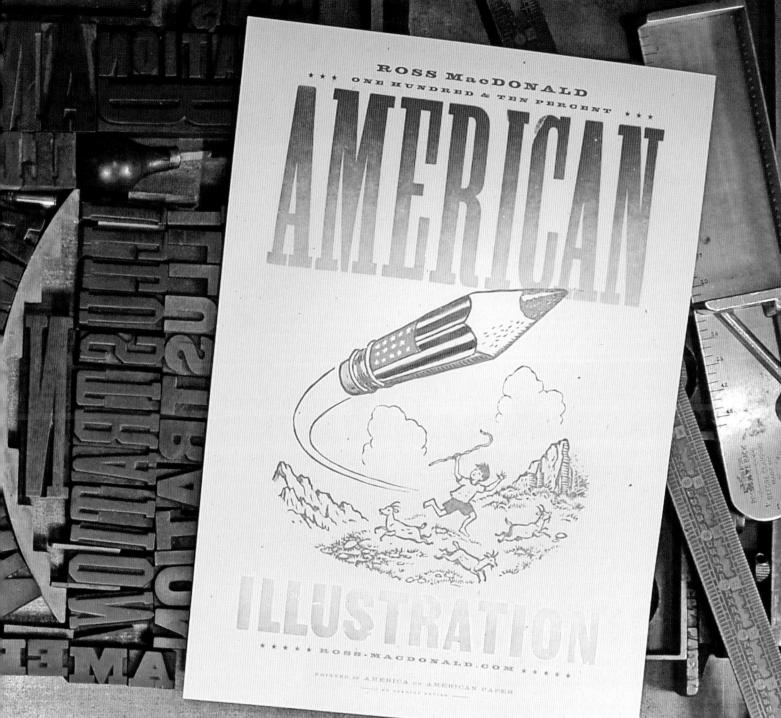

ROSS MacDONALD
*** ONE HUNDRED & TEN PERCENT ***

AMERICAN

ILLUSTRATION

* * * * * ROSS-MACDONALD.COM * * * * * *

PRINTED IN AMERICA ON AMERICAN PAPER

up and stare at them in the evening until I start to see what I like and what I don't, and then the next morning I refine it further.

With this one, I started with a rough map, but I didn't plan the paper size, fonts, or even all the copy. I cut the linocut at a size that seemed about right, knowing I could design around it. Then I tried about a dozen different fonts for the title. Once I'd made my choice, I decided on a rough size and tried different papers until I found one

that worked. Only after I'd printed the main headline did I start to think about the final copy. Being able to see the type, size, and color of the "American Illustration" lines helped me choose the sizes and fonts of the smaller lead type. I tried a few things—some overpowered the larger type, some were overpowered by it. Part of the reasoning for the choices I was making, was getting it to "read" right, with the emphasis in the right places. I wanted "American" to be

emphasized, but not shouted—more like it was spoken in a hallowed, reverent tone. This is probably a good time to mention that I'm an immigrant—the final lines on the poster, printed in tiny type, read "printed in AMERICA on AMERICAN PAPER ... by foreign devils."

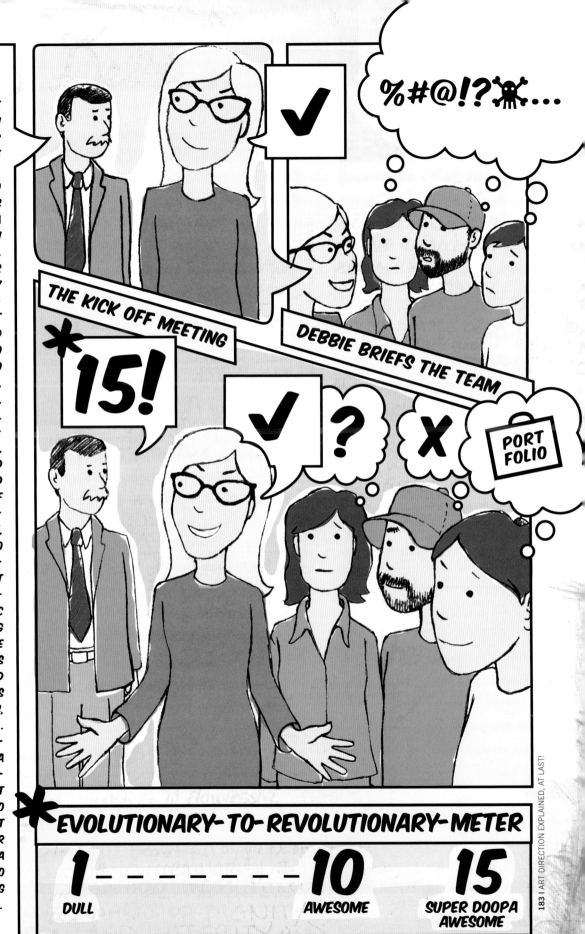

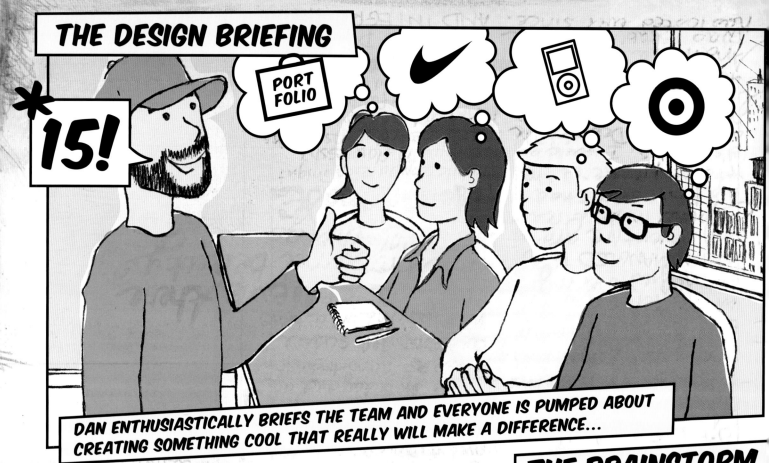

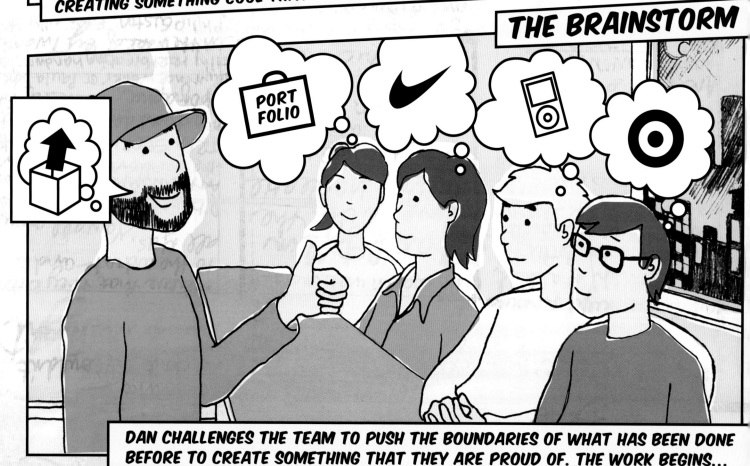

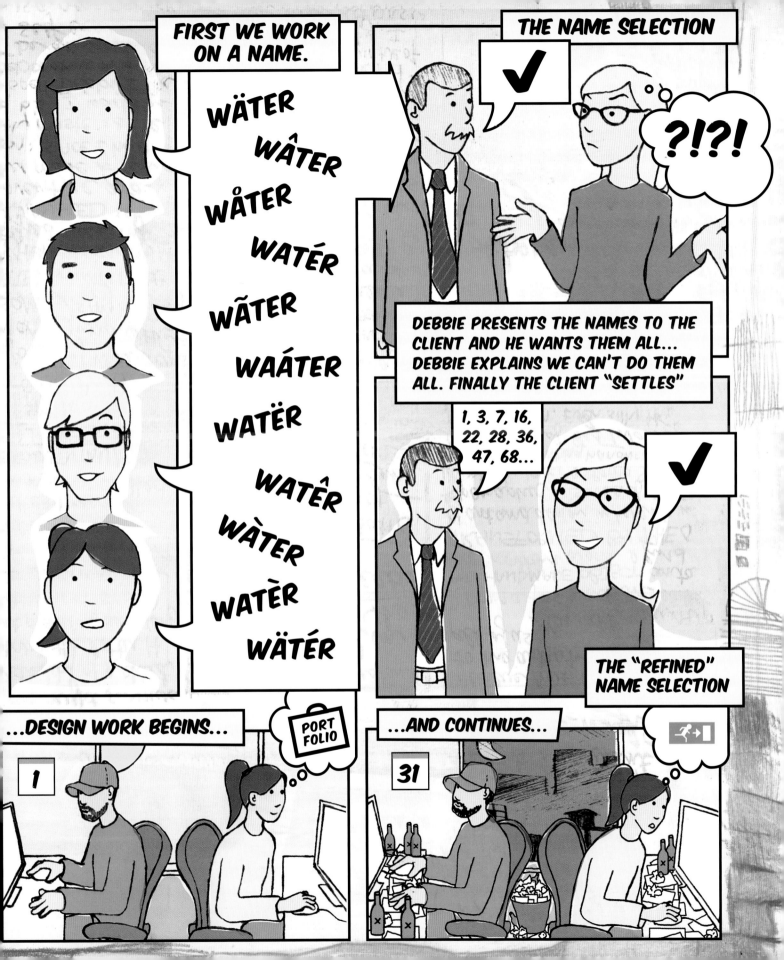

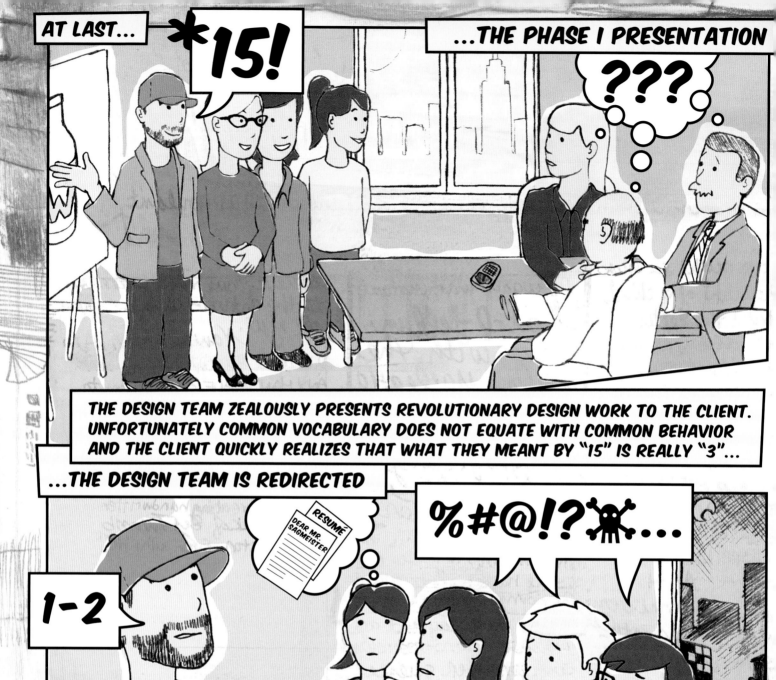

THE DESIGN TEAM ZEALOUSLY PRESENTS REVOLUTIONARY DESIGN WORK TO THE CLIENT. UNFORTUNATELY COMMON VOCABULARY DOES NOT EQUATE WITH COMMON BEHAVIOR AND THE CLIENT QUICKLY REALIZES THAT WHAT THEY MEANT BY "15" IS REALLY "3"...

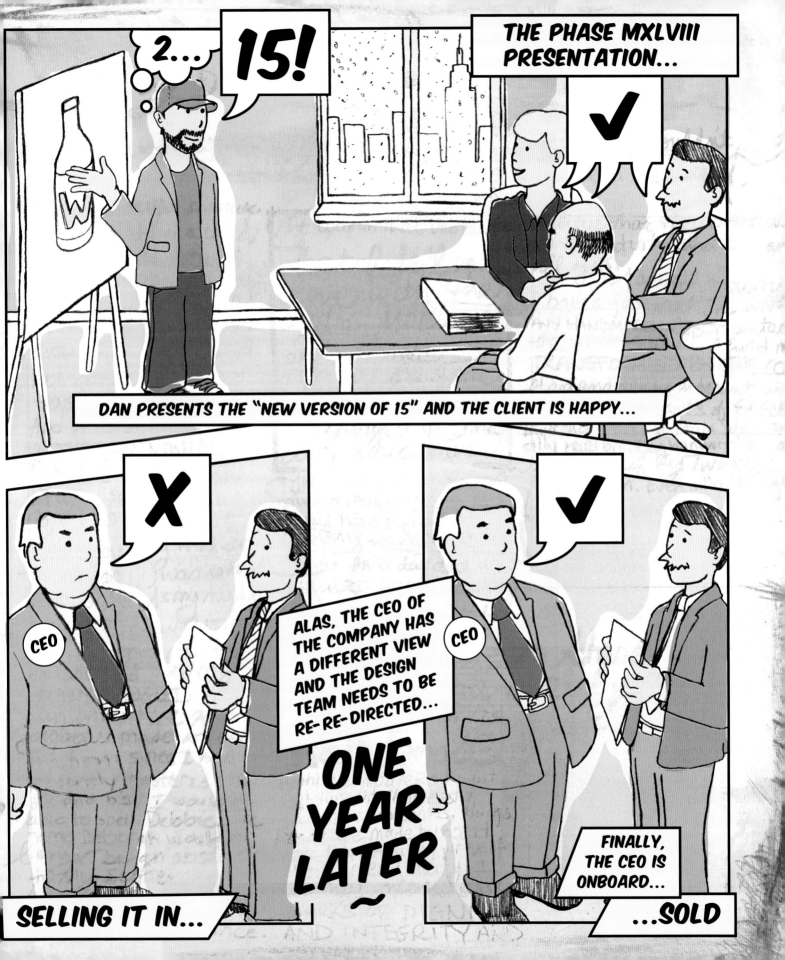

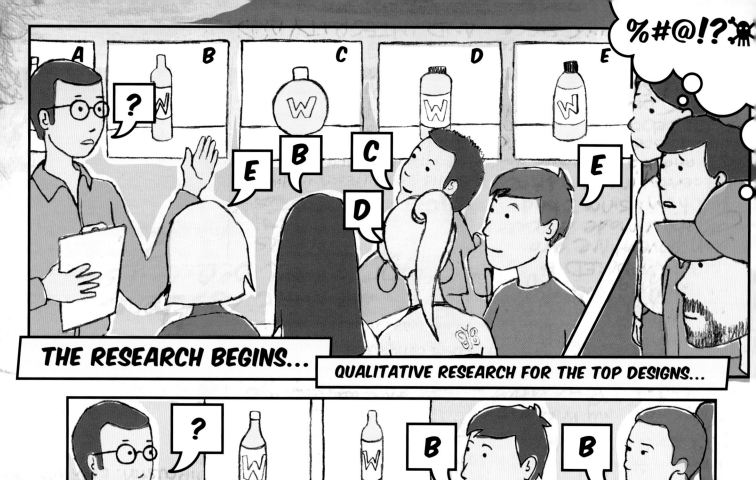

THE RESEARCH BEGINS...

QUALITATIVE RESEARCH FOR THE TOP DESIGNS...

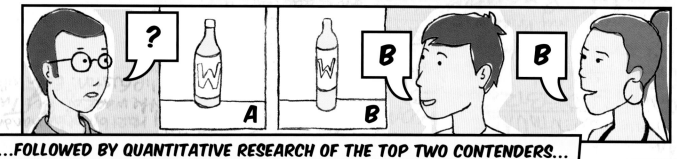

...FOLLOWED BY QUANTITATIVE RESEARCH OF THE TOP TWO CONTENDERS...

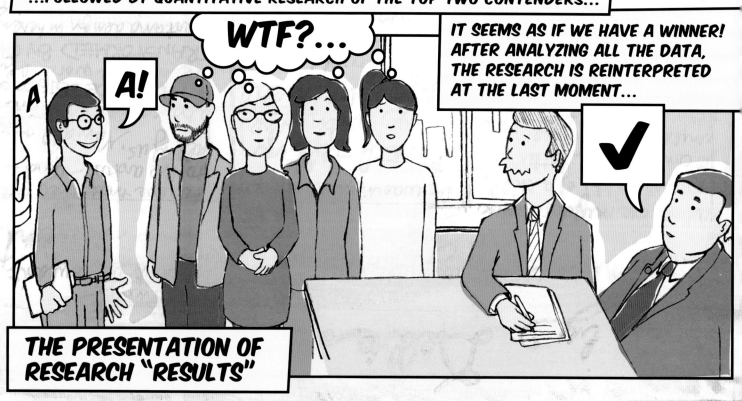

THE PRESENTATION OF RESEARCH "RESULTS"

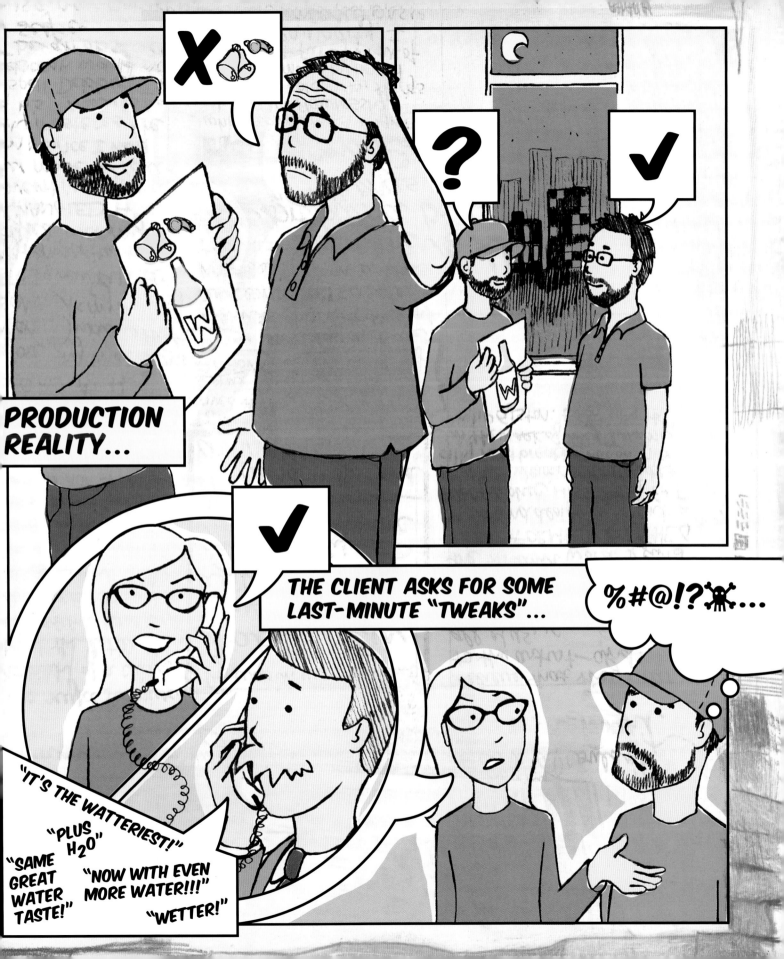

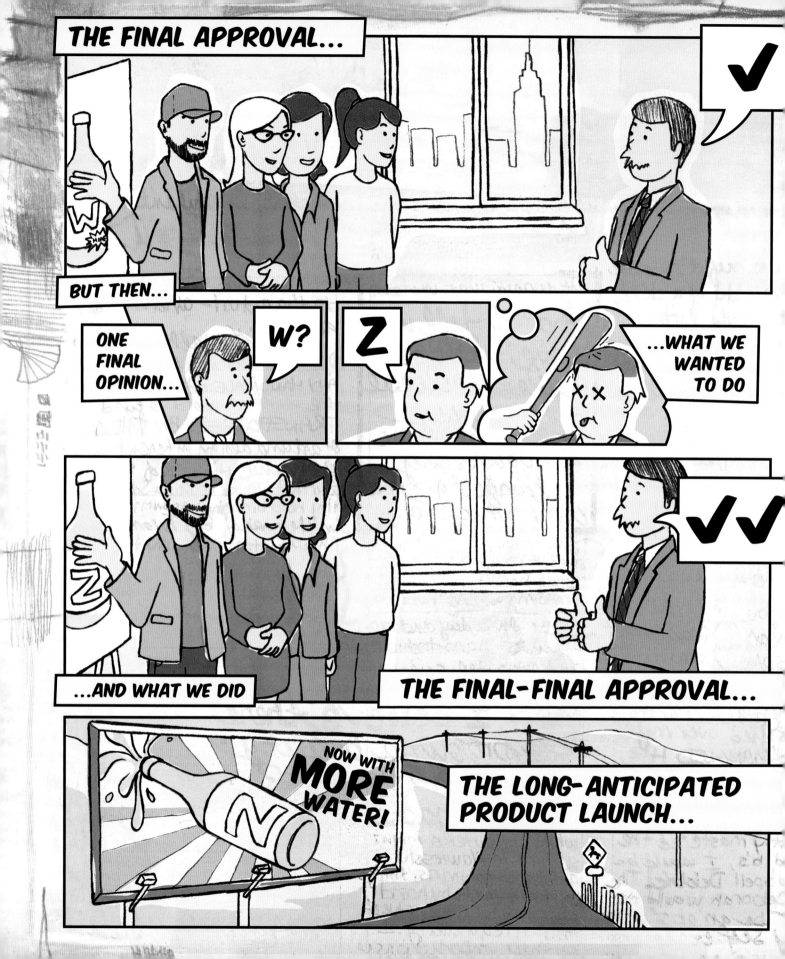

ILLUSTRATION: ALEXANDRA BALD ART DIRECTION: DEBBIE MILLMAN & DAN WALTER COPY: DEBBIE MILLMAN & JEN SIMON

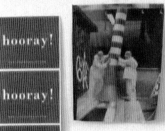

hooray!

hooray!

hooray!

hooray!

3

UNITED PICKLE

+ yellow, lighten to match original

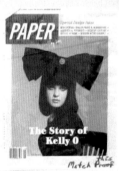

PAPER

The Story of
Kelly O

Match Proof

glossary

by

Peter Buchanan-Smith

Unless otherwise noted, all
photographs by

Jason Frank Rothenberg

Hem: A short cough or clearing of the throat made especially to gain attention, warn another, hide embarrassment, or fill a pause in speech.

Salute: A shout or salute of enthusiastic approval. Hello readers of this book! I hope you are having a beautiful day. I hope you feel inspired. If not, then perhaps put this book down and go clean out your fridge, boil an egg, fold some laundry, watch a movie, or whatever floats your inspirational boat. Getting inspired is half the battle. Make sure you're well and truly inspired before you embark, are equally inspired during the duration of your trip, and are thoroughly inspired upon and after arrival at your destination. There are no rules, just do whatever it takes to get inspired: if not.

Hooray: Variant of hurrah. Hooray that you bought this book, and have turned to this chapter. If you look over on the left-hand page, you'll see four pink hoorays; these are stickers that were designed for Isaac Mizrahi. Isaac often says hooray (not the variant). I am the design director for Isaac Mizrahi. This glossary is a brief introduction to my life with Isaac, and to making things in general.

Rose pink: A moderate to dark pink.

The picture of elegance. A lone pair of gray flannels delicately draped over a thin wire hanger. (Photo: Togashi)

Left: my rotating, ever-changing wall of inspiration. Things are taped or pinned up here without any more thought than just that. I peer into this space every day, and it tells me who I am, reminds me who I should be, or who I want to be. (Photo: PBS)

From the wall:
fabric takes on new
meaning when you work
in fashion; you hang it on
your wall, next to images.

Backs of business cards designed for
Isaac. Each set of cards comes in 12
separate colors, Isaac's rainbow.

Elegant: A trait often described as being characterized by or exhibiting refined, tasteful beauty of manner, form, or style.

Elegant (my definition): Imagine a multitude of factors that suggest a perfectly suitable solution, and there you have it. For example: when you swing at a tennis ball, there are an infinite number of variables or factors at play (wind speed, ball velocity, ball rotation, racquet velocity, tightness of string, position of racquet, etc.) A good tennis player (say Björn Borg circa 1978) makes a winning shot with the tennis ball in that most elegant and mysterious of ways: he connects with the sweet spot. Elegance is characterized by or exhibiting a tendency (especially in matters of style, design, and tennis) to connect with the sweet spot (i.e. the gray flannels delicately draped over a thin wire hanger).

White: White is the bird up your sleeve, the ace in your cap, it is the greatest luxury, it is the greatest riddle. When they are least expecting it, hit them with white and watch as it throws everything before it into question. But beware: like a comedian's pause before a punch line, it must be perfectly timed and dealt. I dare you to try making something that is all-white, completely void of color.

Pinks: Light-colored trousers formerly worn as part of their semidress uniform by US Army officers.

Guffaw: A hearty, boisterous burst of laughter.

Some chairs from Isaac's studio.

FRONT

BACK

A letterpressed invitation to a fashion show, with logo designed by M&Co.

Fashion: A sudden, overpowering terror, often affecting many people at once. Before Isaac hired me, I expressed some concern that I had never worked in fashion. "All the better," he responded.

Synesthesia: A condition in which one type of stimulation evokes the sensation of another, as when the hearing of a sound produces the visualization of a color. I have observed how color can have a narcotic effect on a rare group of people. Learning Isaac's colors is like learning a new language, and sometimes we speak to each other in his language.

Routine: A prescribed, detailed course of action to be followed regularly; a standard procedure. Allen Ginsberg wrote: "Well, while I'm here I'll do the work—and what's the work? To ease the pain of living. Everything else, drunken dumbshow."

Polka dot: One of the greatest inventions to come out of the drunken dumbshow (see above definition). The polka dot is an ancient motif, but rose to popularity in 19th-century Britain during a polka music craze. It amazes me that something so rudimentary could be so ubiquitous, not to mention how it can be simultaneously clown-like and playful, or the epitome of elegant and sublime (and everything in between). If I am ever in over my head, and the task is a complicated mess, I just remember this: at the end of the day, the polka dot is proof that good design can be so astonishingly simple.

From the wall: above hangs a series of polka-dot designs, below a portrait of Giacometti looking very stylish. James Lord's *A Giacometti Portrait* is a favorite creative manual.

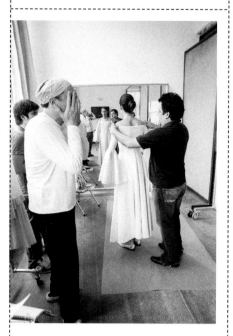

Isaac's Style Book 1 and 2: for two years Isaac, myself, and an editor made two issues of a style magazine that was given away for free in stores across the country. Among other things, Isaac's Style Book documented: 1) the making of Isaac's women's couture collection 2) women who only wear red lipstick (photo: Jon Shireman) 3) the style transformation of two young women in the hands of a professional stylist (photo: Jacqueline Di Milia) 4) a personal tale of coping with panic 5) a recipe from a champion cookie-baker 6) the life of a super model told through her hair 7) Isaac's sketches of readers' fantasy dresses 8) a collection of monogrammed towels (photo: Jon Shireman) 9) in each issue we explored a color, and in this one it was "mint," hence a mint handbag from Helsinki (photo: Jon Shireman).

mint

Kalman, Tibor, and M&Co.: What would a book about art direction be without mention of Tibor? Isaac and Tibor worked together, M&Co. designed Isaac's couture logo. What was that relationship like? I hardly knew Tibor. I took his one and only class at School of Visual Arts, and he died from a long battle with cancer halfway through. Like many of us in design, of a certain age, from a certain era, I hear voices that say: "What would Tibor think?". But unlike many of us they also say: "You schmuck! My logo! What have you done with it?".

Day-glo: Can enhance the effect of being in a fantasy world. I don't think designers realize how much they are allowed to make-believe: stop being so serious people! It's good to pretend (the alternative is so unthinkable, unbearable, and unspeakable).

Butterick, Ebenezer: With his wife, Ellen Augusta Pollard Butterick, he invented tissue-paper dress patterns. This discovery revolutionized home sewing and how clothes are made, and it all goes to show

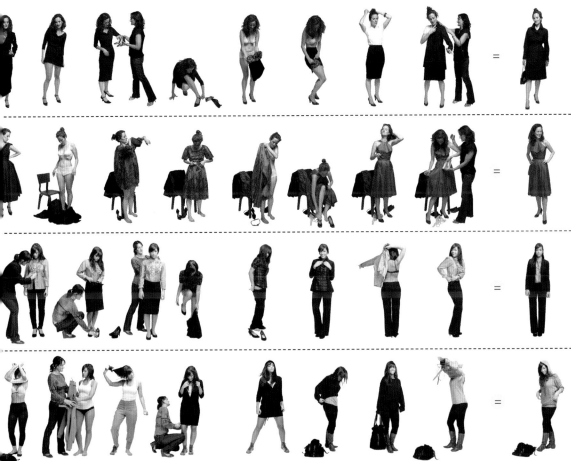

Pink Petticoat
Tail Cookies

COOKIES
1 cup butter
1 cup sugar
1 egg
2 teaspoons rose water
3 drops red food coloring
2¾ cups flour
Pinch salt

TOPPING
6 tablespoons finely
chopped walnuts
¼ cup sugar

EQUIPMENT: baking stone

Heat oven to 350 degrees. Cream butter and 1 cup sugar in a mixer; add egg and mix well. Add rose water and red food coloring and mix well. Stir together flour and salt in a separate bowl, then add to butter and sugar mixture gradually, 1 cup at a time. Roll out dough ¼ inch thick on well-floured surface. Cut into heart shapes with medium-size heart-shaped cookie cutter. Place on baking sheet. Stir together walnuts and sugar with a spoon and gently sprinkle nut and sugar topping over tops of cookies. Bake 6 to 8 minutes.

6

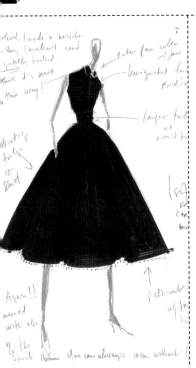

7

1

The

HAIROGRAPHY

of Pat Cleveland

In this installment of Hairography, we chronicle the life and locks of Pat Cleveland, who began modeling at 15 years old, in 1967, and quickly rose to fashion superstardom. Once regarded as a tangle-prone nuisance, Cleveland's hair eventually became one of her most unique—and fiercely coveted—features. Her signature 'do, an un-

From the wall:
Prince Charles
in hard hat and protective
glasses.

sketch

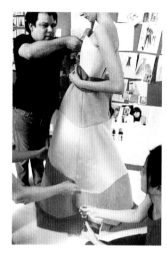

make

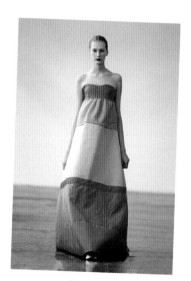

show

look! (a book)

that everything comes back to paper and the printed page, even fashion.

Books: Are accessories. My office has a well-considered selection of books: not too many, not too few. Books can be a weighty burden. I am sure someone has been killed by books, crushed by their mighty force. Some books of mine are left out on shelves to just be looked at, the spines never cracked. When I get my hands on rare and expensive books that I can't afford, I carefully photocopy them onto reams of paper that sit on shelves, and then I wait for the day when some smart publisher puts them back in print. There are also the books that I can't live without and those I can't wait to read, and can't wait to live without. All the books serve a purpose; if not, they go.

Look books: The staple of any clothing collection. Once a collection has been put together, it is documented and a look book is made to catalog the outcome (see facing page).

Vreeland, Diana: Any aspiring art director, no matter what you do or where you work, should read the book *Allure* by Diana Vreeland. I keep a copy on my desk, in my bathroom, and behind my ear at all times. Isaac and I often refer to this book, it is common and beloved ground, maybe a place to turn to when we can't quite put something into words.

Bodoni, Giambattista: "An Italian genius created America's most widely used typeface." So reads the first sentence of the first issue of my favorite magazine ever, Alexey Brodovitch's *Portfolio.* The text you read here is set in Bodoni Book.

Umbrella: Also known as a parasol, brolly, or bumbershoot. Has anyone made couture umbrellas? The movie *The Umbrellas of Cherbourg* made me think of this. Movies on my list: *Broadway Danny Rose, Once Upon a Time in the West, Death in Venice,*

Fantasy design for couture umbrella using a Bodoni J for handle.

Pockets	Sleeves
pocket rocket	batwing
watch pocket	bell
pocket money	bishop
pocket knife	cap
pocket piece	dolman
breast pocket	gigot
pocket-sized	green
pocket mouse	hanging
coin pocket	juliette
pocket pussy	pagoda
pocket borough	paned
pocket sheriff	poet
pocket pistol	puffed
pocket monster	raglan
	set-in
	three-quarter
	two-piece
	virago

From the wall: a printer's proof from a book I designed for Maira Kalman. Maira first introduced me to Isaac when the three of us shared a taxi uptown.

Invaluable designers on these projects have included: Laura Victore, Lindsay Ballant, and Josef Reyes.

From the wall (left to right):
cleaning up the aftermath of an explosion on 51st Street,
Leigh Bowery, portrait of Alexey Brodovitch by Richard Avedon

Zelig, Shampoo, Sleeper, Day for Night, Andrei Rublev, My Favorite Year, and *Touch the Sound.* Color is Isaac's first language, movies is second; I try to keep up but it's impossible.

Film idea: A documentary film about color, where all the subjects in this film would be blind people who once had sight. I would like them to discuss their memory of color. When you go blind, does color really disappear? And if not a film about critics, blind people, and color, then a year in the life of a professional Scottish pipe band.

On usefulness: If I had to choose, I might take something ugly and useful over something beautiful and useless. Diana Vreeland shocked the fashion world when she advocated pockets in women's dresses.

Style: As you design, as you get dressed in the morning, think about who you are doing all this for. Think about the people in your world, your friends who will see you that day, or see your hard work. Isaac said: "Style is how you show the world who you are."

Topics for future glossaries: Humpty-Dumpty, collections as biographies, wabi-sabi, hocus-pocus, topsy-turvy, Chauncey Gardiner, infinity, brevity, a clean desk, *Sgt. Pepper's,* a messy desk, Maira Kalman the designer, polka dots revisited, the pale blue dot, extravaganzas, suspense, and a well-made object.

Things I would like my pockets to include:

Pocket knife
Indelible pen
Discarded sugar packet
Toothpick
Place card from wedding
Free mints
Half a piece of gum
Matches from Waverley Hotel, Edinburgh
Various notes
Coins of foreign currency
Crumpled receipts
Best man speech
Phone numbers
Beer bottle cap
Newspaper clipping
Moustache wax
Missing button
Wife's lipstick
Plastic black comb
Needle and thread
Business card to be discarded
Business card to be kept
Small swatch of silk
Directions to event
Hotel key
Miscellaneous sundries
Cufflinks
Stray collar stay

Right: cover image from Fall 2007 look book for Isaac Mizrahi.

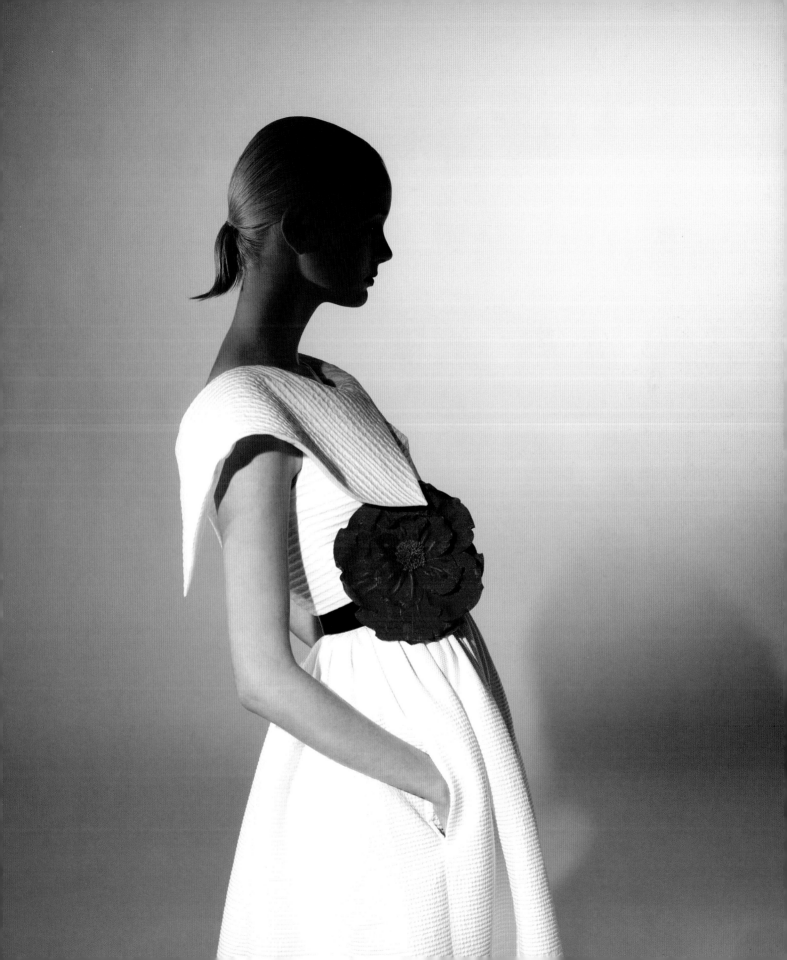

by Vincent Perrottet

Life,
Liberty,
and
the Pursuit
of
Happiness

with

Anette Lenz
and
Selina König,

Myr Muratet and
the "Graphistes
Associés",

Joël Gunzburger,
Karine Louis
and
Marie-Christine
Léger,

Antonio Ugidos,
Didier Jayle
and
Céline Debrenne,

Pierre Kechkéguian
and Marie-Emilie
Gallissot,

Sido, Emile,
Simon, Angèle
Perrottet
and (our cats)
Cheppe and Bibi.

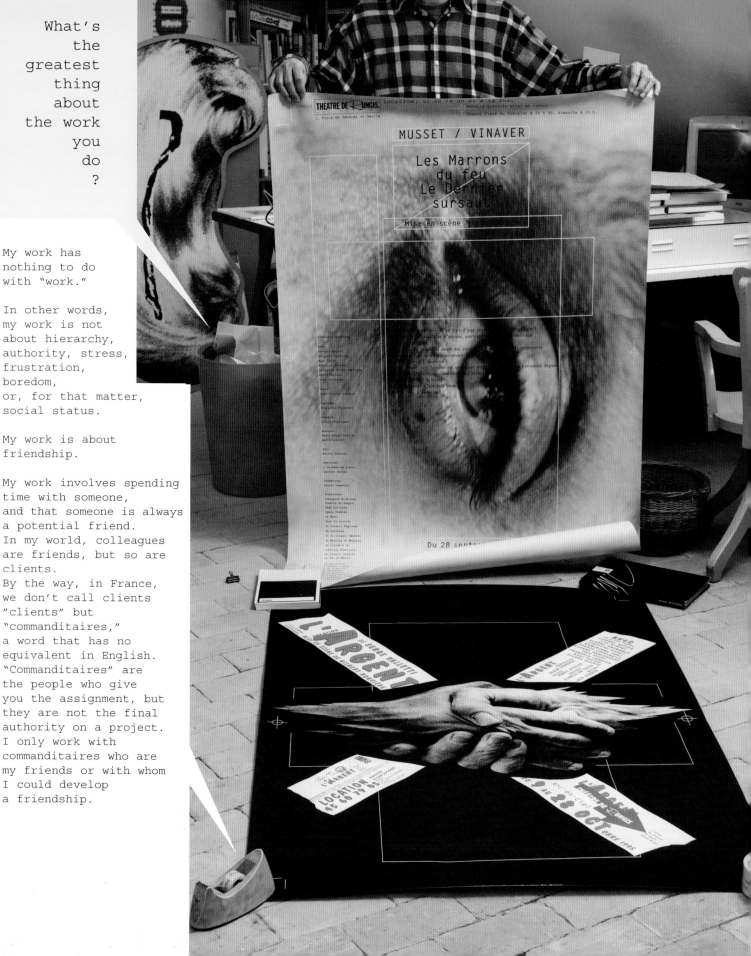

What's
the
greatest
thing
about
the work
you
do
?

My work has
nothing to do
with "work."

In other words,
my work is not
about hierarchy,
authority, stress,
frustration,
boredom,
or, for that matter,
social status.

My work is about
friendship.

My work involves spending
time with someone,
and that someone is always
a potential friend.
In my world, colleagues
are friends, but so are
clients.
By the way, in France,
we don't call clients
"clients" but
"commanditaires,"
a word that has no
equivalent in English.
"Commanditaires" are
the people who give
you the assignment, but
they are not the final
authority on a project.
I only work with
commanditaires who are
my friends or with whom
I could develop
a friendship.

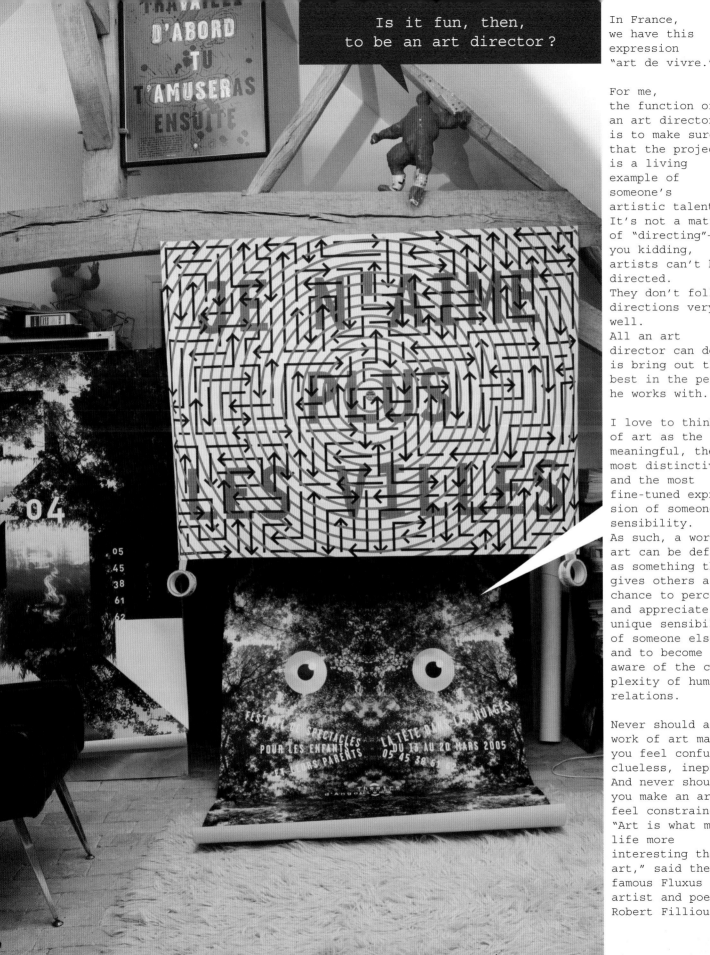

Is it fun, then,
to be an art director?

In France,
we have this
expression
"art de vivre."

For me,
the function of
an art director
is to make sure
that the project
is a living
example of
someone's
artistic talent.
It's not a matter
of "directing"—are
you kidding,
artists can't be
directed.
They don't follow
directions very
well.
All an art
director can do
is bring out the
best in the people
he works with.

I love to think
of art as the most
meaningful, the
most distinctive,
and the most
fine-tuned expres-
sion of someone's
sensibility.
As such, a work of
art can be defined
as something that
gives others a
chance to perceive
and appreciate the
unique sensibility
of someone else
and to become
aware of the com-
plexity of human
relations.

Never should a
work of art make
you feel confused,
clueless, inept.
And never should
you make an artist
feel constrained.
"Art is what makes
life more
interesting than
art," said the
famous Fluxus
artist and poet
Robert Filliou.

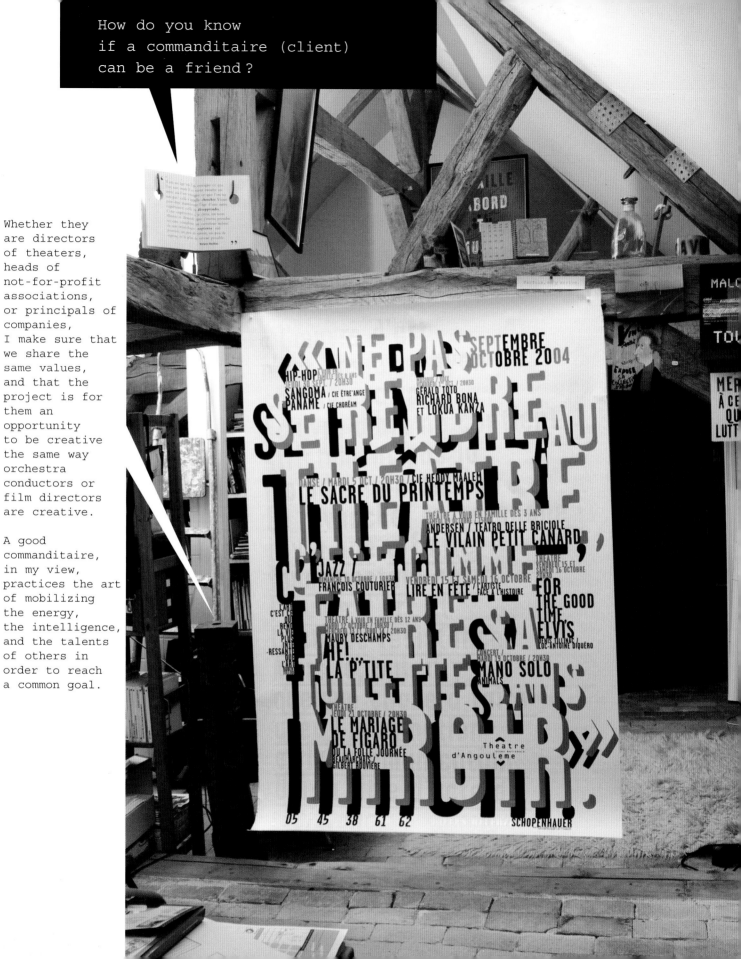

How do you know
if a commanditaire (client)
can be a friend?

Whether they
are directors
of theaters,
heads of
not-for-profit
associations,
or principals of
companies,
I make sure that
we share the
same values,
and that the
project is for
them an
opportunity
to be creative
the same way
orchestra
conductors or
film directors
are creative.

A good
commanditaire,
in my view,
practices the art
of mobilizing
the energy,
the intelligence,
and the talents
of others in
order to reach
a common goal.

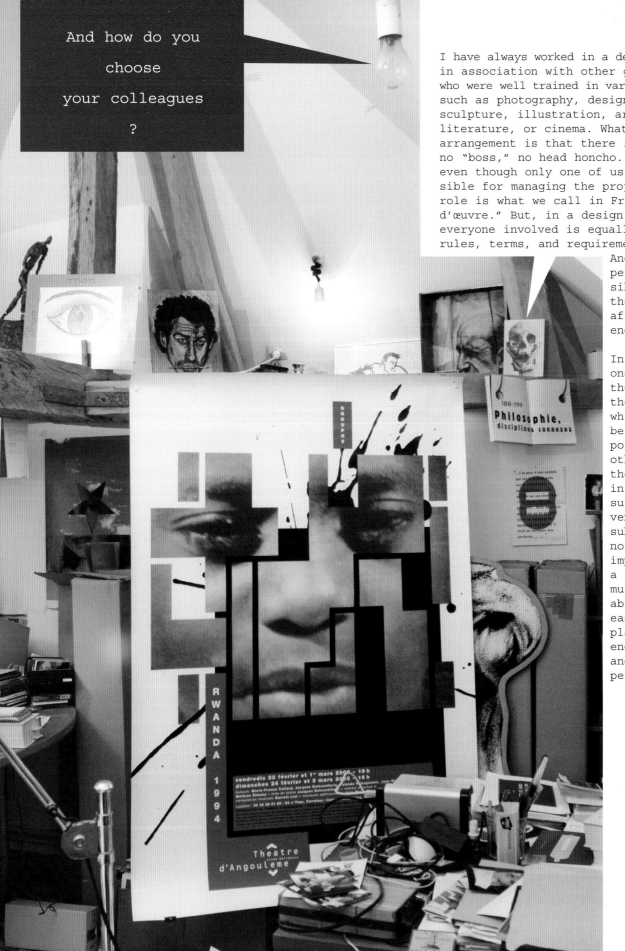

And how do you choose your colleagues?

I have always worked in a design collective, in association with other graphic designers who were well trained in various disciplines, such as photography, design, painting, sculpture, illustration, architecture, literature, or cinema. What I like about this arrangement is that there is no director, no "boss," no head honcho. We work together, even though only one of us might be responsible for managing the project. His or her role is what we call in French "maître d'œuvre." But, in a design collective, everyone involved is equally aware of the rules, terms, and requirements of a project. And all are personally responsible for the way the users will be affected by the end product.

In other words, one must share the premises and the consequences, while all along being open to the possibility that other members of the team might act in ways that are surprising, unconventional, or even subversive. It is not unlike jazz improvisation, a form in which musicians must be able to listen to each other as they play—be skillful enough to change and adapt while performing.

Friendship plays a critical role here. You have to be willing to be critical and be criticized by people you trust. Unlike traditional teamwork, in which people are assigned to different phases or parts of a project, in a design collective everyone works on everything and owns an equal share of the end product. In this type of creative endeavor, there is no room for competition. The commanditaire is as much a creative force as anyone else, and their contribution as much a source of inspiration and delight.

We draw much satisfaction, for instance, from learning about the specific cultural dimension of a project from the client's brief. Nothing is more gratifying than discovering what works and what does not work for a particular type of business or industry.
The more specific the problem solving, the more fun it is. But in the end, I measure the success of a project by the amount of pleasure I derive from it.

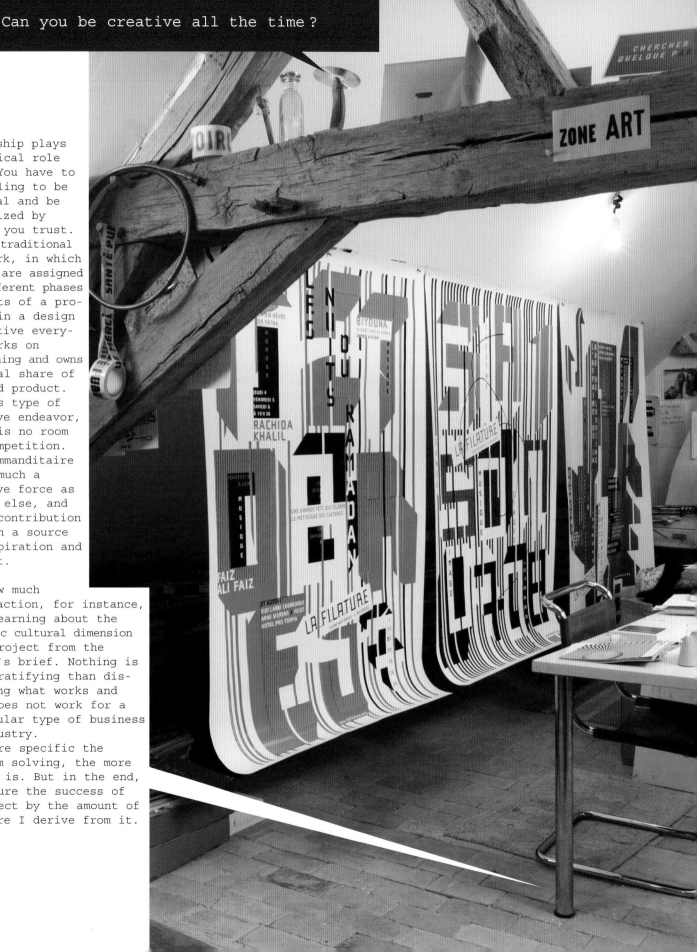

How do you stay current
and open-minded:
do you take classes, read critical
essays, do personal work?

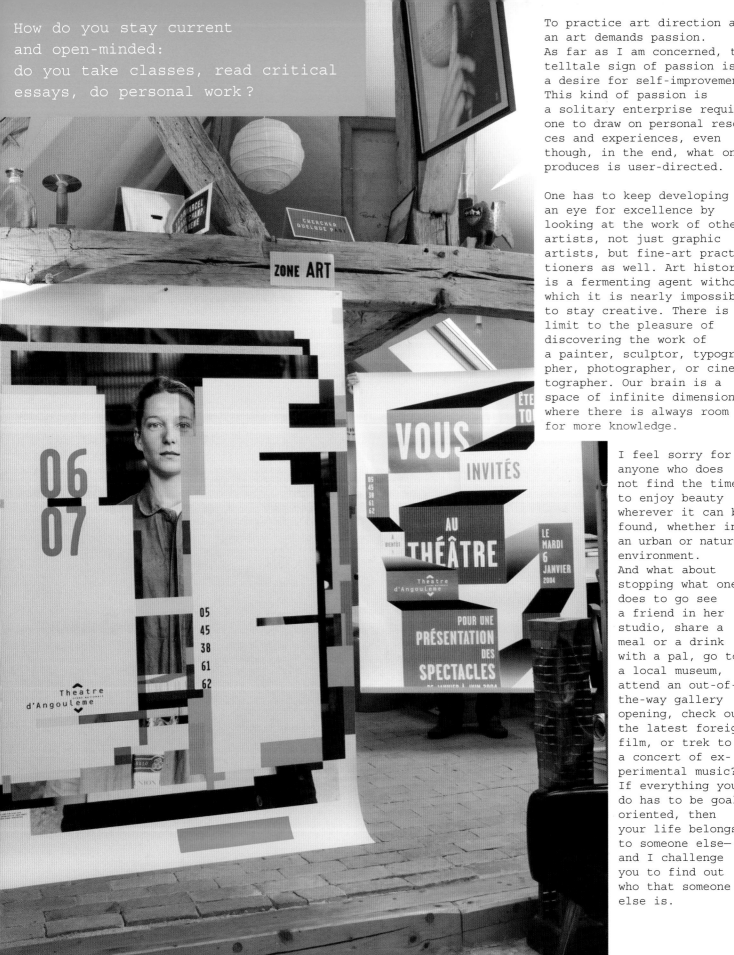

To practice art direction as
an art demands passion.
As far as I am concerned, the
telltale sign of passion is
a desire for self-improvement.
This kind of passion is
a solitary enterprise requiring
one to draw on personal resour-
ces and experiences, even
though, in the end, what one
produces is user-directed.

One has to keep developing
an eye for excellence by
looking at the work of other
artists, not just graphic
artists, but fine-art practi-
tioners as well. Art history
is a fermenting agent without
which it is nearly impossible
to stay creative. There is no
limit to the pleasure of
discovering the work of
a painter, sculptor, typogra-
pher, photographer, or cinema-
tographer. Our brain is a
space of infinite dimension
where there is always room
for more knowledge.

I feel sorry for
anyone who does
not find the time
to enjoy beauty
wherever it can be
found, whether in
an urban or natural
environment.
And what about
stopping what one
does to go see
a friend in her
studio, share a
meal or a drink
with a pal, go to
a local museum,
attend an out-of-
the-way gallery
opening, check out
the latest foreign
film, or trek to
a concert of ex-
perimental music?
If everything you
do has to be goal-
oriented, then
your life belongs
to someone else—
and I challenge
you to find out
who that someone
else is.

How do you discover,
nurture, or
champion new talent?

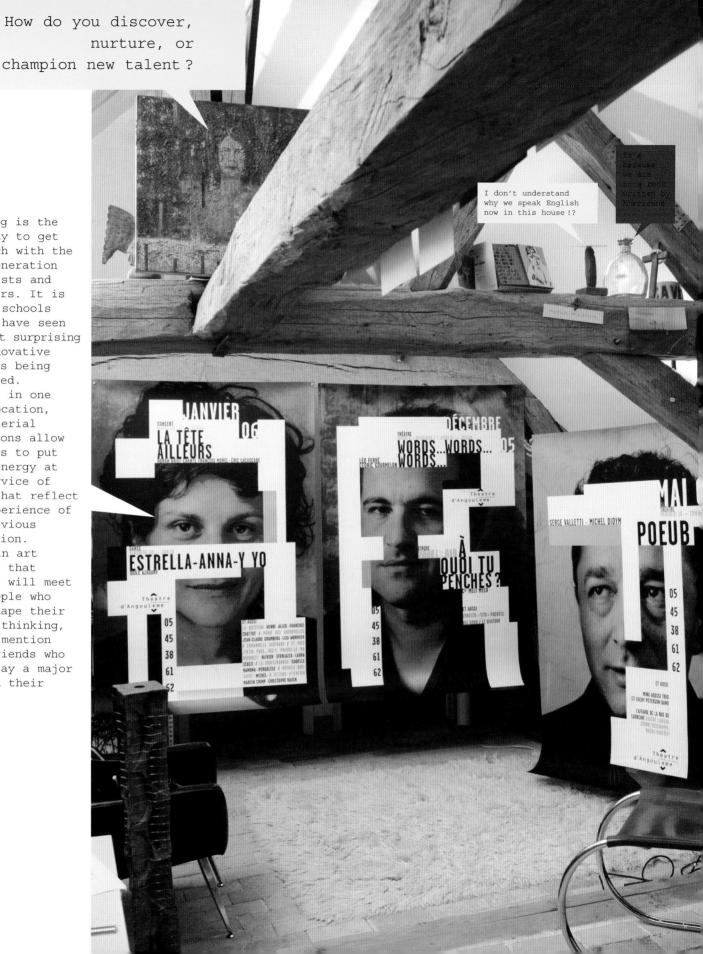

Teaching is the
best way to get
in touch with the
next generation
of artists and
designers. It is
in art schools
that I have seen
the most surprising
and innovative
projects being
developed.
Indeed, in one
such location,
the material
conditions allow
students to put
their energy at
the service of
ideas that reflect
the experience of
the previous
generation.
It is in art
schools that
artists will meet
the people who
will shape their
way of thinking,
not to mention
meet friends who
will play a major
role in their
lives.

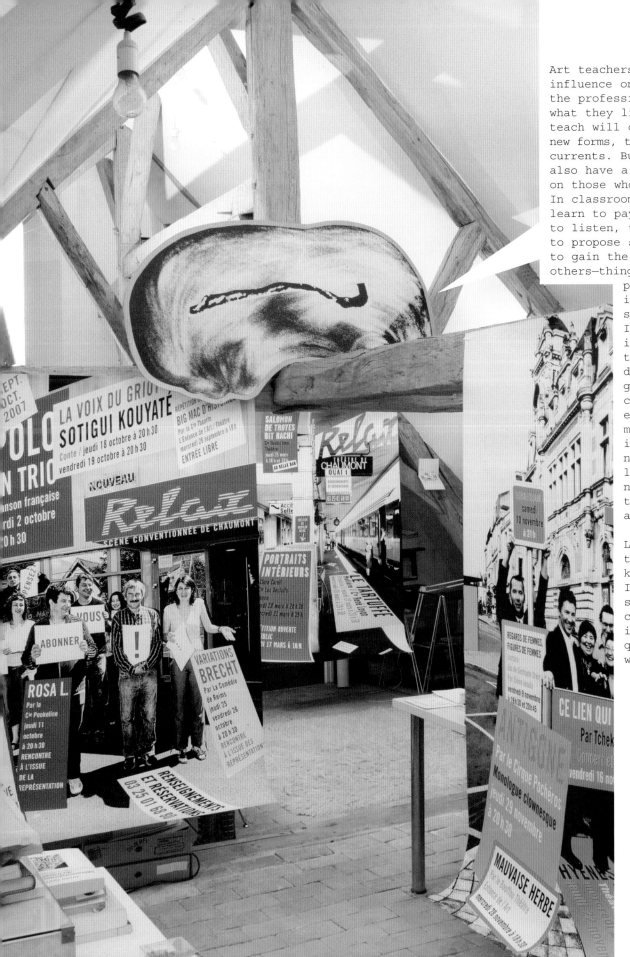

Art teachers are the biggest influence on the future of the profession. Who they are, what they like, and how they teach will determine the next new forms, trends, and artistic currents. But teaching will also have a joyful impact on those who teach. In classrooms, educators learn to pay attention, to listen, to critique, to propose solutions, and to gain the respect of others—things that they can put to practice in their own studios.

In fact, teaching is nothing more than a dialog during which a group of people come together to exercise their minds, engage in intellectual negotiations, and learn to formulate new ideas that they can all claim as their own.

Let's face it, teaching is what keeps us honest. It is the touch-stone by which we can evaluate and improve the quality of our work.

Can art direction be taught
?
What would you say
to someone who wants
to become an art director
?

There is no risk of anyone ever asking this stupid question.
No one "wants" to become an art director. The job can be
interesting, but, in my opinion, the word we have to describe it
is all wrong.

First of all, I don't like the label of art director, because
I don't like people who need the word "director" to explain what
they do.

I don't particularly enjoy being "directed"—so I don't believe
that you can give "directions" to someone creative (I only take
directions from people I love, but that's another story).

I don't wish to work with people who expect me to direct them.

I don't feel good in
the presence of artists
who do not consider
that their job is to
subvert the status
quo—even if it's only
wishful thinking.

I don't have any desire
to support a system
that encourages artists
to wait to be told what
to do—or to support
the idea that there is
a creative pecking
order in the universe.

I don't intend to ever
enter into a transac-
tion that does not
acknowledge the differ-
ences between people
but tries on the
contrary to impose a
consensus.

I don't want to become
mean and hateful
because someone in a
position of authority
is mean and hateful
with me or with other
fellow human beings.

In other words, I don't
think that being
creative should ever require we "direct" people and deprive them of
certain unalienable rights… among them Life, Liberty, and the Pursuit
of Happiness (or, as we say in French, "the pursuit of pleasure").

laurie rosenwald

eine kleine

kidnapped!

art directors i have known, loved, respected and reviled

why bowie trumps brodovitch

a little background

i became, after extensive on-the-job training, and with mixed results, a production artist at the new york times magazine, then a designer at self, mademoiselle, and GQ.

to this day i am not sure what the differences are between creative director, art director, and designer. all i know is that like mel brooks as the 2000 year old man has said, i have known and worked with "the great and the near great." bea feitler, marvin israel, alexander liberman, and david bowie. wait! i think there's a story there, and i have several more.

eine kleine kidnapped

when did most people start using cell phones? it was a year before that. i had been visiting budapest, where i got food poisoning on a train. i had planned to travel from there to prague, but a cab driver told me there was "nothing good to eat" there. so there i was on the train bound for paris (where i could be fairly sure of a decent meal) in the dining car, drinking egri bikaver (bull's blood wine), the only nourishment i trusted. the train stopped at vienna, and on the platform i spied two austrian yuppies in armani suits, and carrying cell phones, board the train, where they sat at the table behind me. i am, ordinarily, a shy flower. but after a bottle or two i just might talk to a stranger. i asked them if i could pay them "anything" to borrow a phone. i hadn't checked my new york answering machine in days, as at that time hungarian phones were rotary, and couldn't make the required beeps to access it. this i did, and found out that i was being offered a huge ad campaign, a solo exhibition, and a first class trip to tokyo.

this was superfantastic wow news and i had nowhere to kvell. i told the austrian yuppies.

GQ layouts

(i'm sure it's just my blind delusion, but to me, these still look good)

NOTA BENE!
the photo quality of my older work is abysmal. they were shot through ancient laminating film in a darkened closet.

they turned out to be art directors from an agency called "dangerous" in salzburg. i should have known—they were wearing those design-y glasses. i had a postcard with my drawings on it. clearly impressed, they started yakking in german. i said "what—you got a big ad job for me?" they asked me my day rate. i was incensed. "day rate? day rate? i am not a prostitute or a photographer! i am an illustrator!" we settled upon a day rate of a thousand dollars, plus airfare to paris. i got off the train with them in salzburg, where hundreds of japanese tourists were attending what seemed to be a permanent mozart festival.

they checked me into a fancy hotel. the next morning i met them at 8:00 a.m. for sacher torte and viennese coffee. my schedule was all typed up. i designed a new identity and name for a company that made things like hang gliding equipment out of rip-stop nylon. i called it "far out." i went to dinner with one of the art directors and we had the following conversation:

AD "what's it like?"

LR "what's what like?"

AD "to be a new york jew. is it like the woody allen movies?"

LR "not exactly. i come from a long line of anti-semitic jews."

AD "oh. you know, i have never met a jew before."

LR "really? *i wonder why.* but danke schoen for the wienerschnitzel, wolfgang!"

i bring brush lettering to japan (finally!)

i had an exhibition at the ginza art space in tokyo, owned by shiscido. i then took a side trip to kyoto, where i stayed at a small cheap ryokan. two art directors from shiseido tracked me down there. they wanted me to do some brush lettering (?!) for a sign for a cosmetics store called "color message." a big rush job. i said i'd be delighted but i was stuck in kyoto and had no art supplies and didn't even have a table in my tiny room. they said they'd fix everything. they showed up a few hours later with brushes, ink, and the huge white paper i'd requested. they asked the lady who owned the ryokan if we could use the table in her dining room, where i proceeded to get ink all over the floor. she threw us out, they paid her off, and we took a taxi to a fancy hotel. i walked into the lobby, covered in ink, holding my wet drawings high and flat like a pizza. the two art directors rented us a room *by the hour.* they drank beer while i finished the work, and then they paid me in cash, which could have equaled ten or ten thousand dollars. i counted the millions of yen in the bathroom, clueless.

when i returned to tokyo two days later, "color message" was already a store.

●

1988

5 plates
shiseido the ginza

they asked for
eggs, fish, peas, cheese
and cherries.
oh, japan.

groove dots
morozoff chocolates

t-shirt, fiorucci

the italians

when i worked for the ⬛⬛⬛⬛⬛⬛ art directors at fiorucci circa 1978, they paid my trip to their headquarters in milan where they put me up at the trendy *hotel diana* for 3 or 4 days, and then... well, it's a good thing i make friends easily. i ended up living with my new boyfriend in a transvestite bordello, and designed everything from bathing suit fabric to shopping bags and in-store displays. i counted the millions of lira in the bathroom, clueless.

everyone who knew fiorucci was surprised i'd been paid at all. i know it was because they liked me. or, more likely, pitied me. personality is everything, and always has been. especially in that tiny, incestuous milanese design world. you ate, drank, slept and discoed together. money was never discussed, let alone a contract. at 'torre di pisa' the cheque never came my way. never. i partied with sottsass and mendini, and babysat valerio castelli's bambini. in exchange i had a studio in the kartell headquarters outside milan. the whole kartell cartel always ate lunch together at a workers' restaurant in a field, where there was only one dish per day, and it was about the best food i'd ever eaten. then we'd buy watermelon from a stand.

in japan, 1990, an art director told me that because picasso was no longer available, i got the job. these truffles used to be packaged in picassos but they lost the rights. they wanted me to put *my* name on them instead. then i had to name them.

LR "how about gooey blobs?"
AD already copyrighted in japan.
LR "crunchy thangs?"
AD already copyrighted in japan.
LR "icky brown stuff!"
AD already copyrighted in japan.
LR "groove dots?"
AD i *think* this is still available.

it was. ●

one art director admired the vintage platform shoes i'd found at the flea market. he forced me to give them to him (a fetish?) at a party, and i walked home in ⬛⬛⬛⬛⬛ bedroom slippers. he copied them for the store, but i never saw them again.

changes

martha voutas, an art director i knew, knew someone who knew someone, and all of a sudden i was working for david bowie. i met him at his manager's office on 57th street. he opened the door and proceeded to charm the socks off me, in spite of his still-british teeth. we discussed the project, an album cover and poster for a documentary of bowie as ziggy stardust, called, appropriately, "ziggy." he then ordered cheeseburgers deluxe and cokes for us. we ate junk food and laughed. then i took the subway downtown and he flew back to switzerland.

this was *way* before e mail. i'd fedex different poster ideas to him. he'd phone me at odd hours, and say things like this:

"you know that poster you sent me last week?"

"yes."

"well, could you do something that's like, the opposite of that?"

"what do you mean?"

"well, you know the way it is?"

"yes."

"well, that's exactly what i don't want, so could you do something that's as different from what you did as possible?"

"um, sure thing, mister bowie!" so that's how i met david bowie, genius music legend and world's worst art director. that said, i've worked with several hundred horrible art directors, and not one of them can sing "rebel, rebel" worth a damn. i'm a bowie fan for ever. they ended up using a photograph, but still. i'll dine out on that cheeseburger as long as i live.

Arts & Events — The World Financial Center — Summer 1991 — CLASSIC

in concert

i once made a poster with art director stephen doyle, for the "classic and cool" jazz concerts at the world financial center. he said "i want to take my wasp sensibilities and your jew sensibilities and smush them together like this" (he rubs his hands together). it came out great, i think! ●

a close call in california or, how i almost became an art director

i knew someone who was friends with doug tompkins, the founder of esprit. they were looking for an art director, so they flew me first class to san francisco for an interview. doug picked me up at the airport on a motorcycle. i was wearing a very short skirt. by the time we got to the office, i looked like i'd been raped in a wind tunnel. you know that robert palmer video? well, esprit was an army of perfect, wholesome blonde girls in black cotton dresses and sneakers. there was a gym, an organic cafeteria, and other perks, if you consider those perks. even before the interview, i knew i'd never be their art director. not if it involved kayaking. ●

three brushes with art director greatness

alexander liberman said to paula greif, "steven meisel and laurie rosenwald are both dangerous, watch out."

i liked that. i worked with him when i was a designer at self and mademoiselle. he was absolutely right about everything he did, and he had those special vents cut into his jacket. i felt a direct line flowing from cassandre through liberman to me, but it was just my imagination.

paul rand called me "duckie" and pinched my cheek, *even after he'd seen my work.*

bea feitler hired me, fired me, and then apologized to me. we worked on the dummy for self together in 1979. i used to call it "young hypochondriac today."

bea was from brazil, always tan and beautiful. she wore silk shirts unbuttoned to the 4th button, with a gold chain. she designed the comeback of the new vanity fair. i tried some covers. her early death was so sad. she was so passionate about her work. she was a fighter! she told me to be creative, to not be so creative, and taught me how to blow smoke rings.

i think this nude was supposed to be on the cover of lears. maybe around 1989? wish i could remember the name of the A.D. he was good.

a lighthearted romp through the daisy-strewn minefield of art direction

c'mon, let's go!

the worst art directors in the world:

the one who tore my name off my 1981 bloomingdale's bag because i wasn't famous.

the one who tore my name off of my "paris '89" poster. because i wasn't french and was jewish.

the one who didn't pay me for my 14 pages of "issey miyake" ads when i was 22.

the one who said, "five hundred dollars? but that's almost as much as we pay for a photograph!"

the best art director in the world:

marvin israel, revolutionary.

why? for one thing, he had been the unlikely art director of harper's bazaar, and fought tooth and nail for the bravest images. he worked with diane arbus, richard avedon and peter beard. for another, because he broke into an art director's office at conde nast and duct taped everything in sight. on a pile of bride's magazines, he wrote "you wish!" in magic marker. because he didn't care what anybody thought of him. also, he kept pigeons.

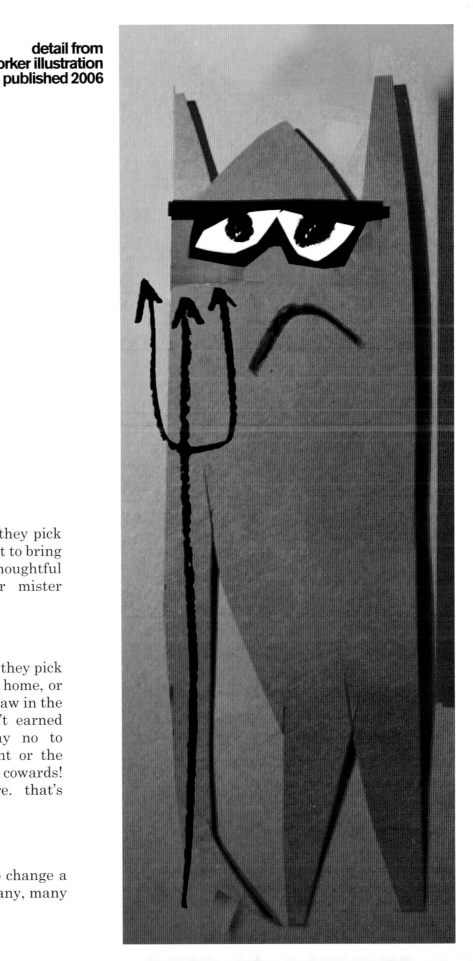

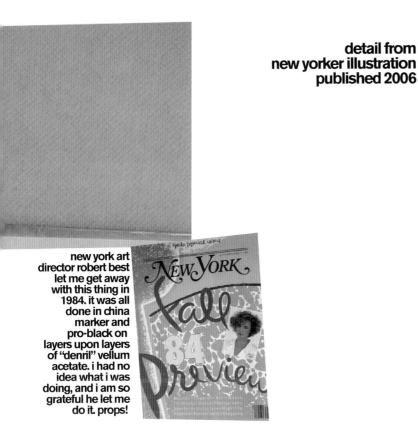

new york art director robert best let me get away with this thing in 1984. it was all done in china marker and pro-black on layers upon layers of "denril" vellum acetate. i had no idea what i was doing, and i am so grateful he let me do it. props!

A.D. angel:

art directors. what do they do all day? they pick the right person for the job and they fight to bring good work to light. they defend their thoughtful solutions to the client or editor or mister moneybags. that's their job!

A.D. devil:

art directors. what do they do all day? if they pick the right person for the job they can go home, or better yet, to that new restaurant they saw in the times. but then they feel they haven't earned their paycheck! so they have to say no to everything. they hide behind the client or the editor, blaming them. the spineless cowards! compromise, endless changes, torture. that's their job!

●

how many art directors does it take to change a light bulb? only one art director, but many, many changes.

i'm sure they all had their reasons. art directors and editors and clients don't like surprises but *i* do, so *i get over half my work killed. literally.* i teach a workshop called **"how to make mistakes on purpose"** so believe me. multiply these by the hundreds, and you'll get the picture. rosenworld: the little house that kill fees built. all those wasted years! so many great drawings nobody will ever see.

but if i'm going to waste time, this is a pretty good way to do it. i have more fun than most, and when i'm (really) old i can retire quite comfortably on my integrity.

r.i.p.

SECTION FOUR:
NUTS AND BOLTS

4

1. WHAT DO WE CALL OURSELVES?
ART DIRECTOR NOMENCLATURE

An art director by any other name...The title means many things to many people; no wonder it's hard to pin down what it means and to actually teach how to art direct. In some quarters titles are very important in terms of prestige and monetary reward, in others less crucial. But for the benefit of those who are confused by the nomenclature, here is a handy glossary to guide you through the maze.

ART DIRECTOR:

The title came into being some time in the very early twentieth century when the American magazine *Burr McIntosh Monthly* listed an art director as well as an art editor on its masthead. Presumably the art director was responsible for the layout of the publication, while the art editor selected (and perhaps commissioned) the art that ran in its pages. Prior to this the only "art" title was art editor. Today, art director is the most frequently used title for the creative overseer of design and images, although it is no longer the top title for the highest position.

CREATIVE DIRECTOR:

Somewhere around the early 1950s, the era in the United States known as the "creative revolution" and noted for the "big idea" in advertising, the title creative director was coined by the advertising executive Bill Bernbach. It was a step above an art director in that it implied a role that oversaw a broader swath of creative activity, that is, the big picture of the big idea. It is also used in other media today, from editorial to corporate to web, particularly for hiring purposes when another tier is required within a business structure.

DESIGN DIRECTOR:

This is another one of those hybrid titles that emerged in the mid-1960s, coined by Milton Glaser to distinguish his role as chief creative person (and part owner) of *New York* magazine, when it was the model for regional magazines in the United States. As design director Glaser oversaw the magazine's format, which was administered on a daily basis by the art director (Walter Bernard). The design director is also responsible for developing visual content. Now, in some structures the design director oversees many autonomous art directors, while in others the title is simply synonymous with art director (a more amiable or prestigious way of stating the same concept). Design directors are common in publishing, corporate communications, and retail areas.

EDITORIAL DIRECTOR:

This is another overseeing position of *über* art director, invented by Alexander Liberman, art director, and later editorial director, of Condé Nast. It conflates the jobs of creative director and editor-in-chief. In recent years the title has been cropping up on magazine mastheads.

CHIEF OR EXECUTIVE:

When these words are prefixed to the words art, creative, or design director one can assume a hierarchy that includes a design director, art director, and others below. In certain situations the prefix "senior" might also serve the same purpose. These titles may sometimes be arbitrarily affixed, but other times they are thoughtfully deliberated on to maintain a clear chain of command.

SENIOR ART DIRECTOR:

The prefix senior can be ambiguous. It might mean the highest echelon (creative director) or just a step above an art director. For argument's sake, let's say it is the position between design or creative director and art director in a multi-tiered art department. Nonetheless, having the title looks good on a résumé, and shows advancement from art director to the next important level.

DEPUTY ART DIRECTOR:

This title routinely means second in command. It is one of the few unambiguous distinctions. The deputy is directly under whichever title is in the top spot. The responsibility of a deputy is to help manage the design of the product and/or the art department or studio. The deputy will also engage in design, probably more than the creative or design director.

MANAGING ART DIRECTOR:

This is not a common title, but is occasionally used. He or she will often be a nondesigning member of an art directorial team, responsible for

managing daily activities from an operational standpoint. Sometimes the role is that of a deputy, other times it is a distinct and integral job.

JUNIOR ART DIRECTOR:

If there is a senior there has got to be a junior lurking. This title can suggest many things. At face value it is the assistant, or one step above assistant, to the art director or higher. It can be an entry-level position or a level above that. The title is fairly common in all media and fields. And if one is just starting out it is a good title to have.

ASSOCIATE ART DIRECTOR:

There is some debate here at glossary-central whether this title should come before junior art director. An associate is often higher than junior, but in a small art department could be synonymous with junior. In any case the responsibilities are usually the same. An associate will design pages, package, or whatever, just as a junior does. But an associate might also oversee certain sections or departments, which a junior may not.

ASSISTANT ART DIRECTOR:

This title can be replaced with junior or associate (though the latter is often higher). Title nomenclature is often determined by a human resources department and, while not arbitrary, is not necessarily in sync with other titles in other businesses. By the way, if the title is "assistant to the art director" it implies a different kind of job, usually a clerk or secretary. Assistant is not a priori a lower echelon of job (assistant managing editors on newspapers and assistant secretaries of state in the US government are high positions "assisting" the higher level position).

DESIGNER:

This title indicates someone who, well, designs, but does not officially art direct. A designer in most media is dedicated to specific projects that are usually overseen by an art director (or associate, junior, or assistant). Sometimes a designer is also a lower-level art director.

FREELANCE ART DIRECTOR:

This is not a title *per se*, but a state of existence. Many companies hire freelance art directors to oversee particular finite projects. In this case the art director is also usually a designer. Sometimes the freelancer works on his or her own but can also nominally be in charge of others working on the project.

VISUALS EDITOR:

In the hierarchy this title is not insignificant. In fact, it was coined by Elizabeth Biondi at the *New Yorker* in the 1990s; she serves as the photography art director. Seemingly, she is the only one to use this title as of the time of writing.

PICTURE EDITOR:

In some editorial or publishing venues this person reports to the art director. But in other venues the picture editor has a separate but equal position and is ostensibly responsible for commissioning and researching photography.

PRODUCTION EDITOR:

In certain venues the production editor acts as an art director, but essentially is responsible for managing, as the title suggests, the production systems. A production editor is not a designer.

MISCELLANEOUS:

Depending on the business the above terms may be used indiscriminately. Sometimes it will depend on how an individual wants to be considered inside and outside the company. Other times a title is based entirely on traditions established early in a company's history. Moreover, in addition to the relative definitions of these titles, the particular responsibilities vary from medium to medium, field to field, and business to business. Art directors for magazines do not do the same work as art directors for fashion companies or cellphone conglomerates, etc. When determining the most advantageous title, also be aware of who does what and who reports to whom.

2. HANDY ART DIRECTOR SAYINGS

THOMAS POROSTOCKY

Key Concepts		
	The Assignment	The gig. The job. The whole reason you're here. Your whole career is based on completing this task successfully. Don't screw it up (if you do, please refer to the kill fee).
	The Budget	The sum of money allotted in exchange for your services. This amount is often inversely proportional to the enjoyment, prestige, and virtue of the assignment. Note: a good art director will tell you what the budget is. A GREAT art director will ask you for a number, in case it's lower than he has money for.
	The Dimensions	While we realize your genius knows no boundaries, please contain your universe-altering ideas within the following physical parameters.
	The Payment Cycle	The mysterious vortex of time and chance that decides when (or sometimes IF) you will be paid for your services.
	The Deadline	The sometimes flexible, usually negotiable, time when your project must be handed in to a client. Be careful, however: stepping over this line without delivery does in fact give them the legal right to render you dead.
	The Kill Fee	The money given to make a problem go away. This is a bilateral ejection seat. Once it's activated it might be hard to get another chance at flying the plane.
	The Freelancer	This design mercenary is willing to do anything and everything for a price. He or she is smart enough to work for you, but not stupid enough to stick around.

The Excuses

"This looks great! But..."	This is exactly what we need. Which is exactly why we can't use it.
"It was an editorial decision."	It might be your fault. It might be my fault. But it will make both of us feel better to blame it on the guy down the hall.
"Sometimes these things happen."	You're the reason print is a dying industry.
"This will be a great learning experience for you."	The belief that a particular project will allow for the elevation of both skills and prestige to a previously unattainable level, forgoing the need for proper monetary compensation. Sometimes this belief is a sign of wisdom. Often, it is just a sign of cheapness.
"Let me run this by the folks here..."	I need to ask permission from those who don't trust me.
"I don't think it is quite up to publication standards at the moment."	Your picture is worth a thousand words. Unfortunately, most of these words include stars, pound signs, and exclamation points.
"The story has been pushed to the next issue."	Pushed off the cliff, never to be seen again.
"This is way too long. The copy needs to be cut."	While great effort has been made to do so, I regret to inform you that your novel will not fit onto this postage stamp.
"It is what it is."	The verbal equivalent of an ambivalent sigh. Often said in lieu of solid opinion.
"There's always the next issue."	Not for you, but there is one.
"It was a pleasure working with you."	Thanks for making me look good.

The Brief

"We're looking for something fresh."	We'd like something new. But not too new. I guess something that our clients can relate to. Sort of like this project we did before. But more so. Actually, you know what, just do that one again.
"We're looking to do something in the style of (X)."	Here's a fresh supply of tracing paper. Now get to it.
"This shouldn't take too much time."	Your loved ones might not recognize you by the time this is over.
"Does that sound acceptable?"	These are the terms. Take it or leave it.
"Have fun with it!"	Giving you the freedom of exploring new and exciting options will allow me the freedom of rejecting them in new and exciting ways.

The Comments...	"This is a good start."	One small step for man. One giant disappointment for mankind.
	"I have a few thoughts."	Here's what you did wrong.
	"We have a few tweaks"	Brace yourself for a massive shift in direction.
	"Make it bigger."	I'm going blind, and therefore so is everyone else. *-or-* I need glasses, but I'm not quite ready to admit it.
	"Can you make this pop?"	Make it bigger.
	"Can you give it more energy?"	Make it bigger.
	"Can you make this snappier, more colorful, more exciting?"	Make it bolder (and bigger).
	"That's the wrong orange. I was thinking of another orange."	Make it blue.
	"Yellow just doesn't work with our aesthetic."	I was attacked by a banana at the age of six.
	"Make it new, yet familiar."	One step forward. Two steps back.
	"Can you just take a fresh look?"	Please start from scratch.

...The Comments

"I don't know what it needs, but I'll know it when I see it."	The phrase that leads to the realization that you should have charged by the hour.
"This will require a lot of back and forth."	The endless conversation necessary to ensure a satisfying end.
"It's too modern."	I wanted a Buick.
"It's not modern enough."	I wanted a Buick...with racing stripes.
"Is it possible to..."	Do this. Or else.
"Can't you just Photoshop it?"	This phrase underlies the belief that simply to possess this magic software is to possess all skills necessary for any task, no matter how hard, in an amazingly brief amount of time. It is, however, impossible to Photoshop the sadness in your heart that this statement will undoubtedly cause.
"You're making the readers work too hard."	A, B, C, D, E, F, G...Won't You Dumb This Down For Me?
"It's too high-concept."	Progressive thinking has no place within these walls.
"Sorry to keep pushing but…"	That which doesn't kill you, only makes you want to kill yourself.
"This is great."	This is great. Seriously.

The Little White Lies...

"I'm just checking in."	Half of our staff have retired since you last made contact.
"I'm pretty well known in my field."	By field, I mean my class at school. And by well known, I mean present.
"Let me know if something comes up. I'm up for anything."	Yes, I AM willing to compromise my ethics.
"What's your schedule like these days?"	If you're too busy, we can't use you. If you're not busy enough, you just might not be worth it.
"The possibility of future work."	If you'll let us take advantage of you now, you'll win the chance for us to take advantage of you in the future.
"I've heard good things about you."	The lazy, yet ultimately effective, art of appropriating your colleagues' contributors instead of going out and looking for new talent yourself.

...The Little White Lies

"Wow, that's weird, I never got that email."	It's big enough to connect people across continents and support billions of dollars in commerce, yet the Internet is still mindful enough of your needs to know when to conveniently lose those important emails that require uncomfortable responses.
"Wow, that's weird, I guess the cheque got lost in the mail."	When blaming email is just not an option, your local postal service can be a wonderful fallback.
"This'll be great exposure for you."	You look like someone who could use career advice from someone who has no idea what you do.
"Got it. Thanks."	Often said after a contributor has sent in their work, this phrase indicates an art director who wishes to deflect attention away from their disappointment, by emphasizing the highly important fact that they are in indeed in possession of the negotiated material.
"Experience is not useful in this business."	The less you know, the more we can exploit you.
"The new management will keep the staff intact and has no plan to change the editorial direction."	The new management is pleased to announce this fabulous opportunity for all employees to reinvigorate their résumés.
"Keep in touch."	Go away now. Feel free to make contact in the future. But do go away.

3.WHAT AND WHERE
JOB LISTINGS

What art direction is, and what it is not, is still an open question. The title of art director is not necessarily an indication of the job. Creative directors, editorial directors, graphic designers, photographers, production designers, picture editors, stylists, publishers, exhibition designers, fashion designers, and even product designers are often acting as art directors, whether or not they acknowledge it.

Only one thing is sure: an art director is someone for whom the creative process involves interacting with other artists as talented as he or she is, the same way the conductor of an orchestra interacts with musicians. One could say that an art director is someone whose main leadership quality is an ability to listen to what others have to say, or are trying to say. The list below is a practical guide to where art directors are most needed.

IN NEWSPAPER PUBLISHING:
Art directors are assigned to specific sections of a newspaper, such as the book review, the Sunday magazine, the business pages, or the home section. They have quite a lot of independence since they only report to the editor of their particular section, with whom they work closely. While journalists will get a byline, the names of newspaper art directors seldom appear on the publication masthead.

IN ADVERTISING AGENCIES:
Art directors traditionally are teamed up with copywriters, and their relationship is that of two equals. They both report to an account executive who handles their clients. Frustrating as it is sometimes, not being invited to the big meetings with clients can give the creative pair more independence. The art directors are never credited for the advertising campaigns they design; neither is anyone else in the agency for that matter. The clients take full ownership of the work.

IN BOOK PUBLISHING:

Art directors not only design book covers, they are also in charge of developing the style and character of various imprints: special collections, classic series, or branded titles. They are usually credited on the back flap, under "Cover design by...", above the name of the photographer responsible for the author's portrait.

..

IN MAGAZINE PUBLISHING:

Art directors interact on a daily basis with the editor-in-chief, to whom they report. They are the emissary of the many photographers, illustrators, and typographers whose work they must "sell" to editors. They sign off on all the layouts, though the original format of the magazine may have been provided by someone else and the pages may have been designed by an assistant on their staff. Their name appears on the masthead, either as "creative director" or as "art director."

..

IN DESIGN STUDIOS:

Graphic designers act as art directors as they assemble the various elements of a brochure, a poster, or a package design: photography, typography, lettering, drawings, etc. They report to the studio head, who will usually be a graphic designer like them and thus will speak the same language. They can, and often do, meet their clients and interact with them. This type of art director is seldom credited for his or her part in the final outcome, but is rewarded by being included in the creative process right from the start.

..

IN FILM PRODUCTION:

Art directors are in fact set decorators. They are responsible for the design and the final drawings of the visual environment of a film. They report to the production designer, who not only controls the decor but also the costumes and the settings of the various locations. Though they build 3-D backdrops, film art directors must keep in mind that their work will be seen in 2-D, and that it must meet the approval of the director of photography. They get credited along with everyone else, but their boss is the person most likely to get nominated for an Oscar.

ON PHOTO SHOOTS:

In this situation art directors act as both overseers and facilitators. They are sometimes called "shoot producers." Whether on a set or on location, they are buffers between the ego of the photographer (often a prima donna) and that of the client or the editor. Art directors don't want to interfere with the photographer and undermine his or her authority, yet they must be ready to intervene in case of conflict. They don't say much, but are everywhere and watch everything. Never credited for the final result, they get blamed if anything goes wrong or if the client/editor rejects the pictures.

..

IN THE CORPORATE WORLD:

Art directors are called design directors, presumably because the word "art" makes business people nervous. The job of these in-house corporate art directors is to establish and manage the visual identity of the company that employs them. They may design the logo and supervise its applications, but they are not in charge of the brand itself—something usually handled by advertising agencies and their subsidiaries. Whom these art directors report to depends on the organizational chart. In the worst case scenario it's a marketing director, but with a little luck it may be a vice-president in charge of communications, or, even better, an enlightened CEO. Signing your work is out of the question—Paul Rand signing IBM posters was a noted exception.

..

IN CULTURAL INSTITUTIONS:

Art directors, who oversee exhibit designers, have jobs that resemble magazine art directors. Like their editorial counterparts they work with narratives, telling a story in a linear fashion. Designing a magazine is not unlike designing a catalog, and turning pages is comparable to turning corners as you walk through an exhibition. Museum art directors report to curators who act as editors, with different curators in charge of different shows. These art directors seldom get credited as they are not supposed to compete with the artists whose work hangs on the walls.

4. ALL OF THE ABOVE
A HISTORICAL QUIZ

The history of art direction in ten easy, insightful, multiple-choice questions.

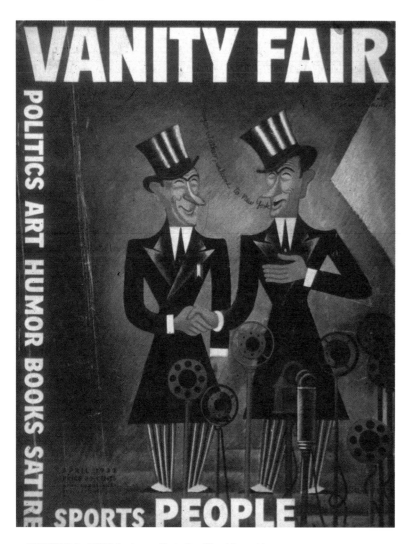

▲ *VANITY FAIR*, April 1932, front cover. Illustration: Miguel Covarrubias

▲ *VANITY FAIR*, May 1935
Front cover. Illustration: Paolo Garretto

1. Who was Mehemed Fehmy Agha?

Ⓐ The man who should be credited for inventing the profession of editorial art director.

Ⓑ A fierce Russian émigré who worked in New York at *Vogue*, *House & Garden*, and *Vanity Fair* between 1923 and 1943.

Ⓒ A pioneer of Modernism who introduced asymmetrical compositions and full-bleed color photography to magazine layouts.

Ⓓ Not to be confused with Alexey Brodovitch.

Ⓔ All of the above.

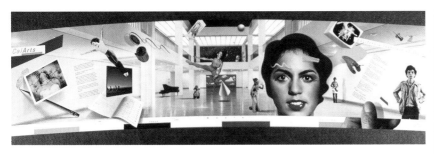

▲ *CALARTS POSTER*, 1979. Art Directors: April Greiman and Jayme Odgers

2. Who invented—and reinvented—photomontage?

(A) Hannah Höch with *Da-Dandy*, in 1919.

(B) Raoul Hausmann with *Tatlin at Home*, in 1920.

(C) Max Ernst with *La Santé par le Sport*, in 1920.

(D) Alexander Rodchenko in *Pro Eto*, in 1923.

(E) El Lissitzky with *The Constructor*, in 1924.

(F) John Heartfield with *Deutschland, Deutschland über Alles*, in 1929.

(G) April Greiman in *Design Quarterly*, in 1986.

(H) All of the above.

3. Why were post-WWII Polish poster designers such great art directors (the greatest, probably)?

(A) Because they had learned to overcome Communist repression by thinking conceptually.

(B) Because they were interacting with a visually literate and politically involved audience.

(C) Because they shared with their public a love of theater and drama.

(D) Because they were respected as full-fledged professionals.

(E) Because they were well trained in prestigious state-sponsored art schools.

(F) All of the above.

CONTAINER CORPORATION OF AMERICA

▲ *DESTINY OF AN OLD DIRECTORY*, 1939
Poster. Art Director: Herbert Bayer

4. What do the initials CCA stand for?

(A) Container Corporation of America.

(B) The progressive packaging company that hired prestigious designers to art direct its famous advertising campaign "Great Ideas of Western Man."

(C) The first sponsor of the Aspen Design Conference.

(D) A Chicago firm that pioneered modern design through its association with artists such as A.M. Cassandre, Man Ray, Herbert Bayer, Fernand Léger, Herbert Matter, René Magritte, László Moholy-Nagy, and John Massey.

(E) All of the above.

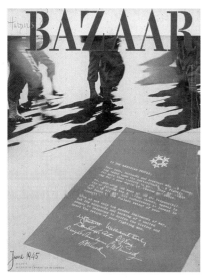

▲ *HARPER'S BAZAAR*, June 1945
Front cover. Art Director: Alexey Brodovitch

Ⓐ The other fierce Russian émigré, who was art director of *Harper's Bazaar* in New York from 1934 to 1958.

5. Who was Alexey Brodovitch?

Ⓑ A legendary figure known for his use of fashion photography, which he laid out in such a way as to express movement, energy, and modernity.

Ⓒ An innovator who knew how to turn text blocks into elegant abstract forms.

Ⓓ A visionary who assigned cover illustrations to avant-garde artists such as A.M. Cassandre, Herbert Bayer, and Salvador Dalí.

Ⓔ The genius who art directed the short-lived magazine *Portfolio*.

Ⓕ All of the above.

6. Which industry leader was most supportive of art directors?

Ⓐ Adrien Bénard, Paris Métro (Hector Guimard).

Ⓑ Condé Montrose Nast, Condé Nast (M.F. Agha, Alexander Liberman).

Ⓒ Walter P. Paepcke, CCA (Charles Coiner, A.M. Cassandre, Herbert Bayer).

Ⓓ Thomas J. Watson Jr., IBM (Paul Rand, Charles and Ray Eames).

Ⓔ Steve Jobs (Paul Rand, Clement Mok).

Ⓕ Adriano Olivetti (Giovanni Pintori, Ettore Sottsass).

Ⓖ Luciano Benetton (Oliviero Toscani, Tibor Kalman).

Ⓗ All of the above.

▲ *PSYCHO*, 1960
Title sequence. Art Director: Saul Bass

7. What's so special about the shower scene in Hitchcock's *Psycho*?

Ⓐ It's an early example of animation graphics (1960).

Ⓑ The storyboard was drawn by art director and film-title master Saul Bass.

Ⓒ It is the subject of countless debates in film courses, but also in design classes, because no one can figure out why it's so terrifying.

Ⓓ Each frame is carefully composed, each a graphic masterpiece.

Ⓔ It shows that a good art "director" knows how to direct.

Ⓕ All of the above.

8. Which art director turned to photography mid-career?

Ⓐ Art Kane.

Ⓑ Henry Wolf.

Ⓒ Alexey Brodovitch.

Ⓓ Richard Avedon.

Ⓔ Lloyd Ziff.

Ⓕ Peter Knapp.

Ⓖ Fred Woodward.

Ⓗ All of the above.

9. Which historical style is most often copied by art directors in the United States?

Ⓐ Dada.

Ⓑ Russian Constructivism.

Ⓒ De Stijl.

Ⓓ Swiss Typography.

Ⓔ Beach Culture.

Ⓕ Retro Vernacular.

Ⓖ All of the above.

▲ *THE DADA PAINTERS AND POETS*, 1951
Front cover. Art Director: Paul Rand

10. Which book on design theory written by an art director should you own?

Ⓐ *Language of Vision*, György Kepes (1944).

Ⓑ *Vision in Motion*, László Moholy-Nagy (1947).

Ⓒ *Thoughts on Design*, Paul Rand (1947).

Ⓓ *Never Leave Well Enough Alone*, Raymond Loewy (1951).

Ⓔ *Typography*, Aaron Burns (1961).

Ⓕ *A History of Visual Communication*, Josef Müller-Brockmann (1971).

Ⓖ *L'ABC du Métier*, Robert Massin (1988).

Ⓗ *The Art of Advertising*, George Lois (1977).

Ⓘ *Visual Thinking*, Henry Wolf (1988).

Ⓙ *Hybrid Imagery*, April Greiman (1990).

Ⓚ *Design Writing Research*, Ellen Lupton & J. Abbott Miller (1996).

Ⓛ *The Art of Looking Sideways*, Alan Fletcher (1998).

Ⓜ *The Education of an Art Director*, Steven Heller & Véronique Vienne (2006).

Ⓝ All of the above.

ANSWERS: All of the above.

EXTRA! EXTRA!
DEPARTMENT OF IRRECONCILABLE DIFFERENCES: MY DINNER WITH BERNARD
VERONIQUE VIENNE

You've heard of *My Dinner With André*, the 1981 cult film by Louis Malle? In the opening scene, the playwright Wallace Shawn is on his way to have dinner with a well-known New York theater director, André Gregory. The following script is a remake, the only difference being a change of venue (a Paris brasserie instead of a Manhattan restaurant) and a change of characters: the two theater men are replaced by two French creative directors.

In this setup the role of Shawn is played by Pascal Grégoire, a bearish figure, whereas Shawn was more beaver-like. The role of André, a tall and angular fellow, is played here by the gentler looking Pierre Bernard. But otherwise the dynamics between the pair are the same: like Shawn and Gregory, who had been avoiding each other for years even though they were in the same business, Grégoire and Bernard have ignored each other forever. The two men live in parallel universes, advertising and graphic design, and they do not speak the same language. Contrary to popular belief, the visual language is not a universal means of communication. In fact, in the case of Grégoire and Bernard, it is a subject of profound disagreement.

Indeed, had Bernard and Grégoire accepted a real invitation to meet, the encounter would have been yet another maddening episode during which people talk at each other, but never to each other.

Amazingly enough, in France tempers still flare up when the topic of art versus commerce comes up. Graphic designers and creative directors get riled in the presence of colleagues who do not share their opinion on subject matters such as the importance of "readability," the origins of the word "commerce," or the relationship between typography and politics.

Yet, even though they don't seem to agree on anything, professionals in the design world share a passion for concepts, ideas, issues, principles, and doctrines. In the United States the only graphic artists who can still get people to write angry emails or storm out of a room are Chip Kidd and Milton Glaser—bless their hearts. In Paris creative types consider that they are first and foremost "agents provocateurs," and that unless they can stir up a little trouble they are not doing their job.

MY DINNER WITH BERNARD

[We see Grégoire riding a cab through the streets of Paris and we hear his narrating voice as he goes past famous monuments: the Eiffel Tower, Notre Dame, and the Louvre.]

PASCAL GREGOIRE'S VOICE-OVER: The life of a creative director is fabulous. I always loved advertising. I adore it and make no apologies for it. It's my passion, it's my life, it's my métier. I am not saying that advertising is an art, mind you. Nonetheless it is connected to the contemporary art scene, and as an adman I am constantly crossing over to the other side, even building bridges between the two worlds. I don't care much about graphic arts though. And that's why I am sorry I agreed to have dinner with this Pierre Bernard fellow, a man I have made it my business to avoid all these years. But this American journalist trapped me into it. She said: "You are the creative director of a trailblazing ad agency, and a very persuasive individual, by all accounts. You are a genius when it comes to convincing people to see things your way. So, let me ask you, could you convince Pierre Bernard to change his mind about the design of the logo of the 'McLouvre' in Abu Dhabi?" I had no idea what she was referring to. She explained that Bernard had recently turned down, for "ethical" reasons, a design assignment from the Agence France-Muséums, the organization that is in charge of managing the potentially lucrative Abu Dhabi Louvre project. It will be designed by Jean Nouvel and is scheduled to open in 2012 in the Emirates. I foolishly said that I would love to try to convince Bernard to reconsider, and embrace both art and commerce in the name of "culture." So she arranged this dinner. To get ready for it I had to do some research to find out who exactly Pierre Bernard was. I discovered that he had designed the original Louvre logo back in 1993, right after the breakup of Grapus, the left-wing collective he had co-founded with a handful of disenfranchised poster artists like him. Why did he get that prestigious assignment? Beats me. Back then we were under a socialist regime! Bernard was not as radical as his colleagues, though. He said in an interview that unlike other members of his collective, who only wanted to work on projects with a progressive political agenda, he believed that graphic communication, when applied to cultural institutions, could be an instrument of social change. Social change! Such bullshit. Anyway, he said that back then he didn't want to support the cliché that the Louvre was a place of "order, reverence, and boredom"—his exact words! He wanted instead to express the fact that the works of art inside the museum were the property of the French people, not the property of a cultural elite. The whole idea of meeting him makes me nervous. I mean, I really am not up for that sort of thing. I can convince prospective clients, because we are in a business relationship, but this is personal. Political choices are personal. *Merde*, here we are. "Bofinger," that's the place. I hope that the maître d' gives us a good table.

NOTE: Though this conversation is fictitious, it is culled from separate interviews and chats with both Pierre Bernard and Pascal Grégoire during the spring of 2008, and from articles and books by them or about them. Don't be surprised, though, if portions of the dialogue are reminiscent of the *André* screenplay. With apologies to the late Louis Malle, we are here in pastiche land.

Pierre Bernard is one of the founders of the legendary Grapus collective and now the principal of the Atelier de Création Graphique. A role model for young graphic designers in Europe, he is a member of the Alliance Graphique Internationale (AGI) and also the recipient of the prestigious 2006 Erasmus Prize.

Pascal Grégoire is former president of CLM/BBDO and co-founder of La Chose, a cutting-edge Paris advertising agency specializing in online interactive communication. A maverick adman, he is perhaps the most aggressive spokesperson for his profession.

HEADWAITER: Monsieur Grégoire? Yes, your table is ready. Follow me.

GREGOIRE: How did you know who I was?

HEADWAITER: Monsieur Bernard told me to expect you. He described you as a tall handsome man. Here we are.

PIERRE BERNARD. Monsieur Grégoire? It's you, isn't it? I saw your picture on your website. [They shake hands awkwardly.] I did my homework before meeting you!

GREGOIRE: So did I. [He sits down.] I had my assistant buy all your books. I had to hunt for the last one, *My Work Is Not My Work*. Weird title. I even got the transcript of your acceptance speech for your Erasmus Prize. Truth be told, I didn't understand a word of it!

BERNARD: Well, truth be told, I am just as baffled by your ad campaign for the Milk Bureau. I saw it on YouTube. It's that strange animation showing a huge black-and-white cow showering milk over two dozen tiny white skeletons, isn't it? Once fed, the miniature skeletons prance and dance like Michael Jackson?!? It's chilling. Were you deliberately mixing racial codes?

GREGOIRE: Wait a minute! Weren't you also mixing codes with your Louvre logo? You used a black-and-white photograph of a cloud as the background for the word LOUVRE, spelled out in all caps. The letters look like they have been carved out of marble, yet they float in space. It makes no sense.

BERNARD: I was trying to convey the idea of grandeur, something associated with the Louvre institution, but also with the concept of public space and the democratic values attached to it. Originally, I had proposed a logo inspired by I.M. Pei's pyramid, but he vetoed it. It was written in his contract that the only triangle would be *his* triangle. So I decided to evoke the presence of the glass pyramid by integrating in the design of the logo a photograph of the cloudy Parisian sky as seen through Pei's iconographic skylight.

HEADWAITER: Would you like to order drinks?

GREGOIRE: How about champagne? What do you think, Monsieur Bernard? Let's celebrate the coming together of Art and Commerce.

BERNARD: As you please. But instead I'd like to drink to the health of Design for the Public Domain.

GREGOIRE: Well, you leave me no alternative but to raise my glass to the health of Private Enterprise!

[They both laugh nervously.]

▲ POSTERS FOR THE LOUVRE, PARIS, 1989, 1991. Atélier de Création Graphique/Pierre Bernard

▲ **LOGO FOR THE LOUVRE, PARIS**, 1989. Atélier de Création Graphique/Pierre Bernard

GREGOIRE'S VOICE-OVER: Graphic designers are all autistic, in my view. They refuse to communicate with the outside world. They talk inside their own heads. This guy is going to be hard to convince because he won't hear what I have to say. That's why I don't hire graphic designers at my agency. Instead, I hire video artists. These kids can take a project from beginning to end and come up with a solution overnight. They are in a participatory mode: they understand that there is no longer a boundary between broadcasting and receiving. Still, I'm going to try to nail this chap.

GREGOIRE (ALOUD): France-Muséums is a prestigious client. The prospect of designing the corporate identity of the Abu Dhabi Louvre! Wow. That's the kind of assignment I would kill for.

BERNARD: Like you, when I got the initial phone call from the director of France-Muséums I thought, why not? I knew that Abu Dhabi was a controversial project because the works of art in the Louvre are considered part of the national heritage, and as such they are sacred objects that cannot be sold, traded, bartered, or loaned. But I am against political correctness, so at first I agreed to look into it. Exporting culture is a good thing, isn't it? But then I realized that the museum in Dubai would be part of a luxurious "cultural" shopping mall, and that the Louvre would be treated as just another French prestige brand, like Chanel, Hermès, or Vuitton. I bristle at the thought of turning art into a luxury product! Art is for everyone, not just for a happy few. So I refused to get involved.

GREGOIRE: But what's wrong if rich folks discover art while on a shopping spree? In fact, right now, there is an upscale shopping mall on the lower level of the Louvre in Paris. If you live in the real world, as I assume you do, then you must accept the situation for what it is. Why would you be upset because a museum benefits from its proximity to commercial venues? One of the reasons the Centre Pompidou in Paris is so popular is its location at the heart of a lively shopping district.

BERNARD: I live in a real world by creating, designing, and organizing graphic signifiers in such a way as to offer an alternative vision of democracy. Unlike you, I do not exploit visual codes in the name of commerce. I stay away from the world of advertising for this reason.

"I bristle at the thought of turning art into a luxury product! Art is for everyone, not just for a happy few."

GREGOIRE: I don't believe in the separation of art and commerce. It's an old-fashioned concept, very European. I follow the Anglo-Saxon model. In England and the United States the word commerce means exchange of words, ideas, and goods. It doesn't mean "to sell." But in France commerce is about selling, about money, and money is considered dirty, shameful, vile. In France advertising, which encourages commerce, is seen as the devil.

BERNARD: Don't assume I hate commerce. I do not consider it to be a necessary evil. On the contrary, I believe that it is one of those social activities whose attainments, opportunities, and insights have contributed greatly to the development of all cultures. But what I resent is its loud totalitarian pretension!

GREGOIRE'S VOICE-OVER: *Loud totalitarian pretension!* That's pure Marxist jargon! You cannot have a real debate with left-wingers like him. This conversation is doomed. Where is the champagne? I need a drink!

GREGOIRE (ALOUD): So, in your view, there is good commerce and bad commerce? Good commerce profits the lower classes, while bad commerce profits the upper classes?

BERNARD: Let's not oversimplify! What I condemn are advertising campaigns that are nothing more than grotesque ornamentation of social disenchantment. The result of this kind of hype is an oversupply of mediocre signs and trinkets. Just like environmental deterioration, the damage that is created by unscrupulous commercial communication strategies has reached a global scale.

GREGOIRE: But why don't you advocate "good" communication strategies that encourage people to look at works of art? If people who never set foot in a museum decide to check out an exhibition at the Louvre, then it's a victory for democracy, right? And that's the job of advertising. I don't see what's degrading about that. If it's what it takes to get people to look at art, then I, for one, see nothing wrong with treating the Louvre like another upscale luxury brand.

BERNARD: The concept of "luxury" is different from that of "wealth." The Louvre is not about luxury but about wealth—a

wealth that has nothing to do with luxurious material goods. When designing the visual identity of the Louvre in Paris my intention was to reveal this wealth in all its complexity through the common language of signs and images.

GREGOIRE: Why are you afraid to give more people access to museums? Why are you barring the door to culture to folks who would enjoy it? I thought that the philosophy of the student revolt of 1968, the doctrine of which you embraced, was about "culture for all," wasn't it?

BERNARD: Again, you are confusing two different concepts: "culture for all," as you call it, and "mass media." Mass media is a form of entertainment, whereas culture for all is an idea that does not imply leveling the messages to lowest common denominators. Culture for all is not necessarily immediately "readable." It requires time, demands patience, invites questions, and even provokes controversy. Mass media is supported by advertising;

culture for all is supported by the work of graphic designers like myself.

GREGOIRE: I never said that advertising was an art! Nonetheless it is connected to the art world, and as an adman I am constantly crossing over to the other side. I work with conceptual fashion designers, with architects, with video artists. My art directors are web designers, internet technicians, game developers, musicians, computer nerds. We cross-fertilize cultures, talents, and disciplines. We are part of the contemporary art scene. So, even though advertising is not an art, people looking at our ads are in the same situation as people looking at an art installation in a museum.

BERNARD: Really? If that is what you believe, then I am afraid that our main disagreement is not so much about the role of commerce, but about the role of art.

GREGOIRE: I want to remove the walls between art and commerce. I want to break down cultural barriers in order to turn streets, malls, desktops, and portable phones into contemporary art museums. You, on the other hand, want to make sure that the separation between these two worlds remains.

◄ **BONY BOYS VIDEO CLIP**, 2007
Agency: La Chose; Creative Director: Pascal Grégoire
Client: Les Produits Laitiers

BERNARD: It's like the separation between church and state, wouldn't you say? It protects the democratic process. Can't we at least agree on that?

GREGOIRE: Ah, *touché*! You got me there. Democracy is safe as long as you and I support secular values. Yes, I'll drink to that! Here is the waiter with the champagne, at long last.

GREGOIRE'S VOICE-OVER: We ended up ordering the same thing on the menu, and kept drinking champagne all the way through. We weren't going to talk about museums anymore when we discovered that we both spend a lot of time at the Centre Pompidou. I hang out there at lunchtime because my office is just around the corner. And Bernard has done quite a lot of work for that museum over the years. Great stuff too. Amazing billboards, handsome posters, and a bunch of communication campaigns too! I was almost jealous, though I never told him so. By the time the meal was over, all the other customers seemed to have left hours ago. We got the bill, and Bernard insisted on paying for the dinner. I walked back home slowly in the rain instead of taking a cab. I had not done this in years. Paris is so beautiful when it's wet.

AFTERWORD:
IN DEFENSE OF DILETTANTES
VERONIQUE VIENNE

Good art directors are inspired dilettantes. As this book attempts to explain, people who embrace this career path are multitalented individuals who dabble in everything. Amateurs, collectors of trivia, observant, inquisitive, they are not erudite: they buy lots of books on design but seldom read them.

They are visually discriminative, though: they flatly refuse to use stock illustration, preferring original artwork to "brand X" pictures. People-oriented, they return phone calls. Technologically savvy, they know the difference between a pica and a point. Best of all, they are jargon-free—unlike their colleagues in marketing, for instance, they will never describe their assignments as "deliverables" or as "design solutions."

In other words, they are fun to be with, personable, engaging—and always willing to put aside deadlines to go to lunch with you.

Being a modern-day dilettante is not easy, though. Our puritanical work ethic celebrates experts, specialists, and pundits, not good-natured, art-oriented generalists. The reason dilettantes are not taken seriously is the same reason art directors have a tough time gaining recognition in the business world. *Dilettare* is Italian for "to delight." Milton Glaser, probably the most famous art director of our times, likes to say that his role is "to inform and delight"—an expression he borrowed from ancient Roman poet and literary critic Horace. And indeed, "inform and delight" is as good a definition as one will ever find to describe the contradictions at the heart of the practice of art direction.

Art directors are dilettantes, but they are also accomplished communicators.

Michel Chanaud, founder of Pyramyd, a French publisher of books and magazines on design, denounces the widespread misconception that art directors are failed artists who have turned what was essentially a hobby into a métier. "The perception out there is that art directors have no real training," he says. "When students consult me about a career as an AD in advertising or publishing, I ask them: 'Do you speak English? Are you curious? Do you like to read?' They usually say no. So I tell them to forget it. To be a good AD, you need all of the above. The profession of art director is not a 'default' option."

He has an interesting theory to explain why negotiating words and images on the same page, something art directors do routinely, is an ambiguous proposition. "In Protestant countries, predominantly in northern Europe, the relationship to the divine is a one-on-one affair between the faithful and the Bible: God's design is manifested through the printed word. In Catholic regions, in southern parts of the continent, that same relationship takes place during Mass, and is brokered through the rich imagery of the Catholic Church." As far as Chanaud is concerned, the creative tension between type and visuals

comes from this profound religious difference. To inform and delight: books versus paintings, the printed words versus the images.

Art directors are straddling both worlds. They are often considered double agents by editors, who think they are on the side of artists. Visuals people, on the other hand, are likely to suspect them of being turncoats as well—mere flunkies of marketing consultants and of dictatorial clients. Skilled layout artists, art directors must also be experienced negotiators in order to mediate this clash of cultures and find a balance in their lives between these two very different realms.

So, even though art directors are passionate aces who love their work and thrive on it, they remain on the defensive. In fact, a number of art directors interviewed for this book have questioned whether or not they should be included. The reasons they gave for their ambivalence toward art direction were varied—but a sense of unease was universally shared.

"I don't think that real artists either can or should be directed," said French contributor Vincent Perrottet (see pages 202–213), a former member of the Grapus collective. "So I don't want to be called an art director. I would never want to work with people who would agree to follow my directions."

"I was uncomfortable with the term 'art director' as it implies that someone else is actually doing the hands-on design, which has never really been the case with me," wrote New York-based Paul Sahre (see pages 74–79).

"Art direction? It's really about getting a lot of people together," said Dimitri Jeurissen (see pages 92–101), art director of Base in Brussels and New York, who always insists on crediting everyone involved in any job he does, down to the last seamstress, manicurist, and messenger boy.

"I have the advantage of not being an art director," claimed the advertising creative director Pascal Grégoire (see pages 240–245), founder of La Chose in Paris. "I function more like a film producer. My job is to have the idea. Afterward, someone else must make it happen. I only control the message."

"No one today ever comes to me asking how to become an art director," said Peter Knapp (see pages 80–83), who established the look of *ELLE* magazine back in the 1960s. "No. Art direction is no longer a relevant profession. It's over. In the last analysis, an art director is simply someone who has taste. And there are many more people who have brains than people who have taste."

"The power of the art director is granted by others," wrote former art director Lloyd Ziff (see pages 62–65), now a photographer. "If you are the only art director in a meeting about design solutions and no one is listening to you, the meeting is about power, and you have none."

"To this day I am not sure what the differences are between creative director, art director, and designer," wrote the peripatetic maverick illustrator Laurie Rosenwald (see pages 214–223), who prefers to be called a 'commercial artist.'

"Design professions are suffering from a confusion at the level of the words," suggests Chanaud. "We don't know anymore what anyone does. Are these folks creative directors, art directors, visuals editors, graphic designers, motion graphics artists, or simply 'designers'?" What do you call people like Fabien Baron, he asked? Big-name art directors these days are blurring the lines by designing magazines, advertising campaigns, and also household objects, chairs and lamps.

So, why all the bellyaching when, truth be told, art direction is in fact one of the last enjoyable, do-it-yourself, seat-of-the-pants, lucrative, and noncriminal occupations left on planet Earth? Go figure. Unless, of course, art directors are such consummate dilettantes that the last thing they want is for their esoteric vocation to be recognized as a legitimate métier and duly classified as a bona fide profession.

CONTRIBUTORS

GAIL ANDERSON is a creative director at SpotCo (spotnyc.com), a New York City-based design studio and advertising agency that specializes in creating artwork and campaigns for Broadway theaters. From 1987 to early 2002 she served as senior art director at *Rolling Stone* magazine. Anderson's work, which has received awards from the Society of Publication Designers, the Type Directors Club, the American Insitute of Graphic Arts (AIGA), the Art Directors Club, *Graphis*, *Communication Arts*, and *Print*, is in the permanent collections of the Cooper-Hewitt Design Museum and the Library of Congress. She is co-author, with Steven Heller, of *Graphic Wit*, *The Savage Mirror*, *American Typeplay*, *Astounding Photoshop Effects*, and *New Vintage Type*. Anderson teaches in the School of Visual Arts' MFA Design program and currently serves on the advisory board for the Adobe Design Achievement Awards. She is the recipient of the 2008 AIGA Medal for lifetime achievement.

...

PIERRE BERNARD studied with Henryk Tomaszewski at the Fine Arts Academy of Warsaw. In 1970 he founded the Grapus design collective with François Miehe and Gérard Paris-Clavel. Alex Jordan and Jean-Paul Bachollet joined the group in 1976. Grapus was famous for its political commitment and for its belief in the creative power of the collective process. From 1978 on, Grapus projects received a lot of media attention thanks to important exhibitions in Paris at the Poster Museum, in Amsterdam at the Stedelijk Museum, in Aspen at the Design Conference, and in Montreal at the Musée d'Art Contemporain. In 1990 Grapus broke up, and Pierre Bernard founded the Atelier de Création Graphique with Dirk Behage and Fokke Draaijer. He designed, among other projects, the graphic identities of the Louvre and of the French National Parks. A member of Alliance Graphique Internationale (AGI) since 1987, he works on commissions in publishing, poster design, signage, and visual identity systems—always exploring the social and cultural dimension of graphic design.

NICHOLAS BLECHMAN is the art director of the *New York Times Book Review*. He also runs Knickerbocker Design, a graphic design firm specializing in illustration and print work. Blechman published, edited, and designed the award-winning political underground magazine *NOZONE*, which has been featured in the Smithsonian Institution's Design Triennial. He has taught design at the School of Visual Arts and Illustration at the Maryland Institute College of Art. Blechman co-authors a series of limited-edition illustration books, *One Hundred Percent*, with Christoph Niemann. He is a member of AGI, and is also a former board member of the New York chapter of the AIGA. He is the author of *Fresh Dialogue One: New Voices in Graphic Design*, *EMPIRE*, *100% EVIL*, and, most recently, *FORECAST*.

...

PETER BUCHANAN-SMITH is the founder and principal of Buchanan-Smith LLC. He is currently the consulting design director of Isaac Mizrahi Inc., and has variously served as the creative director of *Paper Magazine*, art director of the op-eds page of the *New York Times*, and founding partner of publishing company PictureBox Inc. He has been honored by *I.D. Magazine*, the American Institute of Graphic Art, and the National Academy of Recording Arts and Sciences, which awarded him a Grammy for his design of Wilco's album *A Ghost is Born*. He has authored several books, including *Speck* and *The Wilco Book*, and has collaborated on the creation of dozens more, including *The Elements of Style* by Maira Kalman and *Muhammad Ali* by Magnum Photographers. In addition, he designs packages and collateral for fashion and music, including the re-release of Brian Eno and David Byrne's *My Life in the Bush of Ghosts*. He speaks around the world about style, design, and visual culture, and teaches graphic design at the School of Visual Arts in New York. He was a board member of the New York chapter of AIGA (2005–07). He lives in sunny New Jersey with his wife Amy and their dog Maisie.

STEPHEN COATES began his career in editorial design in 1984 at *Blueprint*, the monthly architecture magazine, which won D&AD awards in both 1986 and 1989. Coates went on to become the founding art director of *Eye*, the quarterly review of graphic design, in 1991, and set up a studio in partnership with Tony Arefin working on catalogs and posters for London arts institutions such as the ICA, the Serpentine Gallery and the Tate Gallery. *Eye* won D&AD and Type Directors Club awards in 1993, and a Society of Publication Designers gold award in 1994. He also had spells as art director of *Tate* magazine (1996–2002) and the film magazine *Sight & Sound* (1998–2005). In 1999 he left *Eye* to launch August, a publishing imprint and design consultancy, with Nick Barley, as he wanted the freedom to have a more influential role in the editorial conception of his projects. August's output includes books and catalogs on design, architecture, and fine arts. Coates has been responsible for the redesign of *New Scientist*, *Music Week*, and, in collaboration with Simon Esterson, *Building Design* and *New Statesman* magazines. He is currently art director of *Crafts* magazine and design director for *The Drawbridge*. His work has been shown in several exhibitions, including "Communicate: Independent British Graphic Design Since the Sixties" at the Barbican Art Gallery, London, in 2004.

...

BRIAN COLLINS is chief creative officer of COLLINS, a design and innovation company in New York City. His clients have included Coca-Cola, Motorola, American Express, MTV, Mattel, Levi Strauss & Co., the New York Public Library, the Alliance for Climate Protection, and Hershey's—for whom he designed a 12-story candy factory in Times Square. Prior to founding his own company he led the Brand Integration Group (BIG) at Ogilvy & Mather for nine years. He teaches at the School of Visual Arts, New York, and speaks globally on design, including at the World Economic Forum in Davos, Switzerland. He is a distinguished alumnus of the Massachusetts College of Art.

ROBERT DELPIRE, a French publisher of innovative books on design and photography, is famous for promoting the work of Cartier-Bresson, Brassaï, Doisneau, Lartigue, Bischof, and Robert Frank. He is also known as the creative director of a ground-breaking advertising campaign for Citroën in the 1960s and 1970s. Since 1963 his small art gallery on Paris's Left Bank has showcased the work of young photographers (many of them, such as Eugene Smith, Joseph Koudelka, Guy Bourdin, and Duane Michals, now famous), as well the work of designers and illustrators such as André François, Alain Le Foll, R.O. Blechman, Herb Lubalin, Savignac, and Milton Glaser. Delpire has produced films, been the curator of countless museum shows and art exhibits, and acted as director of the Centre National de la Photographie in Paris. He is the creator of the international "Photo Poche" series, a collection of small, affordable art books with more than 150 titles.

...

DAVE EGGERS is the author of the memoir *A Heartbreaking Work of Staggering Genius* (2000), the novel *You Shall Know Our Velocity!* (2002), the story collection *How We Are Hungry* (2004), and the novel *What Is the What* (2006). In 1998 he founded McSweeney's, an independent book publishing house in San Francisco that puts out the literary journal *McSweeney's Quarterly Concern*, the monthly magazine *The Believer*, a daily humor website, www.mcsweeneys.net, and *Wholphin*, a DVD quarterly of short films. In 2002 Eggers opened 826 Valencia, a writing laboratory for young people located in the Mission district of San Francisco, where he teaches writing to high-school students and runs a summer publishing camp; there are now branches of 826 in Brooklyn, Los Angeles, Seattle, Chicago, Ann Arbor, and Boston. With the help of his workshop students, Eggers edits a collection of fiction, essays, and journalism called *The Best American Nonrequired Reading*. He is also the co-editor of the "Voice of Witness" series of oral histories. His fiction has appeared in *Zoetrope*, *Punk Planet*, and the *New Yorker*. He has recently written introductions to new editions of books by Edward Wallant, John Cheever, and Mark Twain. He writes regularly about

art and music for magazines including *Frieze*, *Blind Spot*, *Parkett*, and *Spin*, and his design work has been featured in many periodicals, including *Print* and *Eye*, and annuals, including *Area: 100 Graphic Designers* (Phaidon, 2003) and *Reinventing the Wheel* (Princeton Architectural Press, 2002). He has designed most of the books and quarterlies published by McSweeney's, and created the templates for *The Believer* and *Wholphin*. In 2003 his designs for McSweeney's were featured in the National Design Triennial at the Cooper-Hewitt National Design Museum, and in the California Design Biennial.

...

VINCE FROST, creative director and CEO of Frost Design, is a member of the Chartered Society of Designers, D&AD, the International Society of Typographic Designers, the Australian Graphic Design Association, and AGI. In the early 1990s he became Pentagram London's youngest associate director. In 1994, after five years at the design industry's best finishing school, he set up Frost Design. Since then many awards have come his way, including D&AD silvers, golds from the New York Society of Publication Designers, and gongs from the New York and Tokyo Art Directors Clubs. In 2004 he moved to Sydney, Australia, where he works for global clients, winning international accolades. Frost's 30-person Sydney studio offers a diverse mix of talents—from graphic and multimedia designers to architects, interior designers, and brand strategists. He works on a wide range of projects, from magazine and book design to corporate identity, environmental graphics, and interactive design.

...

JOHN FULBROOK III is the creative director of COLLINS. Previously he was the senior art director of Scribner, a literary imprint of Simon & Schuster. He teaches at the School of Visual Arts, New York, and has been involved in the design community extensively over the past several years. He has served on the board of the New York AIGA, judged many shows, and won several awards from the AIGA, the Art Directors Club, and more.

...

PASCAL GRÉGOIRE loves to campaign for his clients but he also loves to campaign for the environment. He does it his way, though:

he dreams up crazy schemes at the office, but comes home to a farm where he makes his own cider. He thinks of himself as someone who has his head in the clouds and his feet firmly planted on the ground. His first job in advertising was at CLM/BBDO in 1987. Sixteen years later, in 2003, he became its president. Meanwhile, for Agence Bélier, Groupe Havas, he launched the French subsidiary of Leagas Delaney. In 2006 he came up with a totally new concept for an advertising agency and called it La Chose, meaning "the thing"—or rather "the thingamajig." What's that thingamajig? The digital revolution!

...

STEVEN HELLER was an art director for various underground and alternative newspapers in the late 1960s and early 1970s, then at the *New York Times* for 33 years, originally on the op-ed page, and for almost 30 of those years with the *New York Times Book Review*. He is the author, co-author, and/or editor of over 120 books on design and popular culture, and has produced or curated numerous exhibitions. His latest book, *Iron Fists: Branding the 20th Century Totalitarian State*, is the first illustrated survey of propaganda art, graphics, and artifacts created by totalitarian governments. In 1999 Heller was the recipient of the AIGA gold medal, the highest honor given to a graphic designer in the United States. Currently he is co-chair of the MFA Designer as Author Program at the School of Visual Arts in New York, editor of the *VOICE: The AIGA Online Journal of Design*, and writes the "Visuals" column for the *New York Times Book Review*.

...

TIM HOSSLER is the former in-house art director for photographer Annie Leibovitz and helped to create her memorable images, books, and exhibitions from the mid-1990s through the early 2000s. As an independent art director in New York City he worked with many photographers including Richard Avedon, Steve Hiett, and Martin Schoeller, and with art directors Ruth Ansel and Douglas Lloyd. He holds a degree in architecture from Kansas State University and an MFA from Cranbrook Academy of Art. He was the design director at the Massachusetts Museum of Contemporary Art and is currently the art director of the Wolfsonian–FIU in Miami Beach, Florida.

DIMITRI JEURISSEN is a partner at Base, a design studio with offices in Brussels, Barcelona, New York, and Madrid. Formed in Brussels in 1993, Base is made up of some 45 people working in creative direction and brand development. As an addition to its identity work, Base launched a writing division, BaseWORDS, in 2004. In 2005 the studio added two further complementary departments: BaseMOTION, specializing in film and motion graphics, and BaseLAB, which designs custom typefaces and builds design-oriented tools. The agency also invested in Books on the Move, a comprehensive book publisher that offers services in design, editorial, printing, and worldwide distribution. With a clientele that spans the corporate, cultural, and institutional sectors, Base has worked on a broad range of projects, from creating image campaigns to designing identities for major corporations and institutions.

...

PETER KNAPP trained as a painter at the Ecole des Arts et Métiers in Zurich. In 1952 he moved to Paris where he eventually became a fashion photographer. In 1959 he accepted the position of art director of *ELLE* magazine, a weekly publication that gave him ample opportunity to combine his Swiss typographical flair with an American-inspired sense of style. Part Müller-Brockmann, part Brodovitch, his layouts helped to define the 1960s fashion outlook and launch the career of designers such as Courrèges and Cardin. Now a video artist, film producer, photographer, and painter, Peter Knapp is part of the contemporary art scene.

...

EIKE KÖNIG. Who the hell is Eike König? He is the creator of HORT, a design studio established in 1994 under the previous name of EIKES GRAFISCHER HORT. Formerly in Frankfurt, HORT is now in Berlin, Germany. A creative environment, the studio is a place where "work and play" can be said in the same sentence. HORT was once a household name in the music industry. Now it is a multidisciplinary creative hub, an institution devoted to making ideas come to life. It is a place to learn, a place to grow, and a place to keep growing. We do more than serve our clients' short-term needs: we inspire them. HORT has been known to draw insight from things other than design.

ROSS MACDONALD is an author, illustrator, and designer. He has also worked as a prop-maker and as a consultant on period printing, design, and documents for movies including *Seabiscuit*, *The Alamo*, *Mr Brooks*, *Infamous*, and *National Treasure 2: Book of Secrets*. His illustrations have appeared in the *New Yorker*, the *New York Times*, *Rolling Stone*, *Harper's*, the *Atlantic Monthly*, and many other publications. He is a contributing editor to the *Virginia Quarterly Review*, and is on the masthead of *Vanity Fair* as a contributing artist. He lives in Connecticut with his wife, two kids, dogs, cats, and a barn full of nineteenth-century type and printing equipment.

...

VICTORIA MADDOCKS joined Kiehl's as creative director in 2001. Prior to that she had consulted or held permanent positions with Gucci, Wolff Olins, Saatchi & Saatchi, the Arnell Group, and Munn Rabôt. She was art director for *South Beach Magazine* and *Salon News* (Fairchild Publications), and has consulted for Hachette Filipacchi and for *ESPN The Magazine*. She is currently designing a park on Suffolk Street, in Manhattan's Lower East Side, with the New York Restoration Project. She graduated with a BA with honors in graphic design from the University of Northumbria at Newcastle-upon-Tyne, England, in 1992.

...

DEBBIE MILLMAN is a partner, and president of the design division, at Sterling Brands and teaches in New York at the School of Visual Arts and Fashion Institute of Technology. She is also an author on the design blog *Speak Up* and a regular contributor to *Print* magazine, and hosts a weekly internet talk show, "Design Matters," on the VoiceAmericaBusiness network. Her first book, *How To Think Like A Great Graphic Designer*, was published by Allworth Press in 2007, and her second, *The Essential Principles of Graphic Design*, by Rotovision in 2008.

CHRISTOPH NIEMANN was born in Waiblingen, Germany, in 1970. After his studies at the Stuttgart Academy of Fine Arts he moved to New York City, where he has been working as an illustrator, animator, and graphic designer since 1997. His work has appeared on the covers of the *New Yorker*, the *Atlantic Monthly*, the *New York Times Magazine*, and *American Illustration*. His corporate clients include Nike, Google, Amtrak, and the Royal Mail. His illustrations have garnered numerous awards from the AIGA, the Society of Publication Designers, the Art Directors Club, and American Illustration. His latest book, *The Pet Dragon*, teaches Chinese characters to children.

...

VINCENT PERROTTET joined the now-legendary Grapus graphic design collective in 1983. In 1989 he created the Graphistes Associés with Gérard Paris-Clavel as well as Jean-Marc Ballée, Anne-Marie Latrémolière, and Odile José. A member of AGI since 2002, he is currently an independent graphic designer, collaborating with Annette Lenz for the Theatre of Angoulême. He is also a teacher: in 1992–93 he taught at the Ecole Supérieure d'Art et de Design d'Amiens (ESAD). He contributes in various ways by lecturing, taking part in conferences, and judging for entries and degrees at Ecole Nationale Supérieure des Arts Décoratifs (ENSAD), Ecole Supérieure d'Arts Graphiques (ESAG), Ecole Estienne, Ecole Nationale Supérieure de Création Industrielle (ENSCI), Ecole d'Architecture de Marne-la-Vallée, and a number of other art schools. Since 1999 he has taught at the Ecole d'Art of Le Havre. In 2004, with Anette Lenz, he was awarded the second prize at the Tehran Poster Biennial in Iran, and the grand prize at the Ningbo Poster Biennial in China.

...

GILLES POPLIN, a French freelance magazine art director and graphic designer for over ten years, is familiar with most aspects of the visual communication world, from print to animation graphics. One of his specialities is devising visual identity programs for television spots and music video titles. His other areas of expertise include logo design, typography, and branding of products. He has collaborated with Sylvia Tournerie on developing the graphic format of the contemporary art magazine *ZéroDeux*.

...

THOMAS POROSTOCKY was bred Hungarian, raised Canadian, and currently resides in Brooklyn, New York. While doing his best to scare contributors and children from behind his art director post at *I.D. Magazine*, Porostocky also often sits on the other side of the table, being commissioned by clients such as *Wired*, the *New York Times*, and HBO.

...

LAURIE ROSENWALD is sole proprietor of Rosenworld, and is a loner, a rebel, and, yes, an illustrator-slash-designer. Her status as professional outcast has occasionally been threatened by fearless (and attractive!) art directors. Would you be counted among the elite few willing to take a bullet to defy the forces of corporate greed? And do you have an unlimited budget for daring? Well neither did Ogilvy, J. Walter Thompson, Nike, the Sundance Channel, Bravo, MTV, Apple, Ikea, the *New Yorker*, or the *New York Times*. Nevertheless, they managed to unleash the mighty power that is Rosenworld, and so can you. Rosenwald's new *All The Wrong People Have Self-Esteem* (Bloomsbury) is an inappropriate book for young ladies and, frankly, anybody else. It is the only book you will ever need. Her children's book, *And To Name But Just A Few: Red, Yellow, Green, Blue* (Blue Apple) was named one of 2007's best by *Scholastic Parent & Child*, and they ought to know. Her *New York Notebook* (Chronicle) is the one New York guidebook with a guaranteed hiccup cure and a cult following among graphic designers. Rosenwald's top secret "How To Make Mistakes On Purpose" workshop has been taught at the AIGA national conference, Art Center, the School of Visual Arts, New York, Rhode Island School of Design, Maryland Institute College of Art, and to HRH Prince Carl Philip, Duke of Värmland, which makes her a *kungliga hovleverantör*, or supplier to the Swedish royal court. No one knows where the money goes.

PAUL SAHRE established his own design company in New York in 1997. Consciously maintaining a small office, he has nevertheless established a large presence in American graphic design. The balance he strikes, whether between commercial and personal projects or in his own design process, is evident in such things as the physical layout of his office: part design studio, part silk-screen lab where he designs and prints posters (some of which are in the permanent collection of the Cooper-Hewitt Design Museum) for various off-off Broadway theaters. On the other side of the office he is busy designing book covers for authors such as Rick Moody, Chuck Klosterman, Ben Marcus, and Victor Pelevin. Sahre is also a frequent contributor to the *New York Times* op-ed page. He is the author of *Leisurama Now: The Beach House for Everyone, 1964–*, a book based on a collection of QSL cards, which amateur radio enthusiasts exchange after communication with other operators around the world. Sahre received his BFA and MFA in graphic design from Kent State and teaches graphic design at the School of Visual Arts, New York. He is a member of AGI.

..

SYLVIA TOURNERIE is an independent graphic designer, typographer, and art director who lives in Paris. www.sylvia-tournerie.com.

..

VERONIQUE VIENNE worked at a number of US magazines as art director, including *Parenting*, *Self*, and the Sunday magazine of the *San Francisco Examiner*. She has written extensively on graphic design, cultural trends, and business practices. She has edited, art directed, and written essays for a number of design publications (*House & Garden*, *Emigre*, *Communication Arts*, *Eye*, *Graphis*, *Aperture*, *Metropolis*, *Etapes*, *Print*, etc.). The author of several books on design, she also writes mass-market guidebooks, including *The Art of Doing Nothing*, which has been translated into eight languages. She lives in Paris.

..

VIER5 / MARCO FIEDLER & ACHIM REICHERT decided to move to Paris in 2002 after years working in Frankfurt, Germany. They set up a new graphic design studio, Vier5, in the heart of the French capital. Their approach is conceptual and strategic, yet they like to describe their work as eccentric and singular. Their most recent projects include: the signage systems for the last Documenta in Kassel and for the Museum für Angewandte Kunst in Frankfurt; the identity program of CAC Brétigny, France; and the art direction of the magazine *Fairy Tale*, which they edit and publish.

..

KHOI VINH is the design director for *NYTimes.com*, where he leads the in-house design team in user-experience innovation. He is also the author of the popular design weblog *Subtraction.com*, where he writes extensively on design, technology, and user-experience matters of all kinds. Previously Khoi was the co-founder of the award-winning New York design studio Behavior, LLC. He studied communication design at Otis School of Art and Design in Los Angeles, and practiced branding and graphic design in print for several years in Washington, DC, before moving to New York.

..

LLOYD ZIFF, a former art director, has made photography the sole focus of his career. His photographs have been published in many of the world's most prestigious magazines, including *Vanity Fair*, the *New York Times Magazine*, *Blind Spot*, *Condé Nast Traveler*, *Condé Nast Traveller* (UK), *Condé Nast Traveller* (Spain), *ELLE*, *GQ*, *Interview*, *Kid's Wear* (Germany), *Rolling Stone*, and *Wired*, and have been included in the anthologies *American Photography 18, 19, 20, 22, 23*, and *Graphis Photography*. Ziff has had one-man shows at the Earl McGrath Gallery in Los Angeles and Robin Rice Gallery, New York City. He is also represented by the Jane Corkin Gallery in Toronto, Ontario. Before he became known as a photographer he was an award-winning art director/design director of several national magazines, including *Condé Nast Traveler*, *Vanity Fair*, *House & Garden*, *L.A. Style*, *New West*, *Rolling Stone*, and *Travel & Leisure*. Ziff taught magazine design, photography, and illustration at the Art Center College in Pasadena, CA, the School of Visual Arts in New York City, and, for 13 years, the Parsons School of Design in New York City. In 1999 he was elected to the board of trustees of Pratt Institute in Brooklyn, New York, his Alma Mater.

INDEX:
Page numbers in **bold** refer to illustrations

PICTURE CREDITS:
The authors and Laurence King Publishing Ltd would
like to thank all the art directors, designers, publishers,
editors, and other copyright holders who have granted
permission to reproduce images in this book. Every effort
has been made to contact copyright holders, but should
there be any errors or omissions, Laurence King Publishing
Ltd would be pleased to make the appropriate alteration
in any subsequent printing of this publication.

Herbert Bayer © DACS 2009.
Robert Frank courtesy Pace/MacGill Gallery.
John Heartfield © The Heartfield Community of Heirs/
VG Bild-Kunst, Bonn and DACS, London 2009.
Rmn.fr website © RMN.
Saul Steinberg © The Saul Steinberg Foundation/
ARS, NY and DACS, London 2009.